	2.4			
				•
	~			
		•		

CLASSIC PHOTOGRAPHS

CLASSIC PHOTOGRAPHS

A PERSONAL INTERPRETATION

By John Loengard

A BOB ADELMAN BOOK Designed by Bob Cato

NEW YORK GRAPHIC SOCIETY BOOKS
LITTLE, BROWN AND COMPANY
BOSTON TORONTO LONDON

Picture Research: Gretchen Wessels
Text Editor: Richard Woodley
Proofreading: Barbara Dudley Davis &
Amelia Weiss

ACKNOWLEDGMENTS

A number of people at Time Inc. have been instrumental in the creation of this book. I am especially indebted to Patricia Ryan and Elizabeth P. Valk, as well as Susan Caughman, Roger Herrmann and Peter Howe.

I am grateful to Richard B. Stolley for bringing this project to the attention of New York Graphic Society Books, and to John Maclaurin, its publisher, who has been a steady source of support and encouragement.

It is impossible to work with photographs published in *Life* without getting invaluable assistance from Barbara Baker Burrows and Marie Schumann, as well as Doris C. O'Neil,

Marthe Smith and Beth Bencini Zarcone.

I also received help from Mary Youatt Steinbauer, Harry Johnston, Tom Bentkowski, June Goldberg, David M. Friend, Sue Allison, Jane Furth, Deirdre Wilson, Azurea Lee Dudley, Joseph Aprea, Margaret Sedgwick, Helene Veret, Gail Ridgwell, Mimi Murphy, Geraldine Howard, Debra Cohen, Gedeon de Margitay and Robin Bierstedt.

Peter Christopoulos, Hanns Kohl, John Downey and Carmin Romanelli have conscientiously seen to it that the Time-Life photo lab produced the best possible prints and transparencies for layout and for reproduction.

Outside Time Inc., Susan Hall provided an initial impetus for this project, and Russell

Burrows gave me access to important documents belonging to his father. Elizabeth Kalkhurst offered constant and constructive criticism, and Sean Callahan, Howard Chapnick, Vicki Goldberg, Yvonne Halsman, Charles Loengard, Kirk Morris and Leslie Teicholz provided help and advice.

Last and most important, I want to thank the photographers—and their representatives—who were invariably generous with their time, their information and their encouragement.

The text on pages 52 and 182 appeared in slightly different form in *American Photographer* magazine.

Copyright © 1988 by John Loengard and Bob Adelman

All rights reserved. No part of this book may be reproduced in any form by any electronic or mechanical means, including information storage and retrieval systems, without permission in writing from the publisher, except by a reviewer who may quote brief passages in a review.

First Edition

ISBN 0-8212-1714-3

Library of Congress Catalog Number 88-81004

New York Graphic Society Books are published by Little, Brown and Company (Inc.). Published simultaneously in Canada by Little, Brown & Company (Canada) Limited.

Composition: U.S. Lithograph, typographers Printing: Dai Nippon Printing Co. Ltd. PRINTED IN JAPAN

This book is dedicated to the photographers. Their work has set new standards for photography on the printed page.

William Anders Guy Anderson

Eve Arnold

Dmitri Baltermants

Bruno Barbey

Bill Beebe

Harry Benson

Lena Bertucci

Patt Blue

Margaret Bourke-White

John Bryson

Ian Bradshaw

Larry Burrows

Cornell Capa

Robert Capa

Henri Cartier-Bresson

Frank Castoral

Ed Clark

John D. Collins

Ralph Crane

Loomis Dean

John Dominis

Alfred Eisenstaedt

Bill Eppridge

Elliott Erwitt

Michael Evans

J. R. Eyerman

Andreas Feininger

Enrico Ferorelli

Milton Greene

Henry Groskinsky

Philippe Halsman

Gregory Heisler

Abigail Heyman

Ken Heyman

Ethan Hoffman

Yale Joel

Lynn Johnson

Ray Kennedy

Dmitri Kessel

James Koepnick

Hiroji Kubota

Bob Landry Brian Lanker Annie Leibovitz Patrick Lichfield

Mary Ellen Mark Leonard McCombe Barry McKinley Michael Melford Gjon Mili Charles Moore Ralph Morse Joe Munroe Carl Mydans

Lennart Nilsson

Michael O'Brien John Olson Michael O'Neill

Gordon Parks

Co Rentmeester Mirella Ricciardi Walter Sanders Tobey Sanford Paul Schutzer Sam Shere George Silk

W. Eugene Smith Wayne Source Peter Stackpole Maggie Steber George Strock

Georg P. Uebel

Grey Villet Werner Voight

Denis Waugh Hank Walker Bruce Weber Mike Wells

Theo Westenberger

Gino Zamboni

Introduction

Some photographs stick in the mind and become classics. Why? I suppose it is because they retain their power to surprise. Their depiction of a subject is telling and concise. They are rich in detail. They are apt, dramatic and simple.

This is a personal selection of such pictures that have appeared in *Life* magazine over the past 50 years.

The photographs need no explanation. What I want to write about is not the photographs but the photographers, not their biographies but their methods of working. I want to describe their attitudes—and mine—toward some of the pictures they have taken.

Journalism does not impose on a photographer the same demands it does on other artists. A writer or a painter when working as a journalist has to count and measure and check the accuracy of each physical fact he reports. The camera does this automatically for the photographer.

Journalism extends the photographer's range of subject without altering his basic working methods, and gives him the opportunity to conduct his business—which is looking—without apology. He may observe his subject, camera at the ready, alert for any unexpected posture of the body, gesture of the hand or expression on the face. Consider the fact that almost every picture in this book had news value for the reader when it was first published and it becomes clear that journalism allows a photographer wide freedom in terms of subject, style and technique.

Still, a photographer who is a journalist seldom has the luxury of returning to a subject over and over again until it becomes a motif of his work. His aim is to use the vagaries of circumstance as a means of self-expression.

A photographer points his cam-

era at a subject at a certain time, from a certain place, in a certain light, with a certain sweep of view, and it is these choices that control the pictorial power of the image.

The result, the photograph, mixes the mirrorlike record of what was in front of the camera with the graphic shape the picture has taken. As in speech, where *what* is said may be less important than *how* it is said, in photography, this mixture of reality and form creates tension. Through the tension, a skilled photographer can express feelings we would not have felt even if we had stood beside him or her as the picture was taken.

Oddly enough, the camera itself gets lucky sometimes. The synthesis of form and reality can take place—at least enough to stir our interest—without the intervention of a photographer. Such pictures (an airplane's robot-camera record of Pearl Harbor, for example, on page 128) may even become historic documents, and they create a humbling

standard against which any photograph must be judged.

One might compare this book, therefore, to an anthology of English poetry where works by the greatest writers in the language are lined up with those by poets known only for a single verse and with others simply signed "Anonymous." Here, work by master photographers may be cheek by jowl with the product of a tourist's Instamatic.

I should be able to describe the typical photographer who has contributed to *Life*, but I can't. They are men and women; they have ranged in age from early 20s to nearly 90. They come from all over, from all sorts of backgrounds. One common bit of behavior is that when they are going to take pictures, they almost always arrive ahead of time (even so, someone will say, "You should have been here last week!"). They get along with people, if only because they would not have anyone to photograph if they didn't. Their special interests vary, but they are curious about

everything. Each believes he or she is the best photographer in the world, and this self-confidence makes them generous even to their competition.

Some always tell their subjects what to do; others only catch their subjects on the fly; and many will do both. They are all interested in recording what people do, and their photographs may help describe the human condition, a job that has no end.

Some of their pictures were taken before I was out of diapers. I probably saw Margaret Bourke-White's famous story on the dam at Fort Peck 15 years after it appeared in 1936, as I thumbed through old copies of the magazine in a library. Others were taken in the 1960s when I worked on the magazine as a staff photographer, and some of these I might have seen before they were published, in the darkroom coming off the dryer or while talking with another photographer. George Silk, for example, used to agonize over every assignment, and showed me each hard-won picture as

he edited his film in the office next to mine. I became even more involved in the fears and hopes of my fellow photographers during the 1970s and 1980s when for 15 years I was the picture editor of the magazine.

I have had both amateur and professional reasons during the past 35 years to look through each of the 2,000 issues of *Life* published so far. Therefore, selecting the photographs for this book has been more a question of revisiting old favorites than finding many new friends. I could easily have chosen three times the number I have.

My thoughts about these pictures are not necessarily the same as those of other editors or photographers who have worked for *Life*. Indeed, the reader should take my remarks for what they are—my personal and admiring comments about our small tribe of photographers called photojournalists. We take pleasure in the knowledge that our pictures, once taken, are forever ours. Of course, we hope that once seen, they will never be forgotten.

CLASSIC PHOTOGRAPHS

The date under each title is the date of the issue of *Life* magazine in which the photograph first appeared.

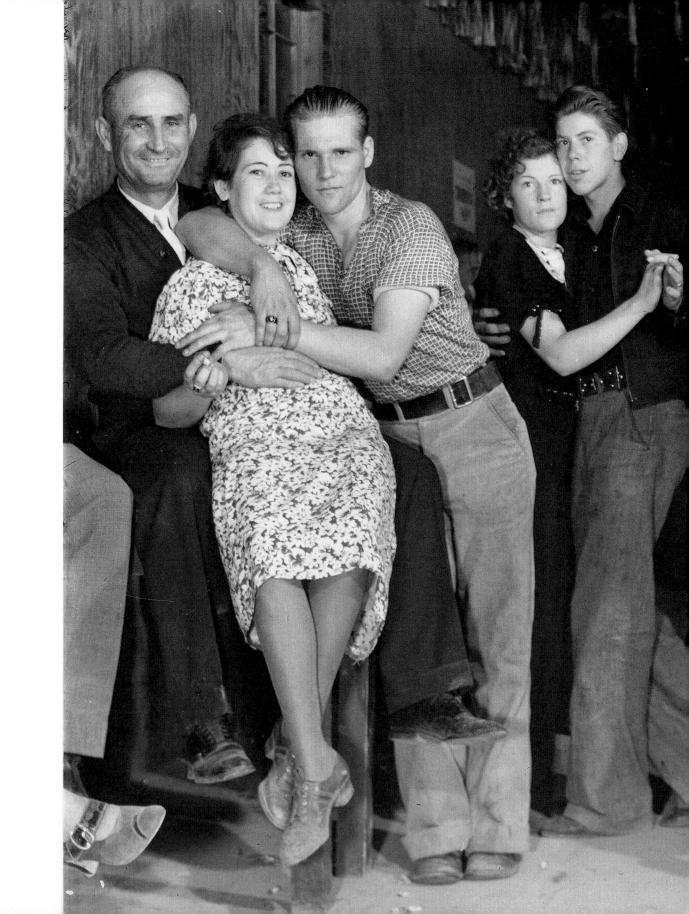

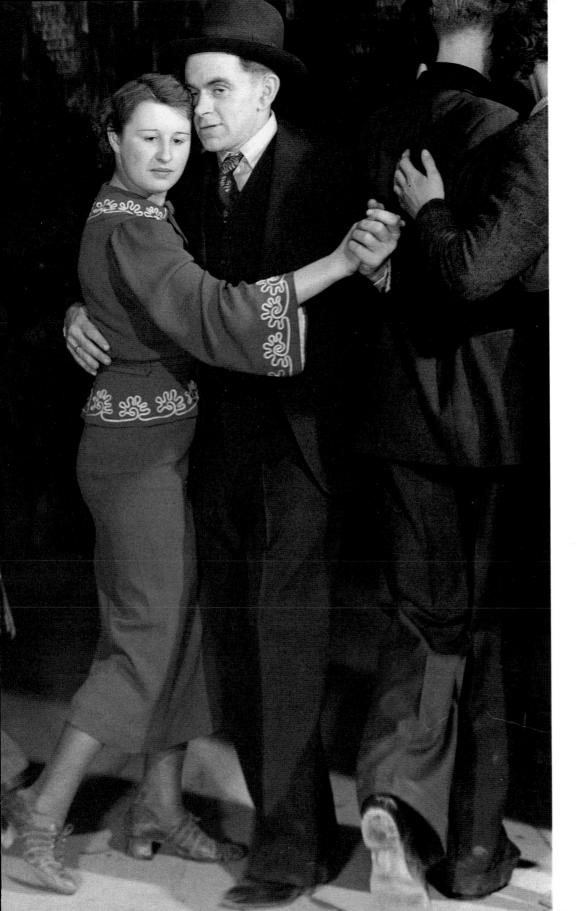

Fort Peck Dam MARGARET BOURKE-WHITE November 23, 1936

argaret Bourke-White made her reputation as an industrial photographer working for *Fortune* magazine. At the height of the Great Depression, that magazine's owner, Henry Luce, decided to start another magazine. He called it *Life*.

Preparing the first issue, he sent the glamorous Bourke-White west to photograph construction projects of the Public Works Administration. Her pictures surprised the editors. While she made photographs showing the grandeur of the concrete spillway beside the dam at Fort Peck—equating it, in its way, to the best monuments of the Egyptian Middle Kingdom (one such picture was on Life's first cover), she also made her own triumphant entry into the field of compassionate reporting. Bourke-White photographed the taxi dancers, whores, bars, and shacks that sprawled around the dam site in towns named New Deal, Delano Heights and Wheeler.

As she would often do, she charmed the Army colonel in charge of building the dam into loaning her his car and driver. When she needed an extra body to fill out a picture, Bourke-White pressed her new chauffeur into service. At least this is how his widow explains the fact that Gene Tourtlotte was dancing, with his hat on, in a bar of questionable repute in Wheeler, Montana, in late October, 1936.

Dali Atomicus PHILIPPE HALSMAN August 9, 1948

t may be a temptation when photographing a painter to mimic the painter's style, as Philippe Halsman did when he photographed Salvador Dali. If taking pictures were like cooking, this might have been Halsman's imaginative recipe:

Have a friend who is a surrealist painter. After seven years, tell him that you want to take his portrait. Suspend an easel, two paintings and a small stepladder by wires from a balcony in your studio. Ask your wife, the "first assistant," to hold a chair up to the left of the camera. Then, in rapid-fire succession, have your second assistant toss a pail of water, have a third toss a cat borrowed from the butcher and a fourth toss two cats borrowed from a neighbor. Lastly, ask Dali to jump. Click the shutter and go to the darkroom to develop the film to see how it turned out. During the ten minutes it takes to do that, mop up the water and catch the cats. Repeat 26 times until you get what you want.

When the photographic tour de force "Dali Atomicus" was published, Halsman got a lot of flak from cat lovers, especially the vociferous ones in England. He told these critics that the cats survived the picture session better than the exhausted humans. To celebrate, in fact, the cats ate up a very expensive can of Portuguese sardines.

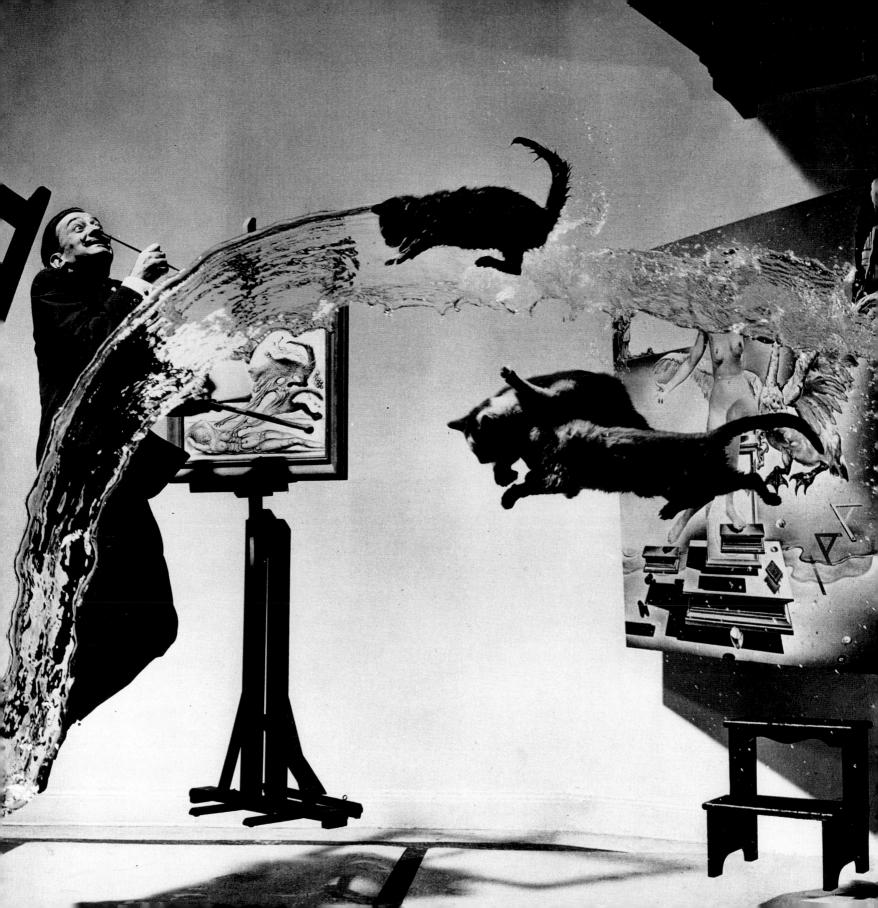

Evidence of an Assassination MICHAEL O'NEILL November, 1983

Ichael O'Neill was a college freshman in Colorado tuning up a car when news of President John F. Kennedy's murder came over the car radio. Twenty years later, to commemorate the event, *Life* asked the National Archives for permission to photograph the evidence concerning the assassination collected by the Warren Commission.

"I was casting a still life," O'Neill explains. "I began with Lee Harvey Oswald's passport photograph staring out at me, and a picture of the President's shirt. In their way, these two photographs stopped time. The picture the FBI took of the President's shirt back then shows blood still red, while the actual blood on Oswald's shirt [at the top right of O'Neill's picture] has lost its color in 20 years.

"I touched nothing. Marion Johnson, the archivist, brought out each item from the storage rooms. When he opened a box, an odor with enormous presence filled the room," remembers O'Neill. "A part of the smell was chemicals from testing for fingerprints, and a part was of preservatives. It was a tainted odor, as if it were the smell of the event itself.

"I lit the objects through tissue paper," he continues. "The soft light gives them a sense of form and dimension. I did not want to use harsh light as in a police mug shot. I didn't want highlights to stop the eye. The eye can peruse what's in this picture easily, although the event that brought these objects together remains really hard to accept."

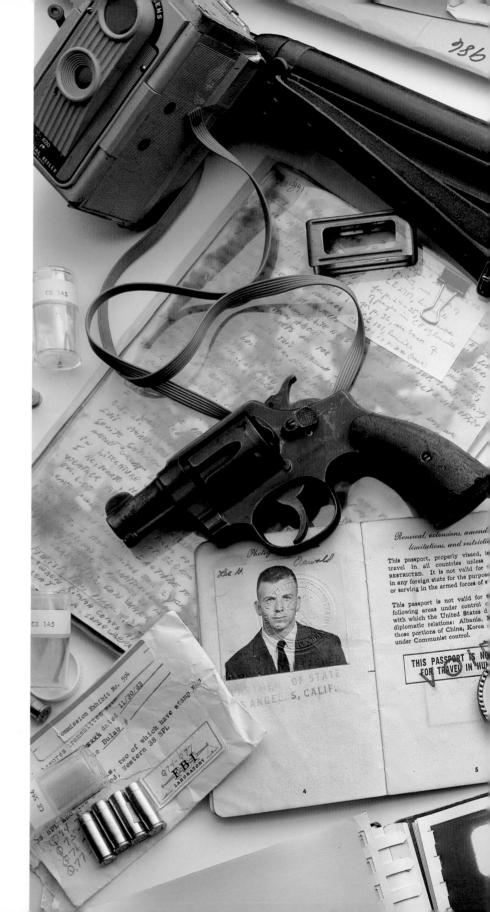

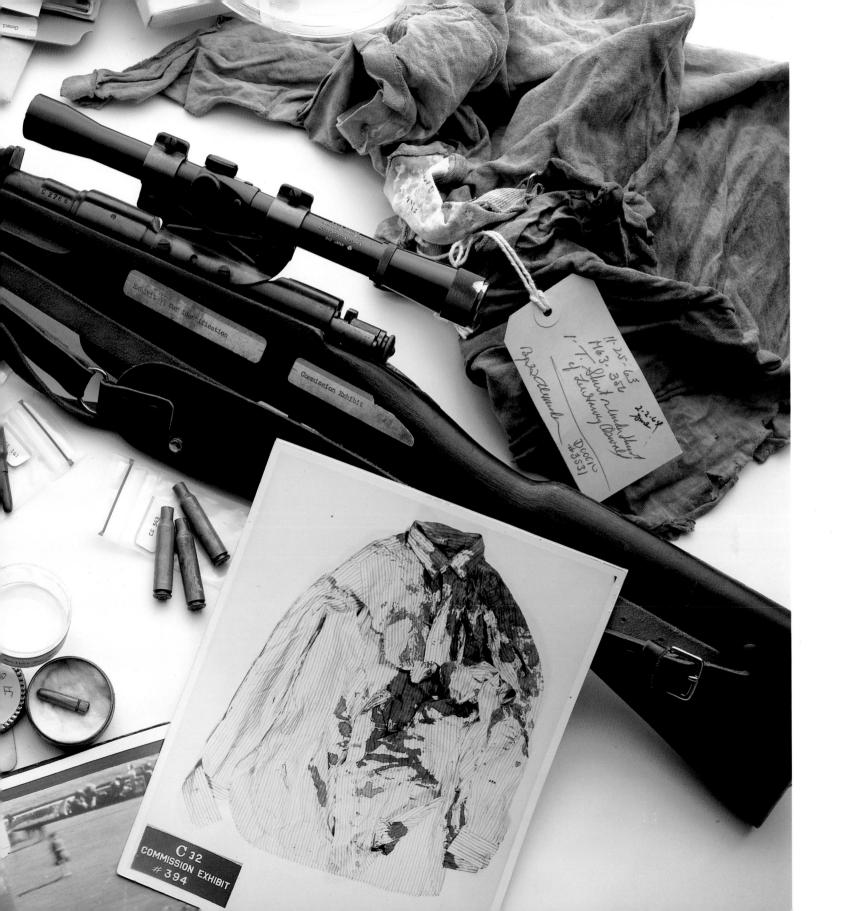

Earthrise WILLIAM ANDERS January 10, 1969

What's probably the most astonishing photograph ever made was not *inconceivable*. Early on, several photographers asked *Life* to assign them to the first trip to the moon. When the time came, NASA decided to give its astronauts cameras and not take along any press.

Apollo 8 was the first manned flight to leave Earth's orbit, allowing someone to see the whole Earth from space for the first time. Considering the fact that Apollo 8 was launched by a rocket 36 stories tall that had taken five years to build, and required the skills of 325,000 people working at 12,000 firms, NASA's caution may seem understandable. Still, I am curious to see what more talented photographers will record someday in space. A new view of the stars? The dark side of the moon?

After one of *Apollo 8's* ten swings around the moon, astronaut William Anders took this picture. "I think it was the 'Earthrise' that got everybody in the solar plexus. Our Earth was quite colorful, pretty and delicate compared to the very rough, rugged, beat-up, even boring lunar surface," Anders explained in the book *The View from Space*, published by Clarkson N. Potter Inc. in 1988. "We'd come 240,000 miles to see the moon, and it was the Earth that was really worth looking at."

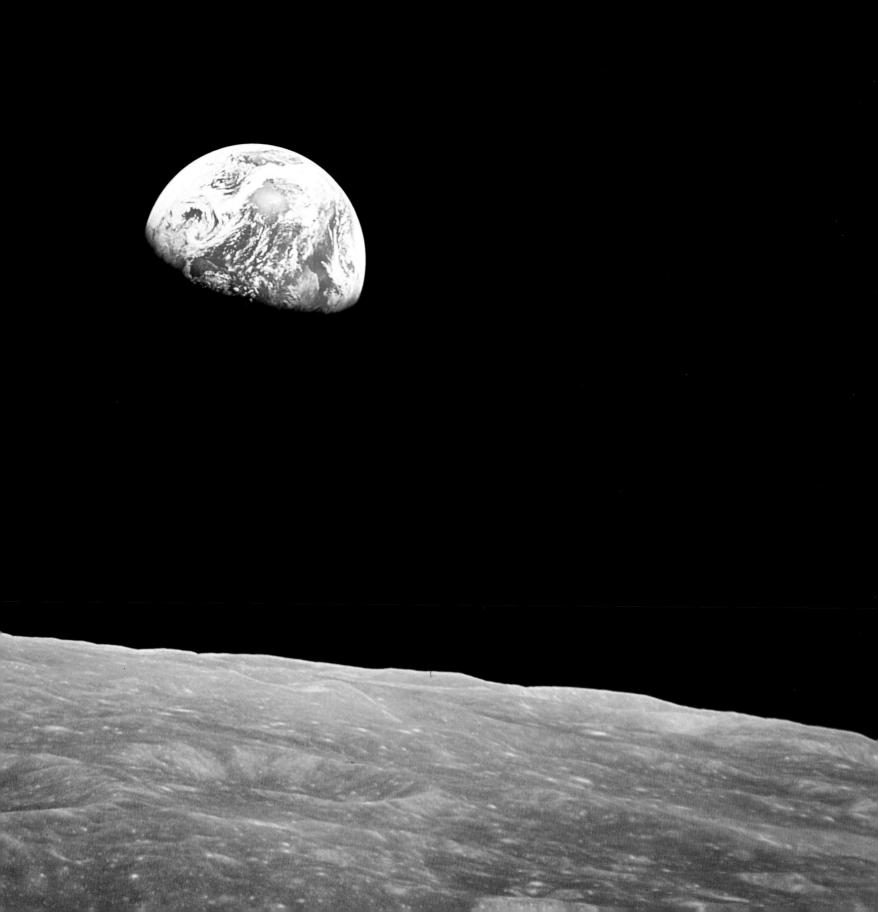

Wheat MICHAEL MELFORD December, 1981

In harvest season in wheat-growing states there can be a shortage of railroad cars to take the grain to ocean ports for shipping. When the grain elevators fill up, there's nothing to do but store the harvest in the street and hope it doesn't rain.

Near Eureka, Washington, truck drivers, farmers and grain-elevator operators stand on a pile of wheat destined for Asia.

The size of the pile and the stiff, formal stance of the men bring to mind the Old Testament pharaoh with his dream of seven lean years, seven fat ones. Even more, the pile reminds me of the pharaoh's pyramids. Transitory it may be, but this stack of wheat symbolizes this country's pyramid of plenty.

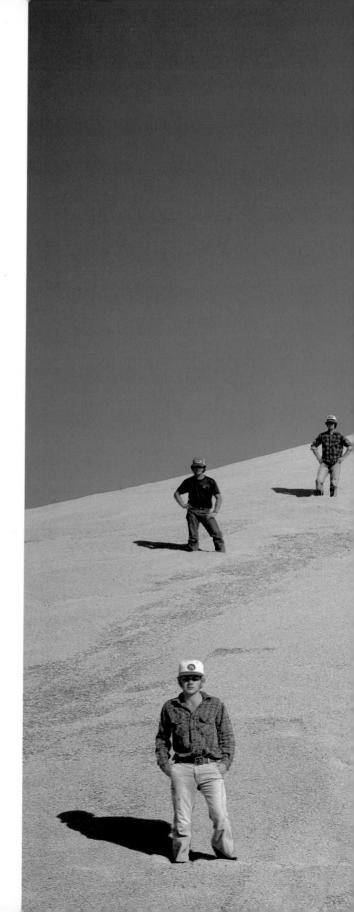

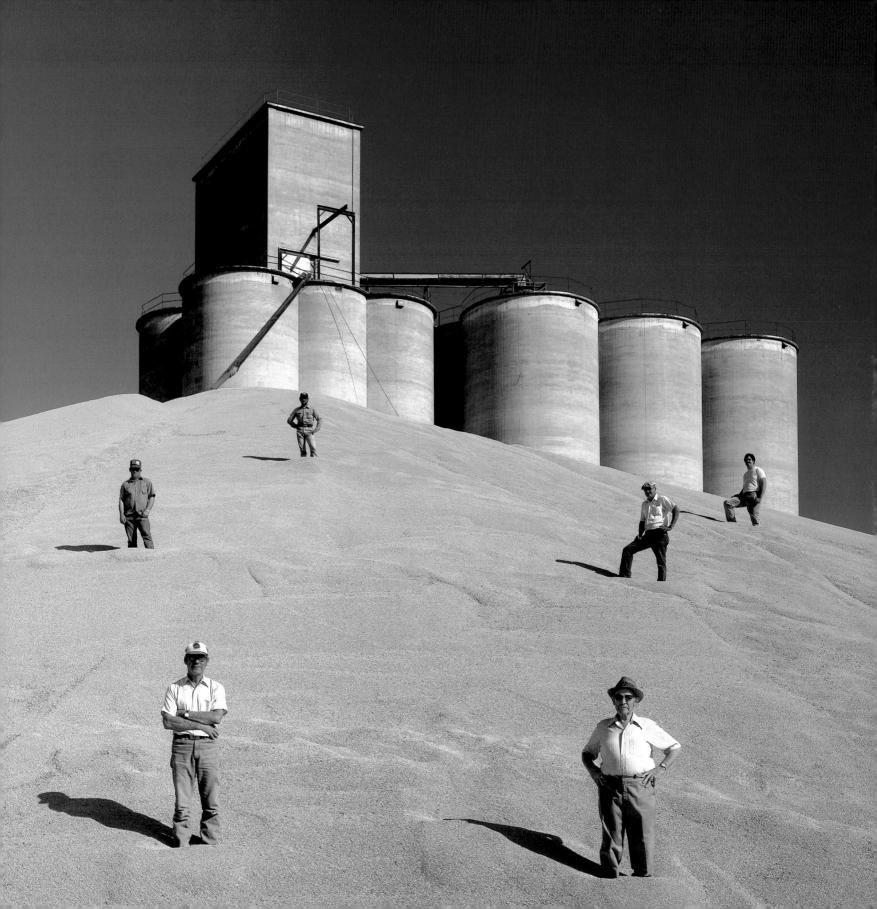

Desert Bikes BILL EPPRIDGE September 3, 1971

Bike riders begin a 75-mile race through the Mojave Desert. Bill Eppridge knew the start was the only spot where he could show all 650 of them together. Even in the largest races the contestants quickly stretch out into a long, dull line.

From the ground, Eppridge felt, he wouldn't get a sense of the wide expanse of the land, so he rented a helicopter. Seen from the air, dust flying, the bikes formed an incredible scene. "Incredible, but it also can be indictable," says Eppridge. "I've seen what harm other bikers have done in the West." So tender is the topsoil in parts of the desert that wagon-wheel tracks made a century ago are still etched clearly in the soil.

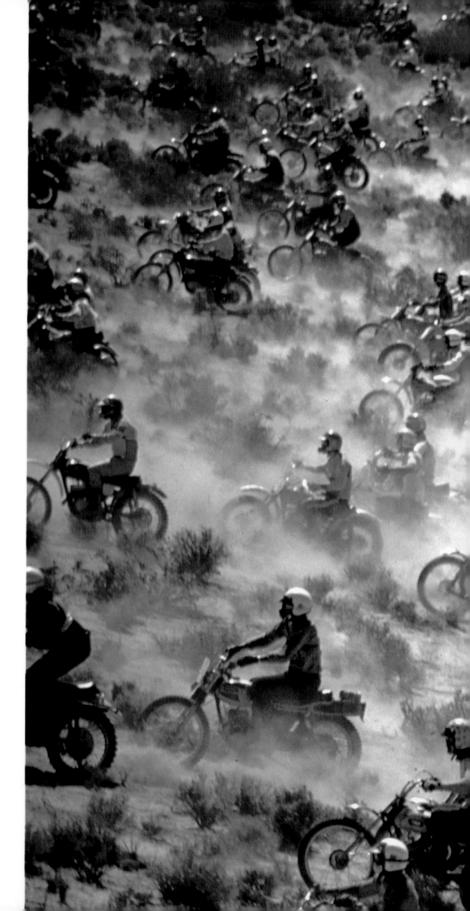

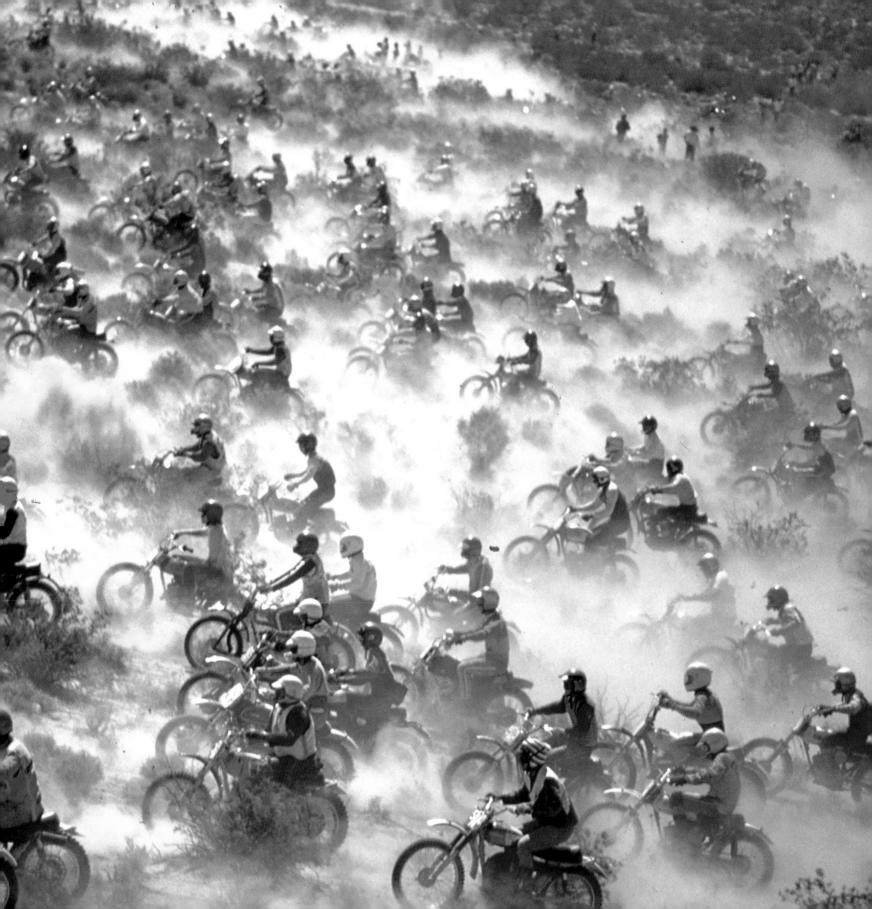

Hindenburg SAM SHERE May 17, 1937

he *Hindenburg*, largest zeppelin ever built, finished its first transatlantic flight of the 1937 season toward dusk. A spark probably set off the 6.7 million cu. ft. of hydrogen gas on board. In five minutes, 35 of the 97 people on board were dead or dying.

More than 20 photographers stood watching the ship's arrival at Lakehurst, New Jersey. As it exploded, some exposed only one side of each two-sheet film holder, fearing they might make double exposures in their excitement.

Of scores of photographs taken within a couple of minutes by photographers standing only a few feet apart, Sam Shere's may be the most terrifying. His timing and sense of composition captured the eerie diagonal pitch of the doomed airship as it slipped to the earth beyond the silhouette of its mooring tower.

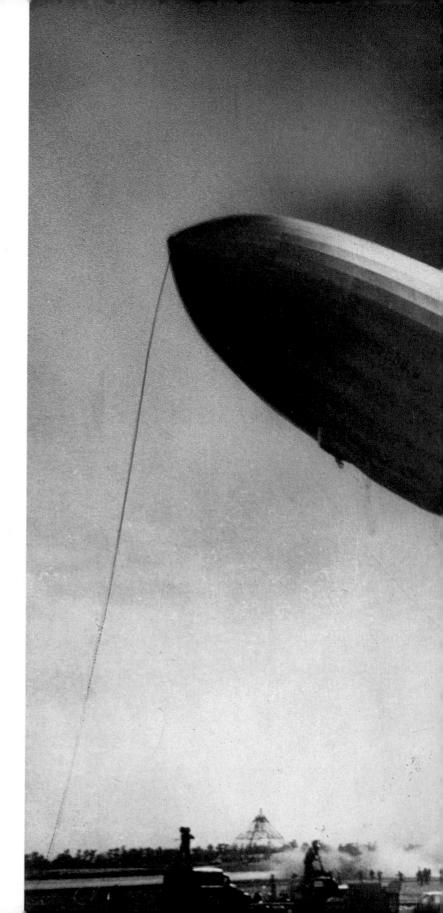

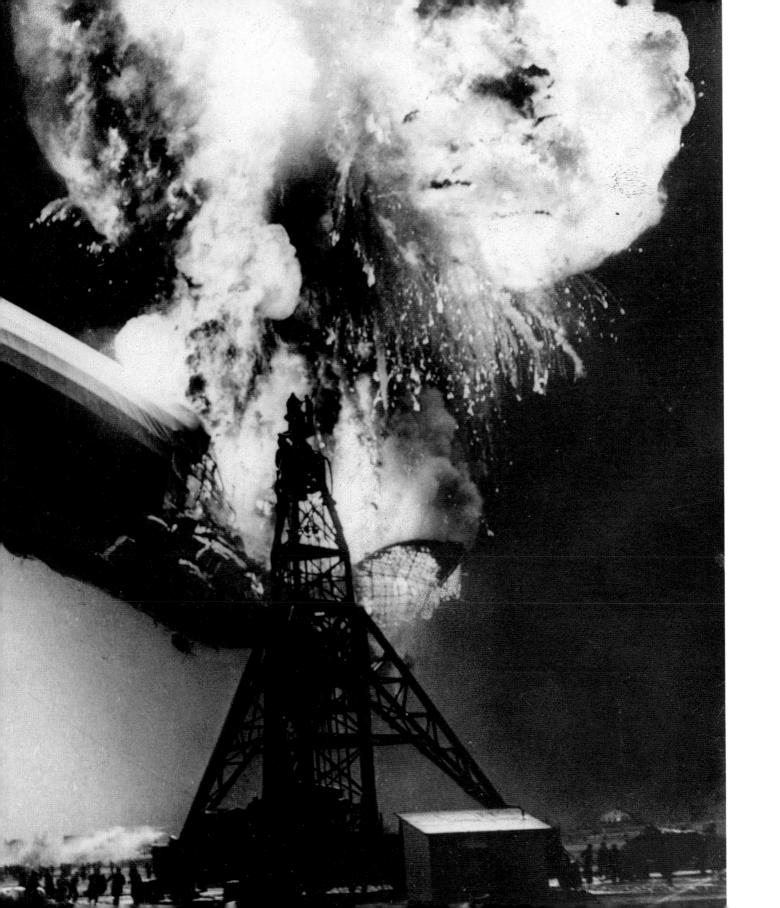

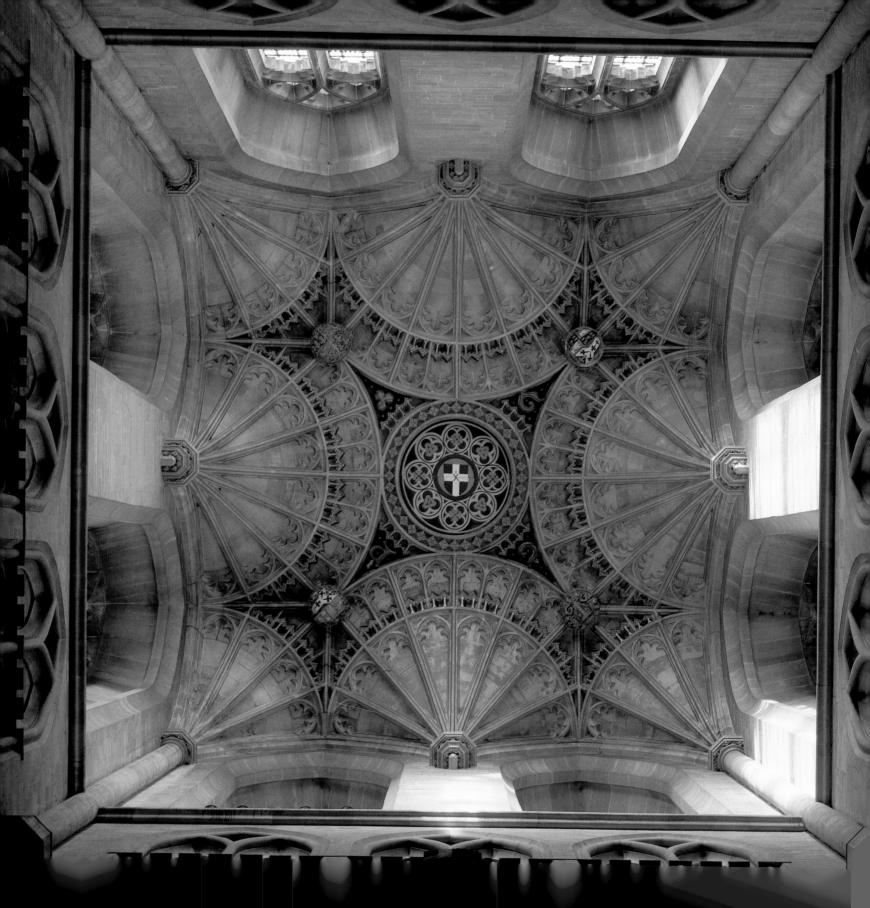

Canterbury Cathedral DENIS WAUGH December, 1981

have always liked things in symmetrical form. Seeing Canterbury made me realize why I live in England and why I don't go back to New Zealand, where I grew up. New Zealand and America have such short histories. I'm overawed by a country where things go back to time whenever," says Denis Waugh, who photographed the 500-year-old bell tower of the 1,400-year-old cathedral in Kent.

Noël Coward LOOMIS DEAN June 20, 1955

llustrating Noël Coward's line about mad dogs and Englishmen going out in the midday sun was what I had in mind. Coward loved the idea, but he never got up until 4 in the afternoon.

"We rented an air-conditioned Cadillac limousine and put a big washtub in the back and filled it with 10,000 ice cubes and bottles of champagne and gin and fruit juice and soda and everything. We even took a waiter along. Late in the afternoon we drove to a dry lake outside Las Vegas.

"'Dear boy, why didn't you bring a piano?' Coward wanted to know when we got there. I think the temperature was 118°. I got on the hood of the car, and Coward did his bit in his tuxedo. I took twelve pictures and was finished in five minutes. Then the damn car developed vapor lock and wouldn't start, so we all got out and pushed. Coward took off the tux and pushed wearing only his underwear.

"Later a researcher in New York called to say that Coward's phrase wouldn't fit the picture since he obviously wouldn't cast such a long shadow at noon. Well, I said, Coward also wrote, "That tho", the English are effete, they're quite impervious to heat." But they didn't use that line either."

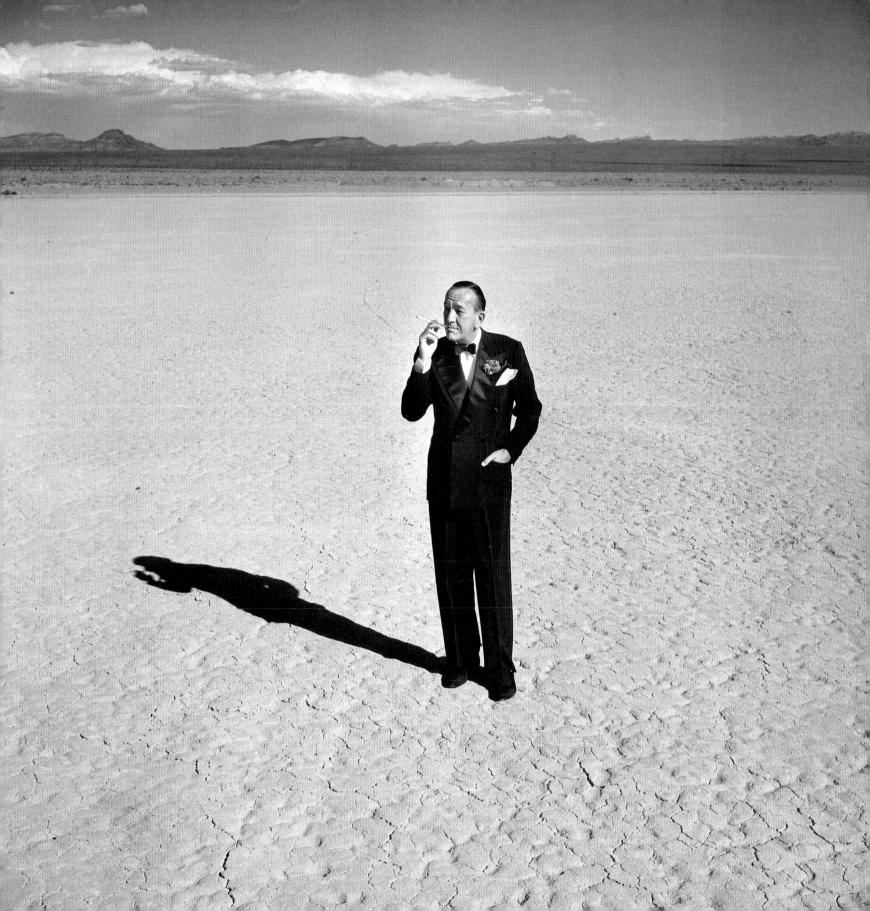

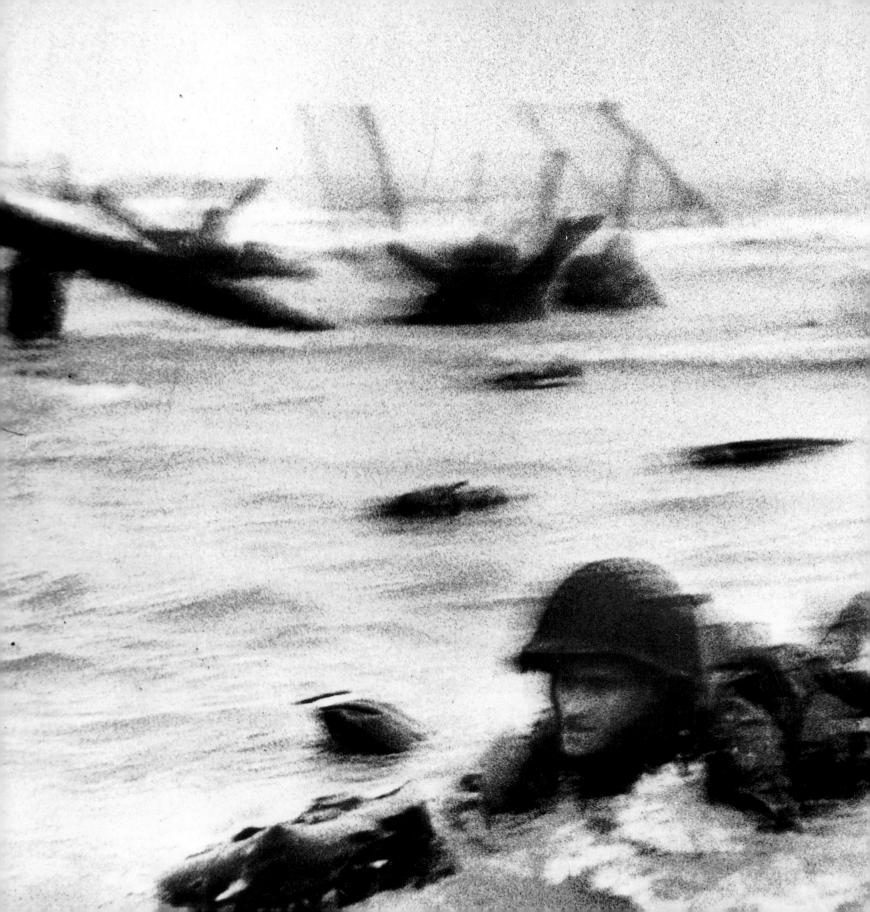

D Day ROBERT CAPA June 19, 1944

Robert Capa wrote that "if your pictures aren't good enough, you're not close enough." He set the pattern for covering a modern war with a camera, going into battle along with the soldiers and sharing their risk. First in Spain, then in China, North Africa and Italy. He took pictures he was willing to die for, and on D day, June 6, 1944, off the coast of Normandy, he nearly did.

"The water was very cold, and the beach still more than a hundred yards away," Capa wrote. "The bullets tore holes in the water around me, and I made for the nearest steel obstacle... It was still very early and very gray for good pictures, but the gray water and the gray sky made the little men, dodging under the surrealistic designs of Hitler's anti-invasion braintrust, very effective."

Capa made it to the shore, taking photographs of soldiers in the water as he went. The first wave was pinned down at the beach's edge, facing murderous German fire across 200 yards of smooth sand. Richard Whelan, Capa's biographer, reports that messages reaching General Omar Bradley were so disturbing that he was considering pulling all troops off Omaha Beach.

Later, as Capa readily explained, he was gripped by an almost convulsive panic and ran to catch a landing craft to return to the fleet. Exhausted when finally aboard a larger ship, he slept until the vessel was back in England. Capa's extraordinary photographs of his 90 minutes under fire were rushed to New York.

Capa was admired deeply by many other photographers, not only for his courage and charm but also for his idealism. Before his death in Indochina in 1954, Capa wrote, "The war photographer's most fervent wish is for unemployment."

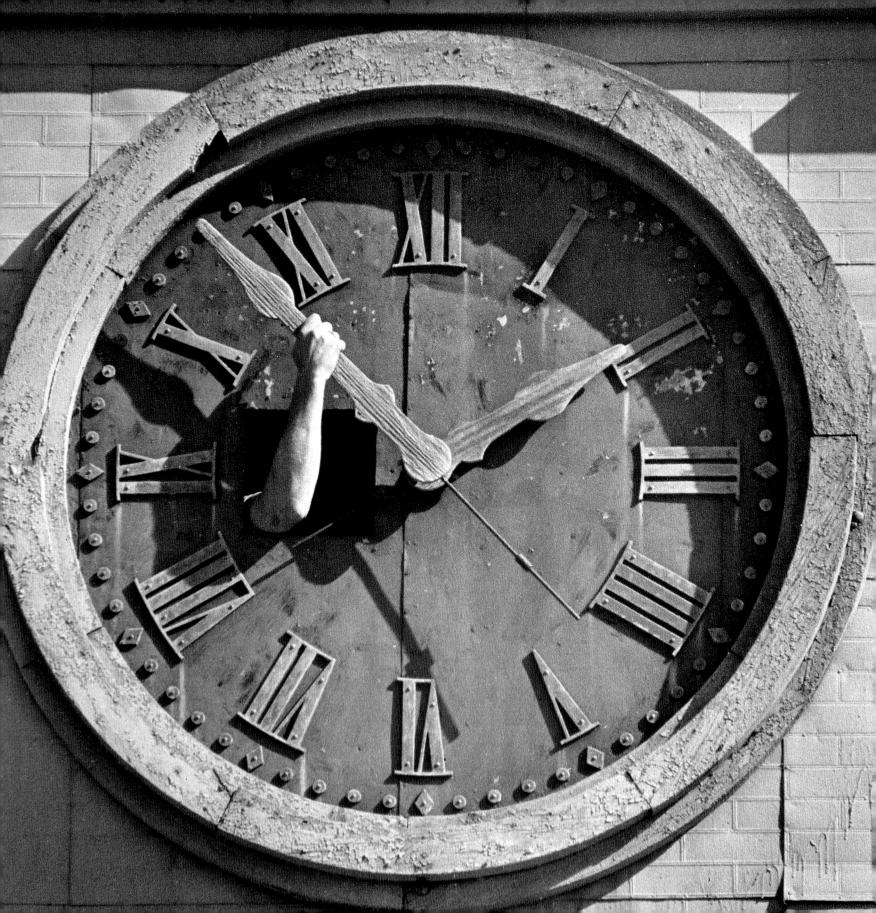

Clock JAMES KOEPNICK December, 1980

James Koepnick has a friend who takes care of a clock. Having nothing better to do one afternoon in Oshkosh, Wisconsin, Koepnick photographed his friend giving the clock another hand.

Peter Stackpole, one of *Life's* original staff photographers, concentrated on covering Hollywood with as much delight as 21-year-old Jeanne Crain seems to bring to this helium-filled, glycerinesoap-flake bubble in the movie *Margie*.

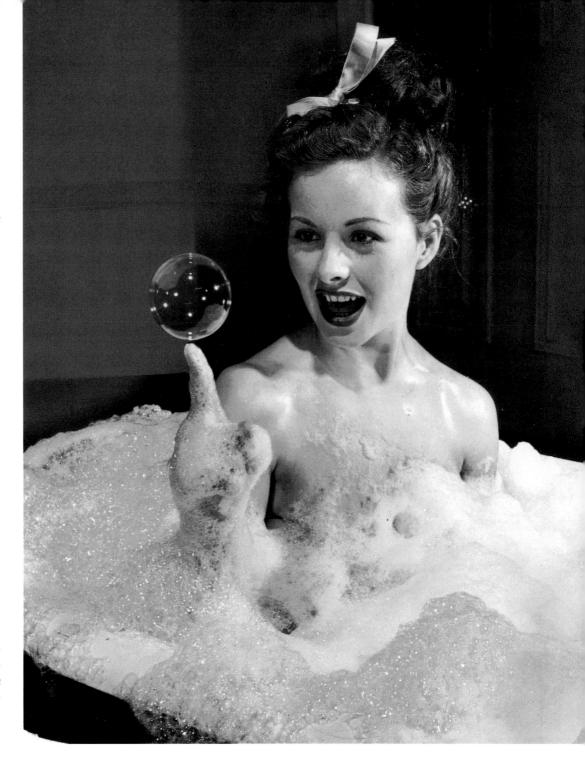

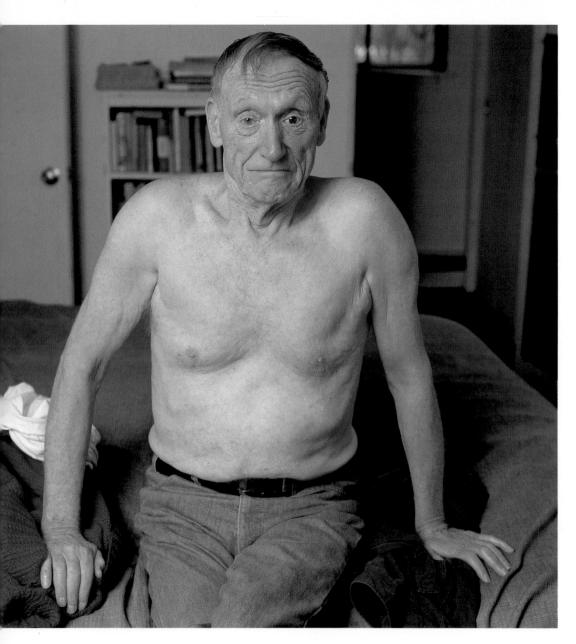

Robert Penn Warren ANNIE LEIBOVITZ April, 1981

might spend two or three days with a subject doing a story, but for a single portrait they expect to see you for only an hour. So I say right up front that we're going to do this several times. I guess I get my best ideas after I leave. Besides, you shouldn't push too hard on a first date...

"Doing twelve American poets, I really wanted to photograph their poetry, not them. A lot of what Robert Penn Warren writes is about accepting the processes of nature.

"On my first and second visit, I posed him under trees and stuff. Poses you'd expect to see a poet in. But there was a look in his eyes. I felt he wanted to give me something, but I couldn't put my finger on it.

"As I drove up the third time, he was standing in his bedroom window looking like something out of an Edward Hopper painting. His bedroom was very plain—all gray. I told my assistant to put the lights up there.

"He was at peace with himself. He accepted everything. He seemed ready for death.

"I asked him to take off his shirt. Then his undershirt. I wanted the picture to be raw. Actually, I wish there might have been another way to do it. I just wanted to strip away everything so that nothing would compete against his eyes."

Bruno Sammartino THEO WESTENBERGER September, 1985

Certain relationships have photographic promise. When Theo Westenberger asked a wrestler to sit in his working togs next to his 87-year-old mother, she figured something interesting might happen.

As usual in this kind of setup, it's Mom who's the wild card. Emilia Sammartino reached over to pinch some flesh on her son's belly. Bruno, as most sons do, managed to look both a little pleased and a lot embarrassed.

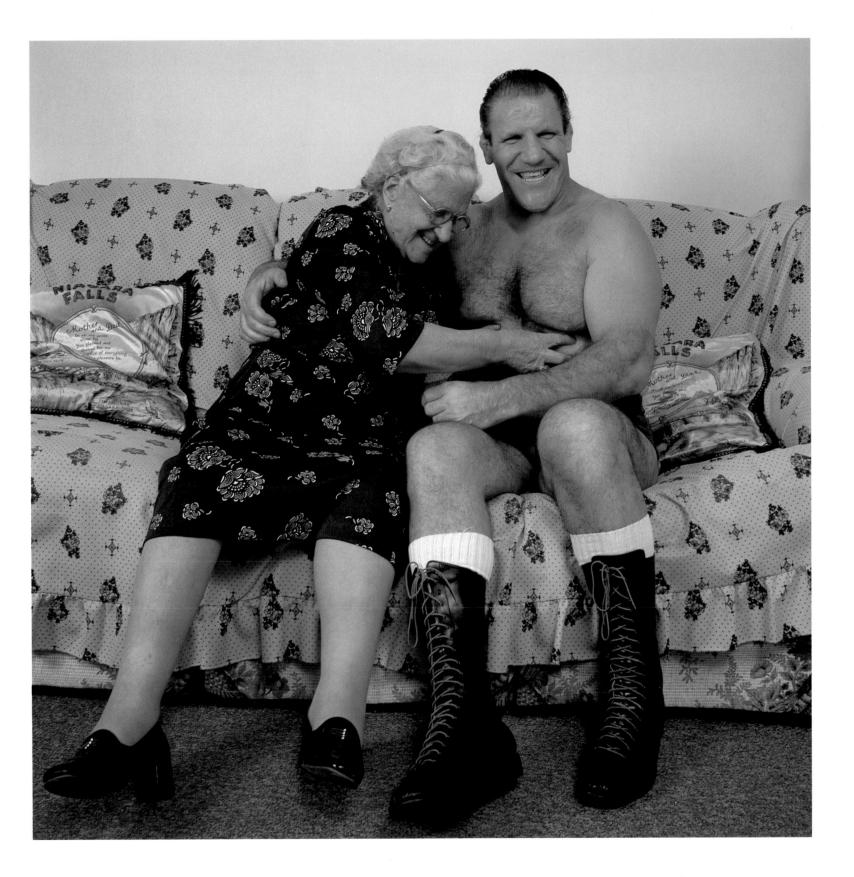

Mafia Rub-Out FRANK CASTORAL September, 1979

In organized crime, corporate takeovers may be highly visual if the photographer arrives quickly. Hearing a call to aid a patrolman on the police radio in his New York *Daily Neus* car, Frank Castoral got to the Brooklyn address 30 minutes before any other reporter or photographer. A policeman he knew told him what had happened but would not let him into the restaurant where it had taken place.

Castoral got permission from a family living in the building to climb to the roof. He looked down on the patio where Carmine Galante and his associate Leonardo Coppola had been lunching. Galante's cigar was still burning. Marks in chalk made careful note of the shell casings from the .45s and shotguns used to settle questions of company policy, and Galante and Coppola await special transportation being arranged to take them from their final appointment.

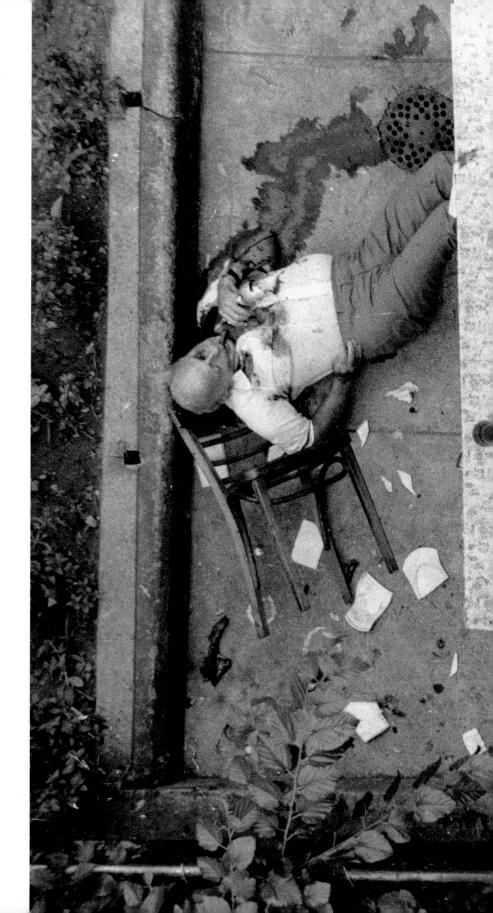

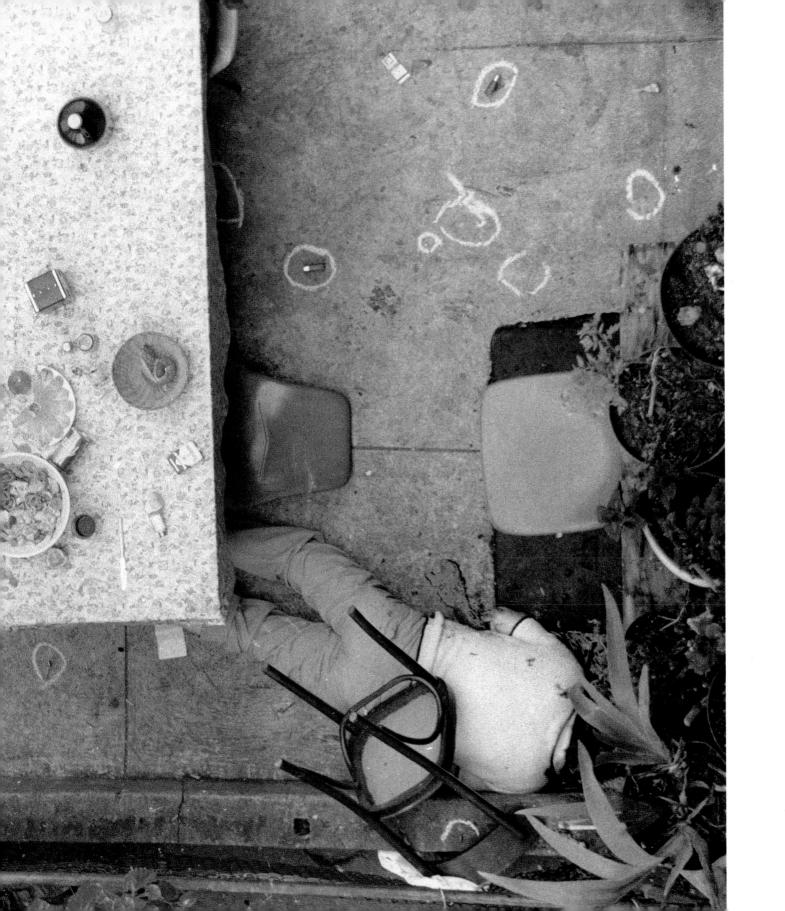

Wendell Willkie JOHN D. COLLINS September 2, 1940

est anyone think that the photo opportunity was invented by the White House just recently, please note that in 1940 Wendell Willkie went all the way back to his hometown, Elwood, Indiana, to deliver a speech accepting the Republican nomination for President.

He didn't just speak. First there was a parade, with a motorcycle escort, through the flag-bedecked main street out to the fairgrounds. Willkie stood in the back seat of a convertible immediately preceded by a truck filled with photographers well positioned to record the "spontaneous" hoopla, splendor and excitement of the 103° day for the next day's newspapers.

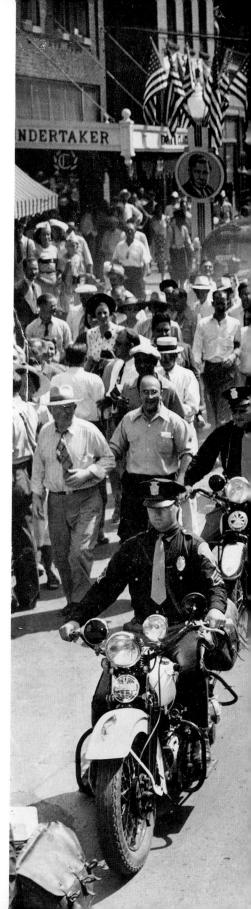

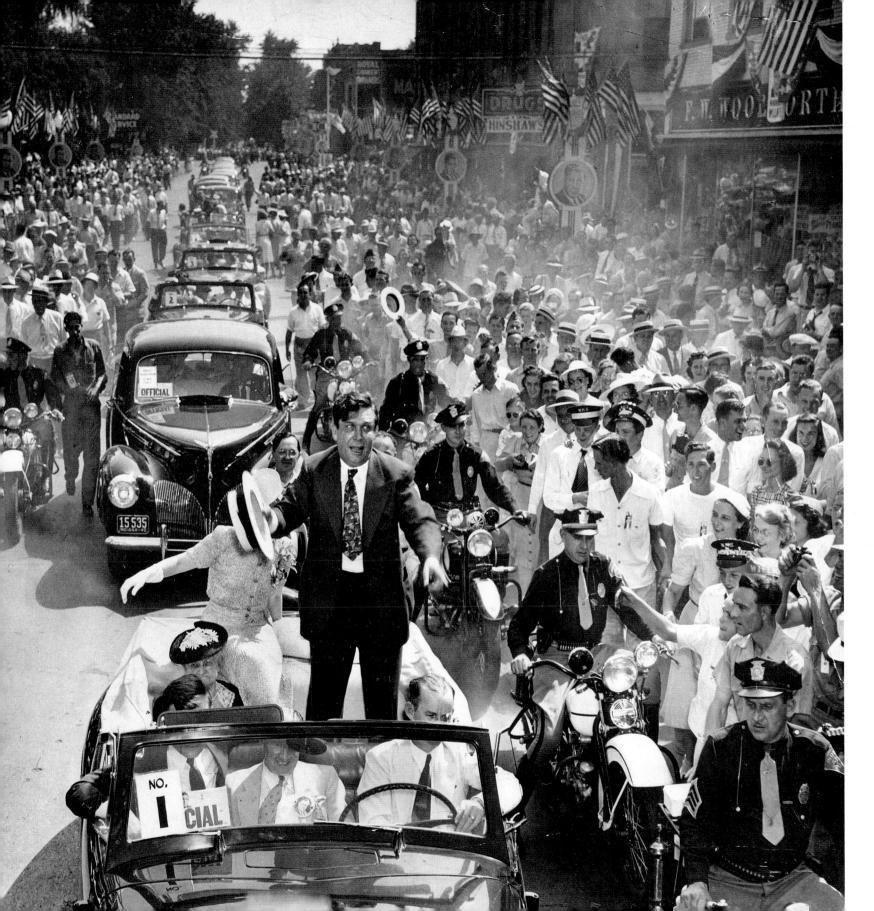

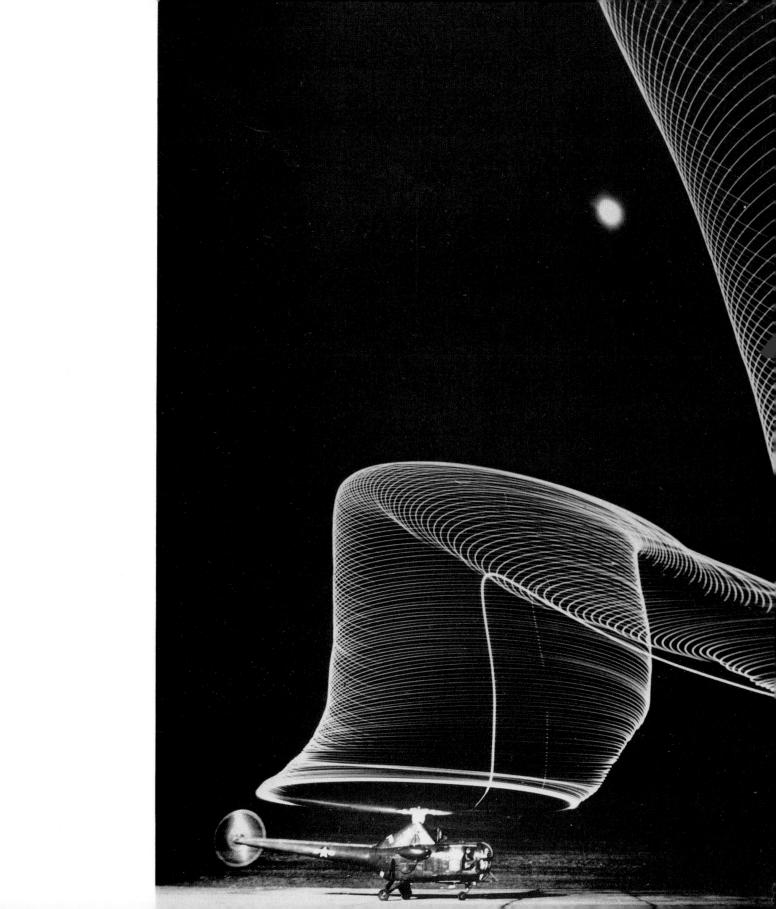

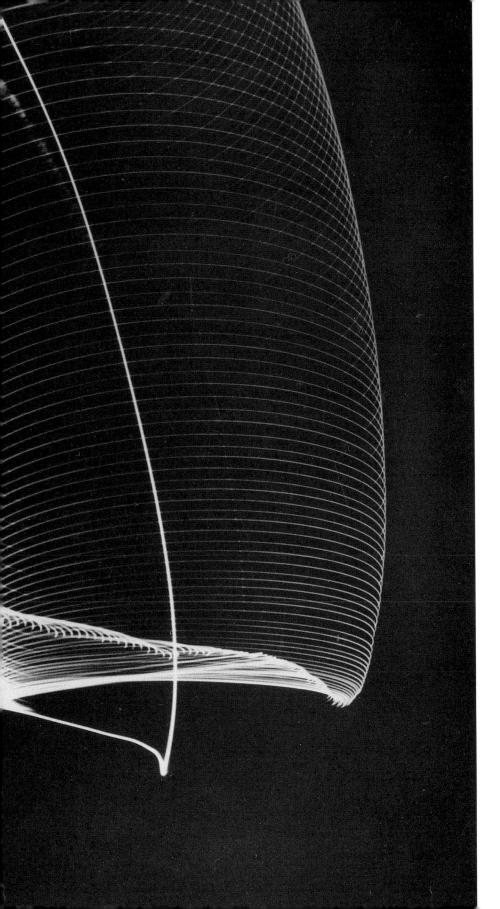

Helicopter ANDREAS FEININGER February 28, 1949

When Andreas Feininger saw a newspaper picture of a Navy helicopter newly equipped with lights on its rotor blades, he told the Navy he wanted to make a photograph that would capture the spiral beauty of the whirlybird's motion.

Feininger opened his shutter 30 seconds before he signaled the pilot to lift off. With the shutter open, the lights on the propeller blades traced a corkscrew pattern when the aircraft moved forward, then gained altitude. "The effect," said Feininger, "was like Santa Claus going up the chimney."

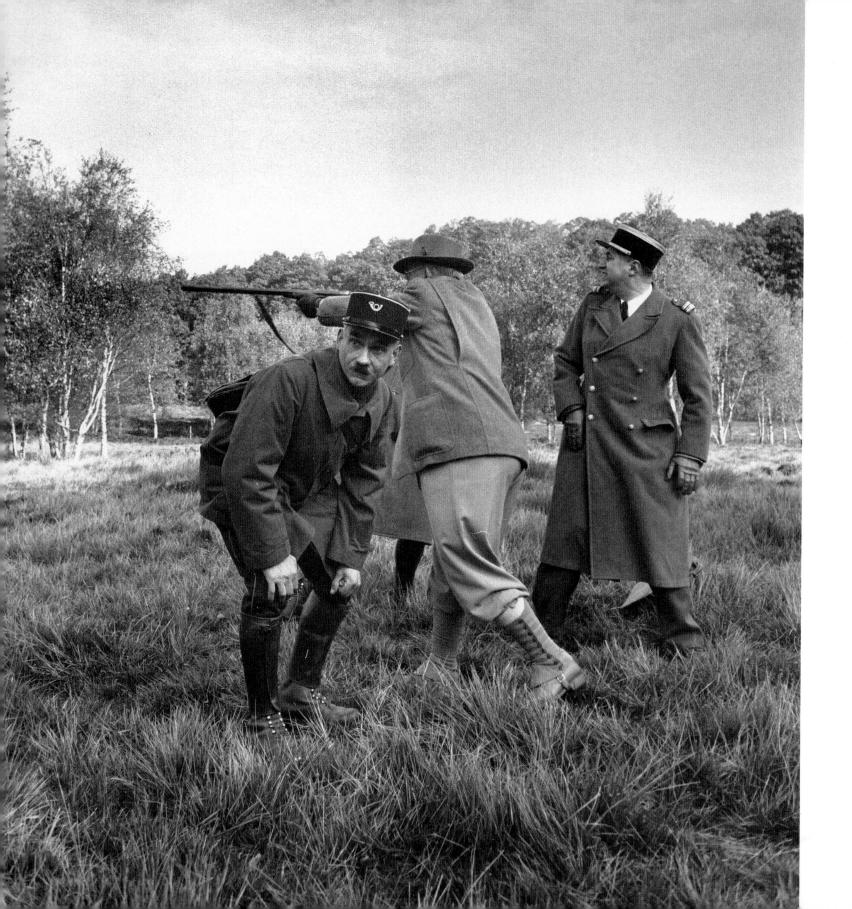

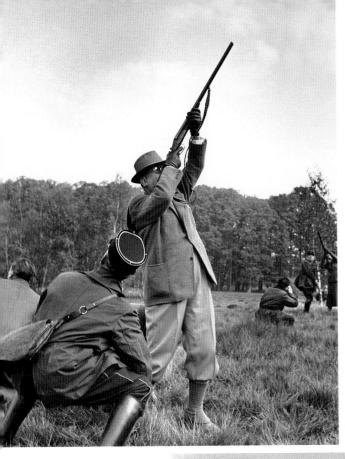

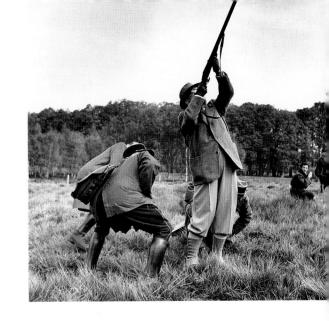

Pheasant Hunt **DMITRI KESSEL** November 20, 1950

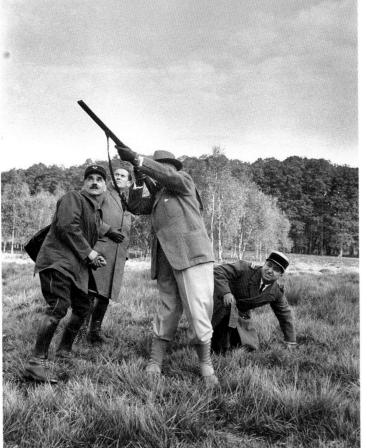

Vincent Auriol, President of France, liked to shoot. He revived the old tradition of *la chasse du corps diplomatique*, which is a pheasant shoot for diplomats. I'm proud to report that the American Ambassador (David Bruce) shot the most birds (114). Monsieur Auriol, shown here, shot 49 before he ran out of ammunition. The representatives of the rest of the world gunned down 325 more, along with 75 rabbits.

Mary Ellen Mark and Edgar Bergen's daughter Candice became friends in 1963, at college, where they were both interested in photography.

In the late '70s, Mark was in Los Angeles to take still photographs on the set of a movie in which her friend starred. The Bergens asked Mark to come to their home and take some family portraits.

Mark found the famous ventriloquist ill at ease in front of her camera. Someone suggested bringing out Charlie McCarthy, so Candice's brother Chris brought the trunk into the hall.

"As soon as Mr. Bergen opened it, the performer in him came out," says Mark. "When he was with Charlie, he knew just what to do for a picture."

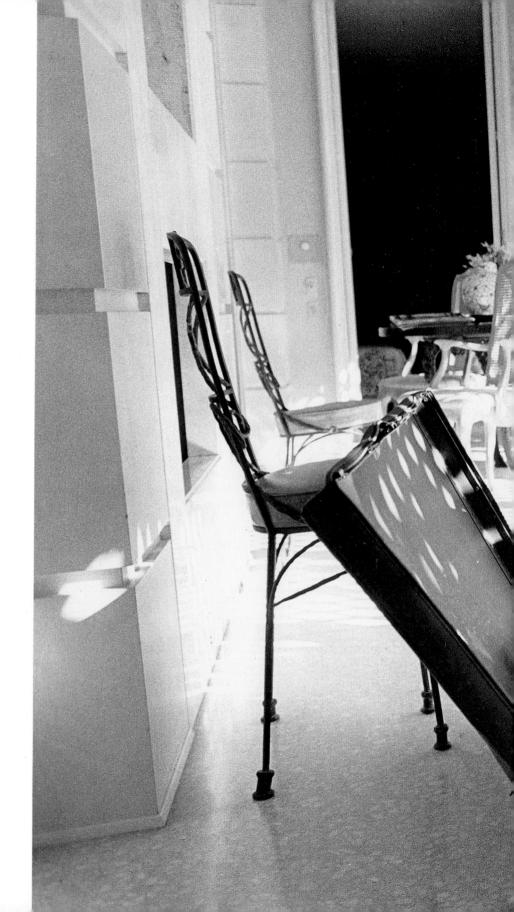

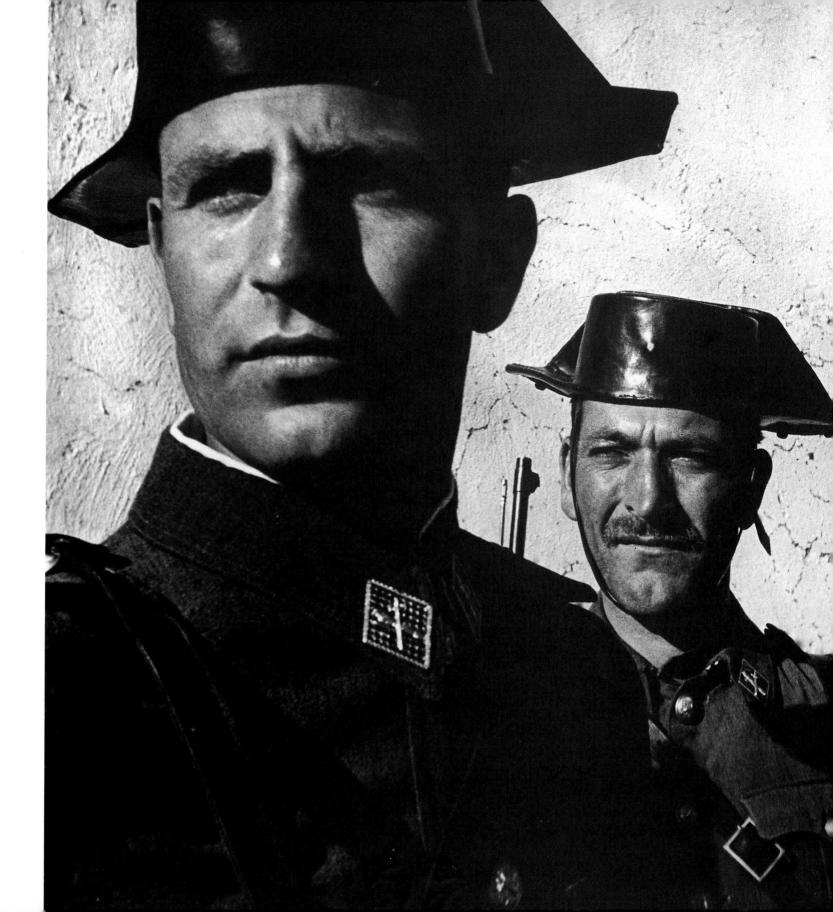

Spanish Village **W. EUGENE SMITH** April 9, 1951

Eugene Smith, who died in 1978, has done the best picture stories to appear in *Life*. His mastery of photographic technique for artistic ends has no match, nor does his ability to invoke the viewer's empathy with his subjects.

In 1938, at age 20, he had a retainer from *Life* to photograph two weeks out of every month. Later he joined *Life's* staff, and while covering the island war in the Pacific, he was severely wounded in the face by shell fragments.

Five years later to the day, his biographer Ben Maddow says, Smith wrote his mother: "This afternoon, at the anniversary minute of a quarter of four, I was crouched in horse dung on a street in Spain trying to translate my indictment of the Guardia Civil (and powers above) into a photographic image."

The obscure Spanish village of Deleitosa, in which he was photographing, lies halfway between Madrid and Portugal. In 1950 it was 25 miles from the nearest railroad, more than a dozen miles from the nearest telephone, and seven miles from a major highway. Smith found there the focus for what was supposed to be a story on Spanish agriculture.

In the story (which has become a landmark in photographic journalism), farm work takes up only two rather dutiful pages. The remaining eight make brilliant use of light and shadow to describe the villagers' rituals of baptism, confirmation and death. Smith also took pictures of important individuals in the village, such as the priest, the doctor and the police.

The Guardia Civil, a rural police force, then received its orders from Generalissimo Franco's oppressive government in Madrid. The police were suspicious of Smith's picture taking, and forbade him to make written notes in the village. Maddow quotes Smith again about this picture: "I would rather make warm and friendly photographs, but when I looked at these people in the Guardia Civil I was aware that at least two of them had tortured their countrymen, and I could not feel very friendly."

Picasso GJON MILI January 30, 1950

On his way to the Riviera to photograph the painter Pablo Picasso, Gjon Mili talked in Paris with Picasso's nephew, the young painter Javier Vilato, who quoted his uncle: "If you want to draw, you must shut your eyes and sing."

"I deliberated," Mili has written. "Why not have him draw in the dark, with a light instead of a pencil?"

Later Mili met Picasso on the beach. "I am a photographer, and I would like to do your portrait."

"Oh? Go ahead," Picasso answered, making a face.

"No, serious. Serious," replied Mili.

"At that point," as Mili tells it, "I confronted him with a photograph, taken in darkness but showing a skater's leap traced with lights attached to the skates. Picasso reacted instantly. Intrigued, he began drawing with his finger in the thin air."

They arranged to meet at a pottery in Vallauris. In the dark, after Mili fired his flash, Picasso sketched a centaur in the air. Even though he neglected to put his signature on the drawing, there can be scant suspicion of a forgery.

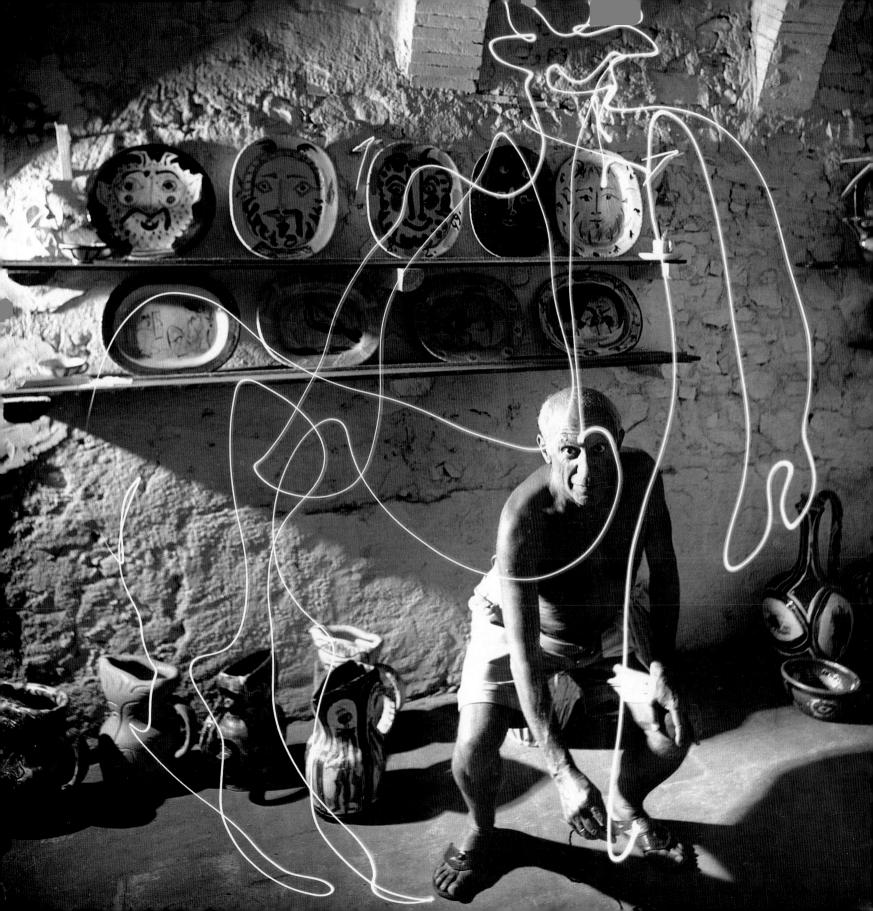

Swimming Baby LENA BERTUCCI June, 1985

t was not until I took my older daughter to visit the University of Vermont and found this picture clipped from *Life* taped to a door next to the admissions office that I realized how good it was.

As an editor looking for pictures every day—looking for the strange, the peculiar, the startling, the different—I can become a bit jaded about seeing unusual sights. But in the real world there is something both natural and unbelievable, beautiful and scary about seeing a babe where you'd expect to see a fish.

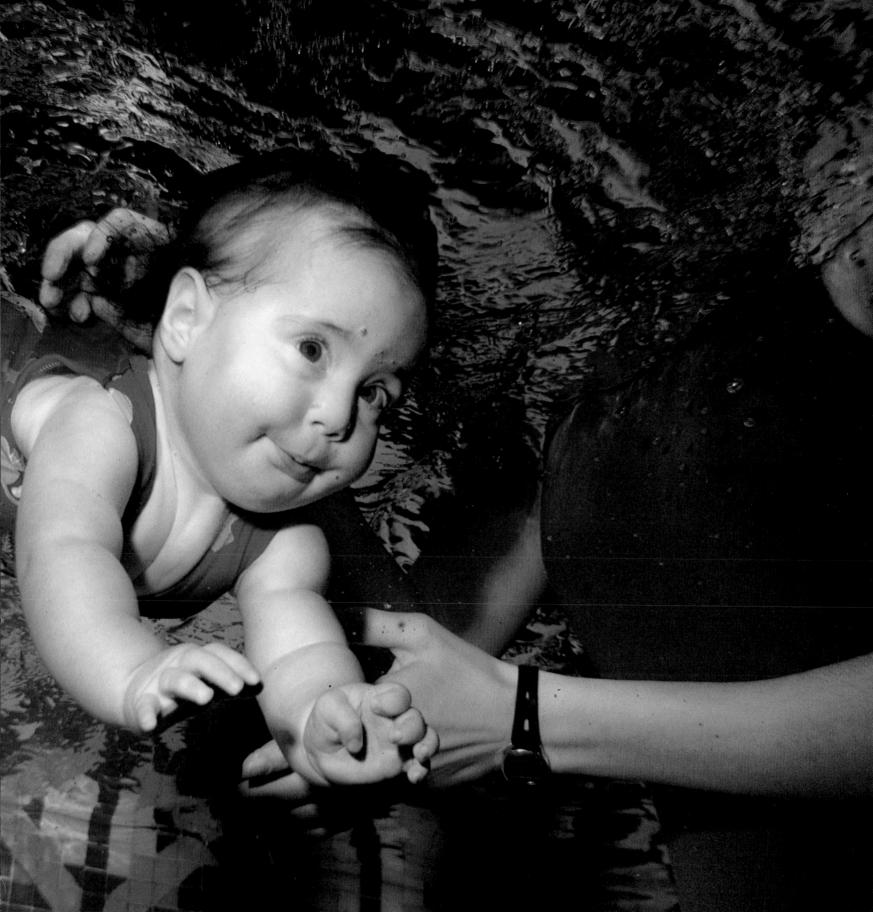

Drum Major ALFRED EISENSTAEDT October 30, 1950

don't remember when I first saw Alfred Eisenstaedt's picture of the drum major practicing, but it was close to the time it was taken (1950). I don't think I liked it. Too cute. I thought the kids looked too perfect.

But now, as I get older, I have second thoughts. I doubt, as I look at the picture, that the event was arranged by Eisenstaedt. I can't imagine him saying, "Go ahead! Follow him around!" because the seven children seem so intent on what they are doing, so concentrated in unison that it must be their game, not some grown-up outsider's, even if they got the idea after seeing that Eisenstaedt was taking pictures.

Actually the drum major in his uniform looks like a dream of some 19th century Polish cavalry officer—or maybe one of Napoleon's marshals. His body is in a position that is a caricature of a proud officer's strut, but he is in a nation with no tradition for such military majesty, and he's in front of a very American stand of elms, followed by a line of very American-looking kids.

Is it wrong to place the burden of a comment comparing the Old World with the New on this simple picture? Perhaps.

It is true that Alfred Eisenstaedt was forced to leave Germany in the 1930s, but his work is characterized by an innocent openness to what he sees. For some 50 years Eisenstaedt has been the perfect guest in America, where he long ago became a citizen. He always knows when to arrive, and he always arrives as a friend.

Of course, this is a man who was blown up by a British shell at Verdun, whose family lost all its savings in a post-World War I inflation, who was forced to leave home by Hitler. He might say, if anyone can, "You want to see what's bad? What's awful? I've already seen that, close up."

What he does say is, "I do not photograph blood or war or the homeless stretched out on the subway steps."

But one of photography's gifts to us is the ability to record the human condition, and for Eisenstaedt, joy is as worthy to record as sorrow. Well, maybe to him it is more worthy. He has reason to know it's much rarer to find.

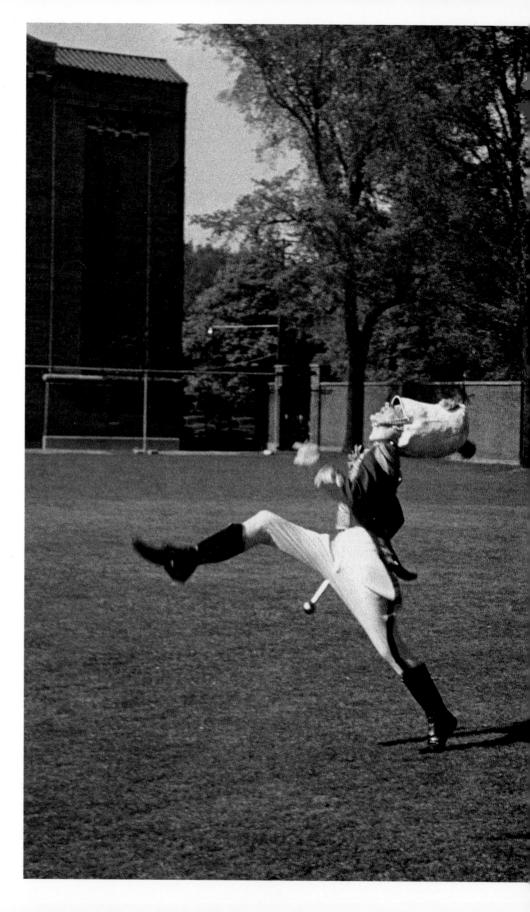

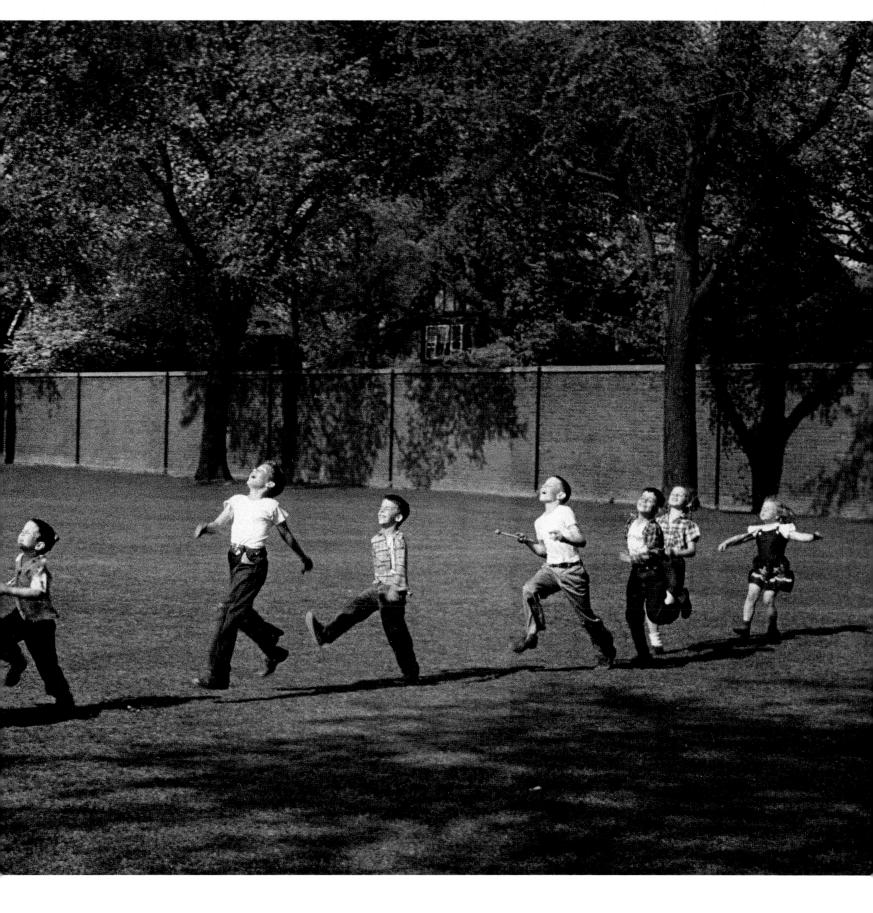

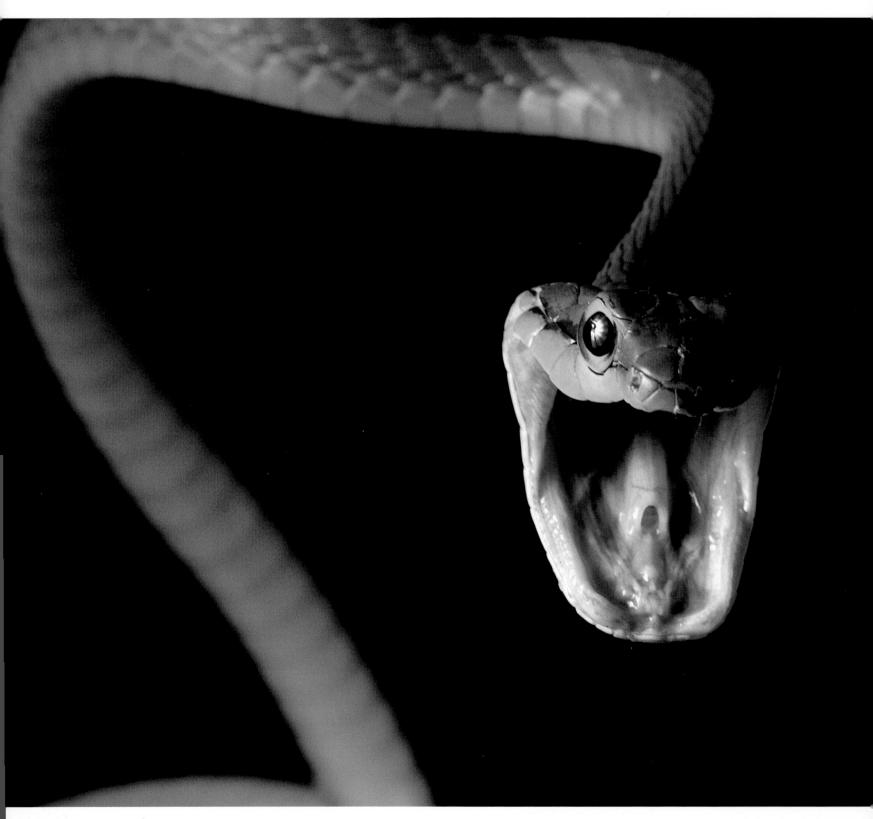

Green Vine Snake MICHAEL MELFORD September, 1982

Sometimes a picture editor in New York can make a suggestion that a photographer in Central America can use. The question was: How do you photograph the little critters that run around the floor of a rain forest in Costa Rica?

Answer: Sharply. O.K.—photographer Michael Melford likes to take precise views of things. Answer: Clearly. O.K.—Melford can light a subject with great skill. In the jungle he'd build a little studio to photograph the rare snakes, bats, bugs and frogs that slither, fly, crawl and hop about there.

Everything sounded O.K., but I worried that we might end up with a series of still portraits that had no sense of the activity of the jungle floor. "You've got to get them in action!" I said. (I did not admit that my closest view of exotic reptiles has been in the Fang and Claw shop in lower Manhattan.) "Why not get a snake to attack the camera?"

What's nice about being a picture editor is that you say things like that, waving your arms a bit and grinning in anticipation of the wonderful picture you imagine. Then you don't have to do anything more. I did not have to schlepp heavy cases of equipment down to La Selva, Costa Rica.

Nor, with the help of a *Life* reporter and 20 scientists, did I have to spend ten days in the 90° heat with a million mosquitoes until finally I made a green vine snake angry enough to put up a fight.

Melford did all that, and he gets all the credit. The snake and I get none. That's the way it should be.

> Mirage Jet ANONYMOUS July 14, 1967

he shadow is like that of a hawk over a barnyard. An Israeli Mirage flashes over Egyptian soldiers lying in the desert during the Six-Day War, its reconnaissance camera taking pictures automatically. No photographer pressed the shutter, but many might have been proud to. Hawk and chicken. Technology and man. A game that seems as ancient and simple as a parent's hand-shadow figure on a child's bedroom wall, but much more sinister.

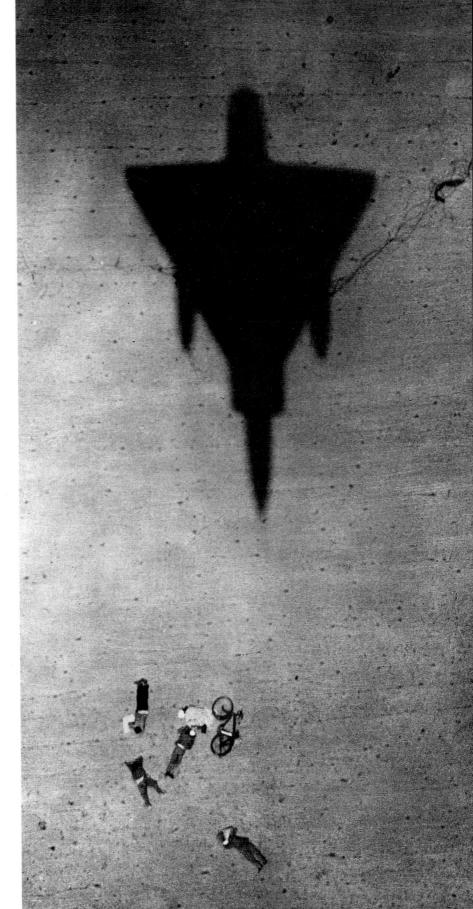

Evidence WAYNE SORCE March, 1982

here is nothing especially dramatic about this scene. It could be the contents of someone's attic. It's interesting enough to look at, but there's nothing that seems surprising. If someone tells us what we are looking at or why it was photographed, that's fine, but if not, these questions won't linger in our mind.

These are pieces of evidence shown during a trial in 1935. The defendant was found guilty and put to death in 1936. Presumably the jury reached its verdict because of what one lawyer said about these commonplace objects.

Wayne Sorce does not call our attention to any particular piece. He used the excelsior made of shredded newspaper as a decorative device, and he placed a child's pajamas centrally in the picture. A ladder, which was important in the trial, is in the foreground. Still, no piece of evidence looks more important than another. Sorce has presented everything with a shrewd lawyer's understatement. But hold on! The very modesty of the picture leads us into it.

These odd bits and pieces doomed a man. They convinced a jury, beyond a reasonable doubt, that Bruno Richard Hauptmann had abducted and killed 20-month-old Charles Lindbergh Jr. The baby's father was the first man to fly the Atlantic Ocean both nonstop and alone. Lindbergh was handsome, laconic and considered by everyone at the time to be a very great hero. That may explain the continued interest in his loss and provide a dramatic reason for taking the picture. But the picture's simplicity sets off a surprise—the fact that 50 years after the murder, the evidence continues to be stored at the headquarters of the New Jersey State Police. Think if in Jerusalem any evidence that might have been in Pilate's court were likewise stored away.

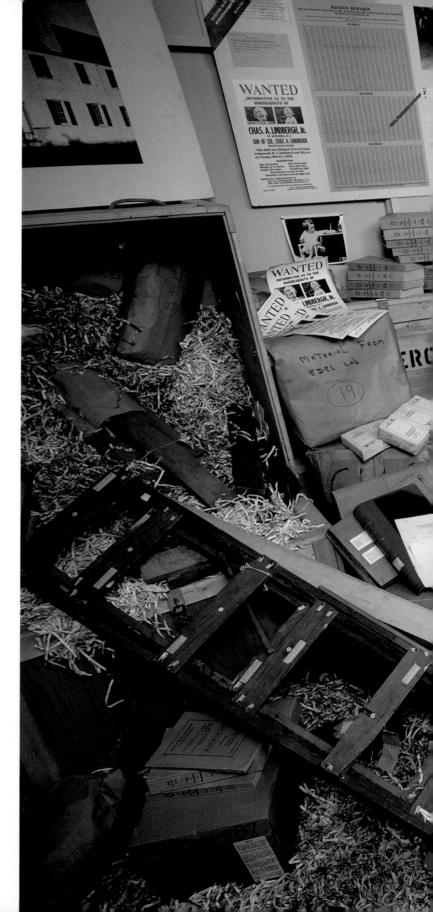

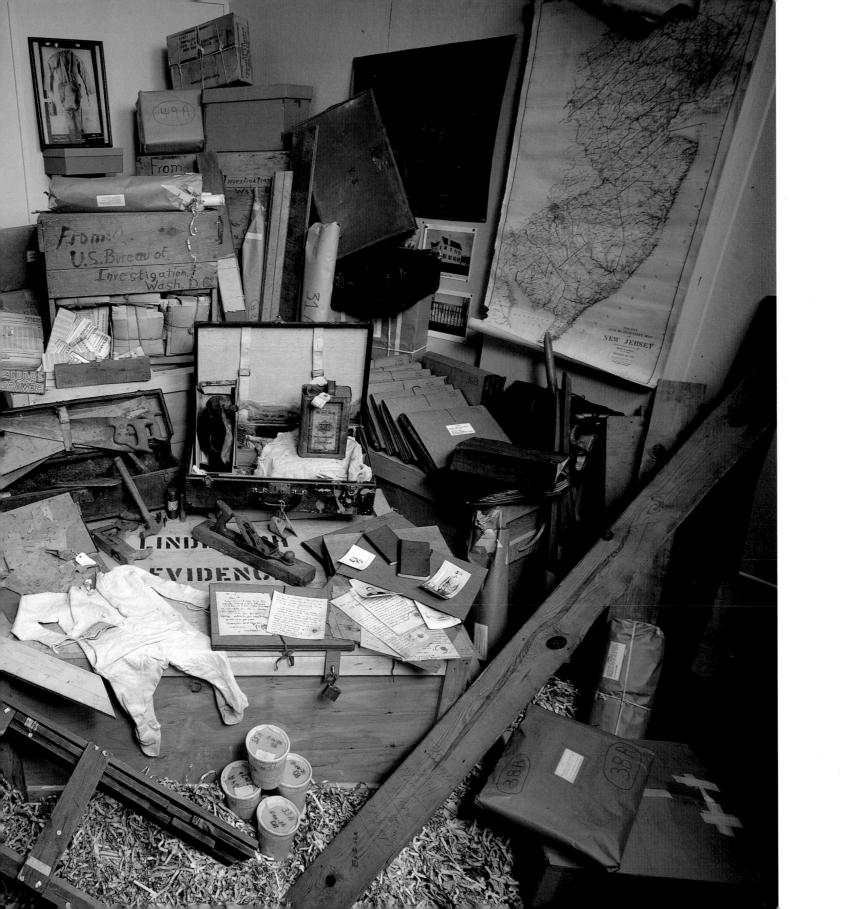

Rita Hayworth BOB LANDRY August 11, 1941

n Hollywood in the 1940s, pinup pictures were the antipodes of the sleek publicity portraits that movie companies had been turning out for two decades. The pinup was a variation of the newspaper cheesecake shot, showing a young woman perched on something like a ship's railing with her legs pointing toward the camera. The photographer might suggest that she put her arms behind her back and take a deep breath, which pushed her breasts forward and upward. Usually the woman

smiled at the camera and tried to look friendly.

In 1941 Bob Landry broke some of these rules to take a classic pinup. Twenty-two-year-old Rita Hayworth had been photographed for three or four *Life* stories already. That afternoon she knelt on a bed in a dressing room near one of the sound stages. She wore a nightgown designed by the mother of a studio publicist. She was asked to take a deep breath, but kept her arms by her side, and that interested look...?

Well, Richard Pollard, Landry's good friend and then *Life's* bureau chief in Los Angeles, says that he'd just asked Miss Hayworth to take that deep breath, and she was looking at him when Landry's flash went off

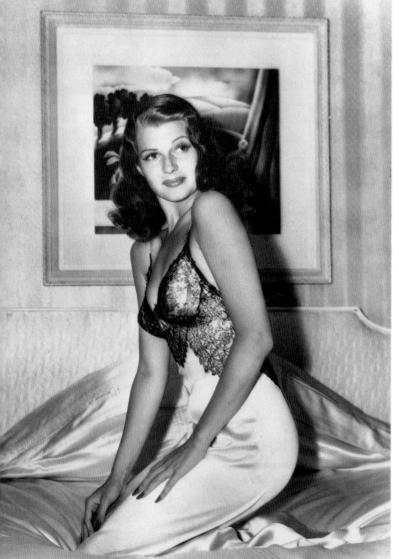

Multiple Exposures
TOBEY SANFORD
October, 1982

f the camera doesn't lie, consider this question: How can a woman wear nothing but a bathing suit and also wear a business suit in the same picture? Only by legerdemain. If the photographer puts a piece of black paper on a piece of glass in front of his camera, and cuts the paper into pieces, like a jigsaw puzzle, and then removes one piece and exposes through the hole, and then replaces the piece while people change clothes and positions, and (when they return) opens another hole and exposes through it; and does this four times without ever touching the camera (because the slightest jiggle will throw everything off), the result will be a seamless exposure on a single piece of film, as in Tobey Sanford's patient effort to show five career women clothed for the office admiring themselves dressed for the body-building sport they adore.

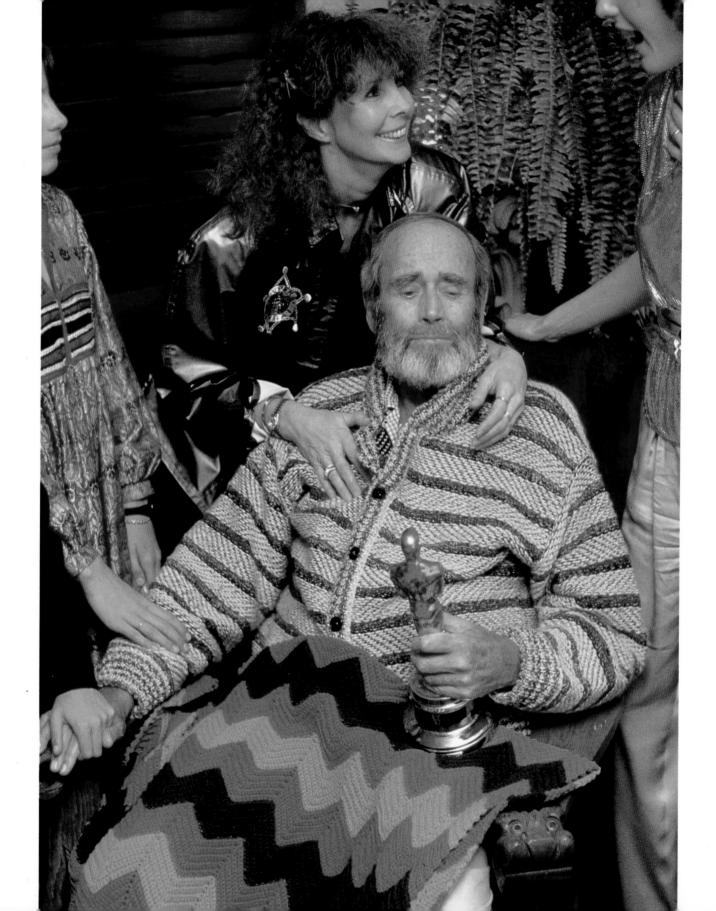

ohn Bryson waited outside the ailing actor's room until Henry Fonda's daughter Jane rushed the Oscar from the awards ceremony to his bedside. Then Bryson exposed two rolls of film, pushed through the crowd of press waiting outside the Bel Air house and caught the red-eye night flight to New York. A press blackout (except for Bryson, who is a family friend) had been decreed. He thought he had an exclusive.

A strong competitor, John Bryson takes pride in being where the rest of the press is not. Coming straight to *Life's* offices from the airport, he refused to believe our news. His "exclusive" had been on television. As he left California, Jane Fonda let in other photographers and re-enacted the scene with her father. On TV it looked like the real thing.

Later in the lab we looked over Bryson's film in silence. It was easy for photographers to re-create the moment when Jane handed her father his first Oscar. But Bryson, of course, had been photographing an event, not just staging a picture.

A few frames later he captured a moment that could not be restaged. Fonda's wife Shirlee and some children began to fuss over the actor in spontaneous pleasure and happiness. They formed a tableau as in a Renaissance painting. Fonda took on the look of a shy, reluctant Madonna with angels swooping around his head heralding the arrival, not of a divine child but of the well-deserved and long-awaited recognition of his peers.

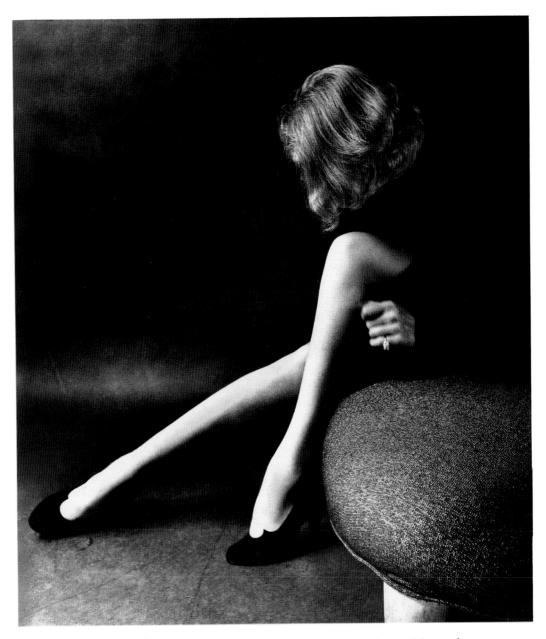

Marlene Dietrich MILTON GREENE August 18, 1952

Onsider Michael Jackson's nose or Jimmy Durante's. Think of Sylvester Stallone's biceps or Arnold Schwarzenegger's. Reflect on Groucho Marx's eyebrows or Joan Crawford's eyes. Even before biotechnology and patented mice, some pieces of some people's anatomy were trademarks.

Photographing these well-known features is not easy. Bring the camera in too close, and you have a picture of a piece of meat that would delight only a plastic surgeon.

Milton Greene stood back from Marlene Dietrich. He included her hair, her black dress, her hand, a piece of a 1950s couch and a sense of mystery.

In such a careful setting, her legs, their energy and grace softly lighted from above, became the unmistakable and cherished emblems of a star.

John Anderson BARRY McKINLEY October: 1979

incoln advised, "You can't fool all of the people all the time," but there's no telling what a politician will do for a photographer. John Anderson was elected nine times to Congress before he ran for President. Barry McKinley asked him to sit beside Lincoln because they both came from the same town in Illinois.

Anderson was a very serious man, not given to gimmickry in a campaign. When he lost the Republican nomination, he started his own party. President Calvin Coolidge was very serious too, and yet he allowed himself to be photographed wearing an Indian warbonnet. But he was already in office.

New York's humorless Governor, Thomas Dewey, during one of his runs for President, was pictured grinning as he walked along with a group of gents dressed like cavemen.

Dewey did not lose because of that photograph, and Anderson didn't lose because of this one. On the other hand, why vote for a man who proves he can't measure up to Lincoln?

Birmingham, Alabama CHARLES MOORE May 17, 1963

A photograph can show us that something is wrong in this country. This photograph of a properly dressed black man having his clothes ripped off him by dogs handled by calm Birmingham, Alabama, police officers said so loud and clear.

Charles Moore's picture was published in *Life*, and similar shots by other photographers were published in newspapers around the country. No defense of Segregation, or extolling of the virtues of the Southern Way of Life, or arguments about the importance of States' Rights could stand up to the sight of such a man in such distress. Jim Crow was dead.

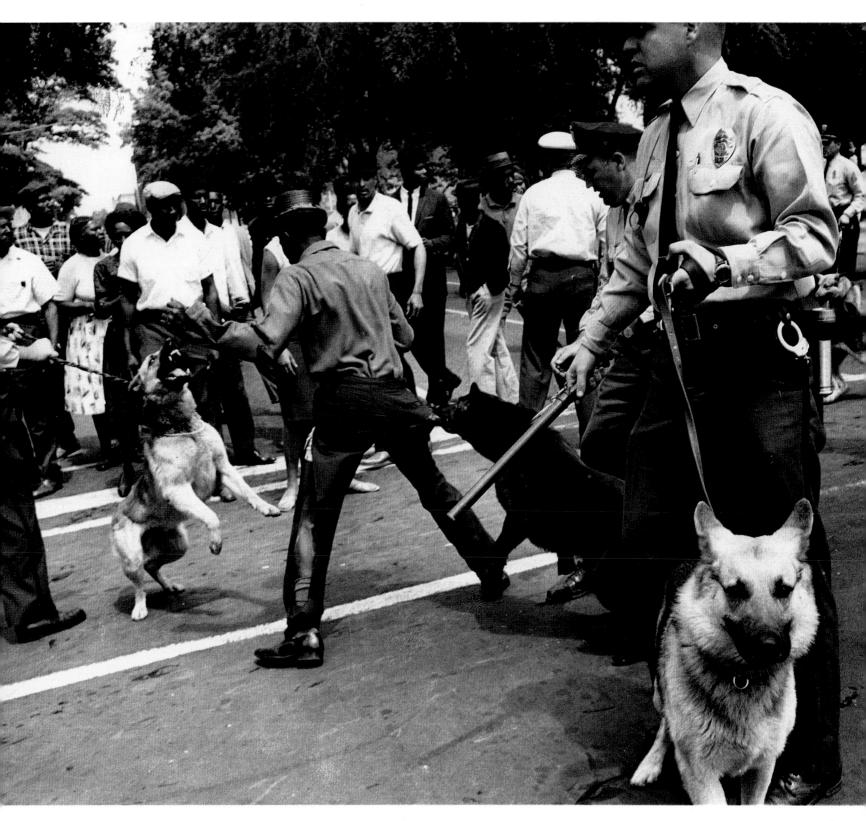

Grief DMITRI BALTERMANTS April, 1985

Sometimes even the best work of a photographer doesn't become widely recognized until long after it's been taken. Dmitri Baltermants graduated in mathematics from Moscow University in the early 1930s and soon took up photography as a career. Working as a war photographer in 1941, he came upon this scene in the Crimea. German troops had gunned down a group of civilians. Survivors are searching for their relatives.

Baltermants took several pictures. One showing a woman collapsing into the arms of a man was distributed in the United States and used in *Life* in April, 1942, but it wasn't until 25 years later that I and many others saw this particular picture from Baltermants' set. It hung in a show at the Metropolitan Museum of Art in New York called "Photography in the Fine Arts, Exhibition V."

The jury for that show consisted of eleven museum directors and curators. In the exhibition's catalog, the director of the Philadelphia Museum of Art was quoted as saying he didn't like the picture because "it didn't work as an idea." The director of the Boston Museum of Fine Arts agreed. Fortunately, the man from the Virginia Museum of Fine Arts argued it was "one of the great pictures of the day."

Their disagreement seems surprising. The stoic stance of the villagers, broken by the grief of the woman in the foreground, makes an image that should pierce the senses of any viewer. If painted, it might be mawkish, but as a photograph the reality it records should humble even the most pretentious connoisseur.

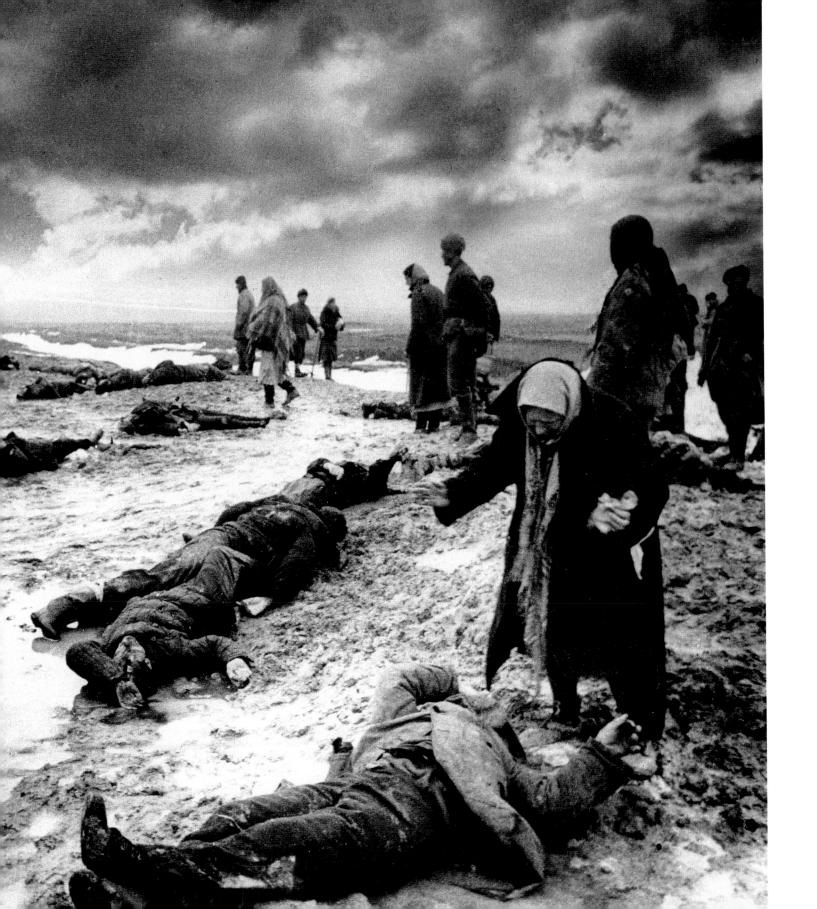

Halloween GEORGE SILK October 31, 1960

fter covering the Kentucky Derby in 1959, George Silk arranged to borrow a photo-finish camera from the track there. He wanted to see if he could use it to take pictures of something other than horses. Silk tested it in his own backyard, aiming it at his and his neighbor's children in Halloween costumes.

In a photo-finish camera the film zips past an open slit that acts like a shutter. This shutter system causes the parts of the children moving in the same direction as the film (but at a slower speed) to be elongated, while anything going faster or in the opposite direction is foreshortened.

Clearly this distortion catches the spirit of hobgoblins, witches and ghosts—or at least children at play—as well as any camera can.

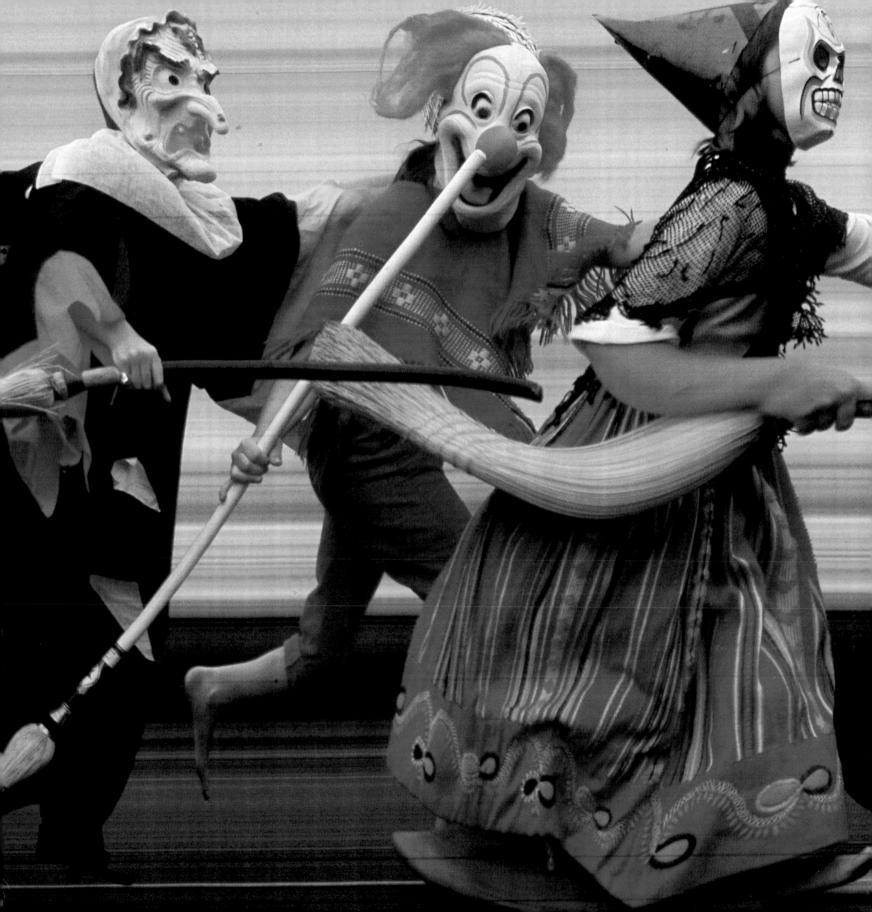

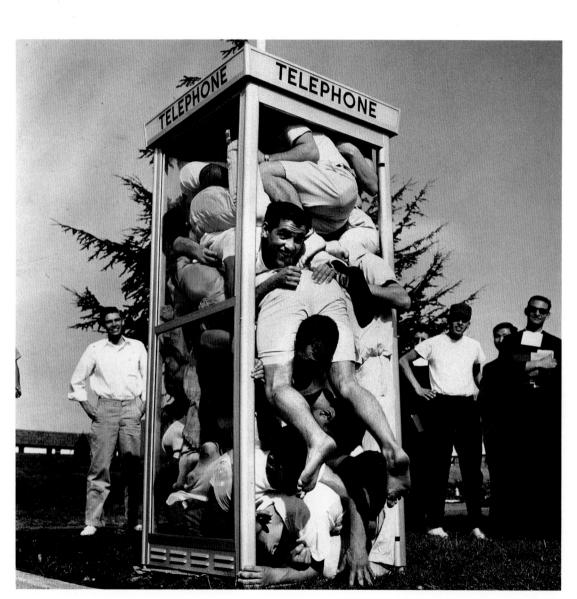

Phone Booth
JOE MUNROE
March 30, 1959

A camera fixes a fad forever (which is one thing fads are not), so that when people stop hulahooping, jitterbugging or streaking, we can remember what they looked like. Thanks to Joe Munroe, we need never forget how many football players can stuff themselves into a phone booth.

Jump PHILIPPE HALSMAN November 9, 1959

The Duchess of Windsor refused the first time, but at a second photo session, when her new book seemed a success, she was more relaxed. The Duke came into the sitting room of their apartment in New York's Waldorf Astoria hotel, saw what was happening, and asked to join.

Philippe Halsman had already learned that he could ask his famous subjects to jump—just for fun—after he took their formal portrait.

Since everyone jumps in a different way—feet together or feet apart; knees bent or knees straight; smiling or no smile; high or low—Halsman's collection of leaps is both amusing and telling.

Telling, too, are the few who refused—pianist Van Cliburn, television's Ed Murrow and several members of England's Establishment.

But not their former King. He and his love were happy to demonstrate that for a moment nothing was beneath them.

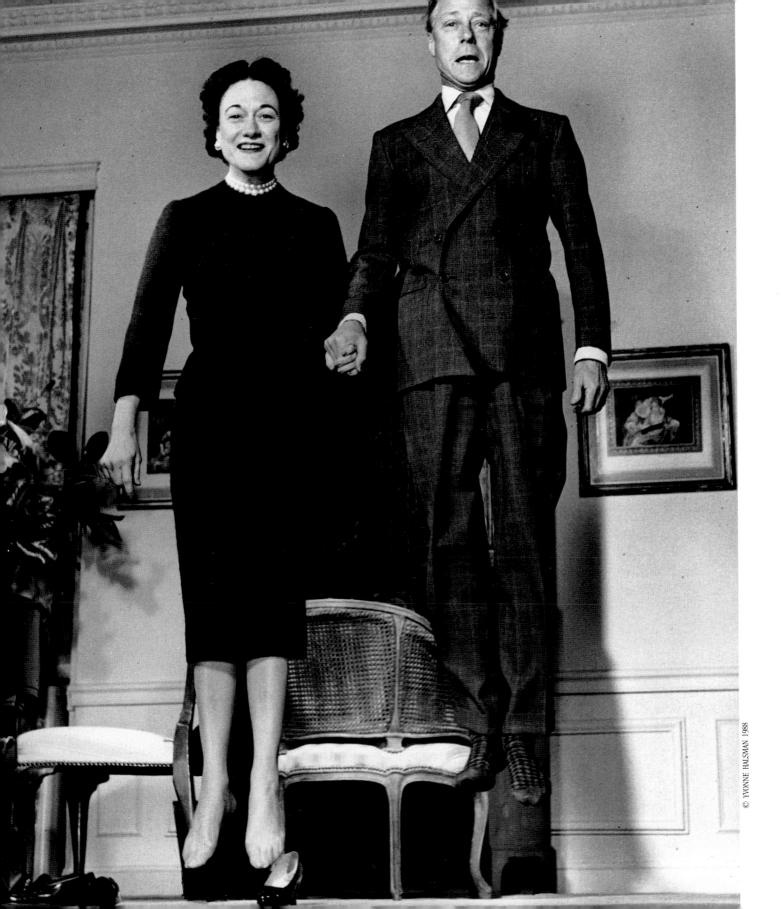

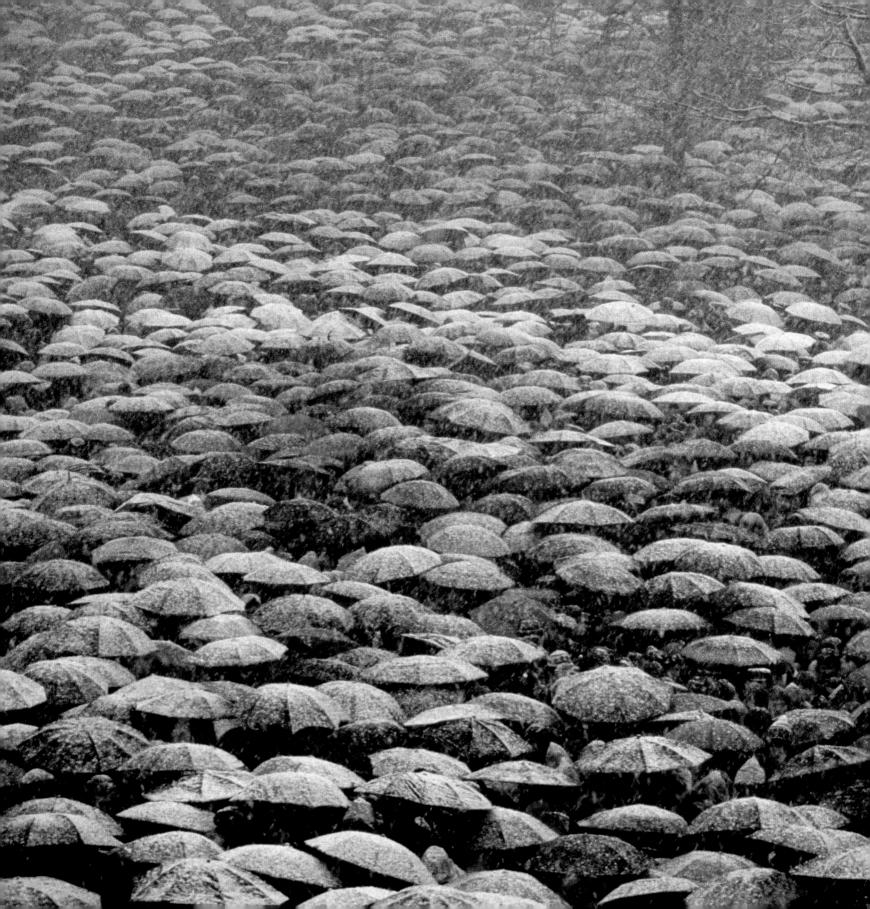

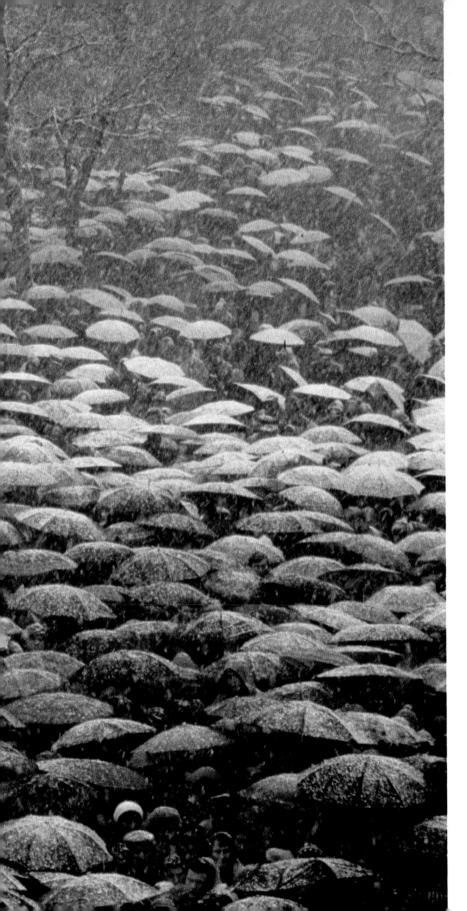

Umbrellas BRUNO BARBEY January, 1982

In 1981, covering the rise of Solidarity, the labor movement in Poland, Bruno Barbey had two things going for him. First, he had a hard-to-get journalist's visa that allowed him to travel freely about the country. Second, he had a camping vehicle in which to do so. In this way he was able to photograph more than a confrontation here or a poster there. The quietest scene might have significance. Pilgrims gathered Easter week in Kalwaria, where fourteen small chapels duplicate the Stations of the Cross. Standing in the snow under the shelter of their umbrellas, they sang and displayed their faith, showing their solidarity with the Catholic Church in one of the few public gatherings the Communist government could not ban.

C.P.O. Graham Jackson ED CLARK April 23, 1945

hen news of President Franklin D. Roosevelt's death in Warm Springs, Georgia, reached Ed Clark in Nashville, Tennessee, he got in his car and drove all night.

Arriving before the coffin left the "Little White House" for the railroad station and the sad trip north, Clark found scores of photographers herded behind barriers set up by the Secret Service—just as if the President were still alive.

Uncomfortable amid the crowd of cameras, Clark heard music. When he turned, he spotted Chief Petty Officer Graham Jackson, a Navy musician who had often played at presidential parties.

Clark had joined *Life* only a few months before, after seven years working on the Nashville *Tennessean*. He knew how easily daily newspapers could scoop a weekly publication. He wanted to keep this photograph exclusive.

Taking only one small 35mm camera, he moseyed away from the rest of the press, moving toward Jackson, who was now playing *Going Home*. Clark took a couple of quick, unnoticed shots. "When I saw him, I knew. My God! What a picture!"

Kim Novak LEONARD McCOMBE March 5, 1956

eonard McCombe often gets close to a subject.

He's aware that his intimate pictures could cause embarrassment or even humiliation when published and he has therefore developed a feeling for discretion and tact.

It is also true that McCombe likes to listen to orchestras whose conductors read meaning into every phrase of music. He feels his photographs should do likewise, bringing out some human quality, some nuance from the facts before him.

Traveling with actress Kim Novak, McCombe wanted to make clear the young star's attraction without making her look larger than life. Chaperoned by a press agent, they went to dinner on a train heading for New York. As the actress removed her jacket, McCombe raised his camera and captured the scrutiny of a banquette of businessmen on the 20th Century Limited.

Chicken RALPH CRANE November 7, 1949

like the rest of the 19 million pictures in the Time Inc. Picture Collection (Time Inc. publishes *Life*), this one can be found under several of 10,000 basic cross-references. You can look under "Auto Driving—U.S.," "Hot Rod Cars," "Youth—U.S." and "Speed," for example, as well as the issue date in which the photograph appears and the photographer's name.

Most of the pictures in the collection (it is the largest indexed picture collection in the world) are about people. Ralph Crane took this one to illustrate the behavior of postwar California youth.

The game they are simulating—called "chicken"—was widely played at the time. A driver would take his hands off the wheel when going at high speed down a narrow road. The first person to grab the wheel and keep the car from running into another car or into a tree was the chicken.

Surprisingly, some of this generation of young Californians lived.

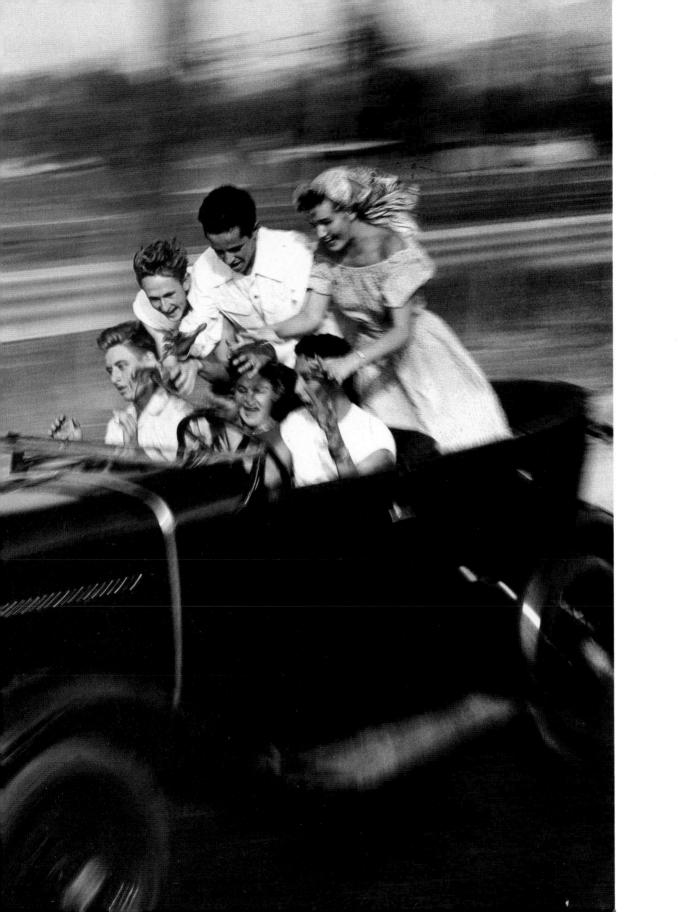

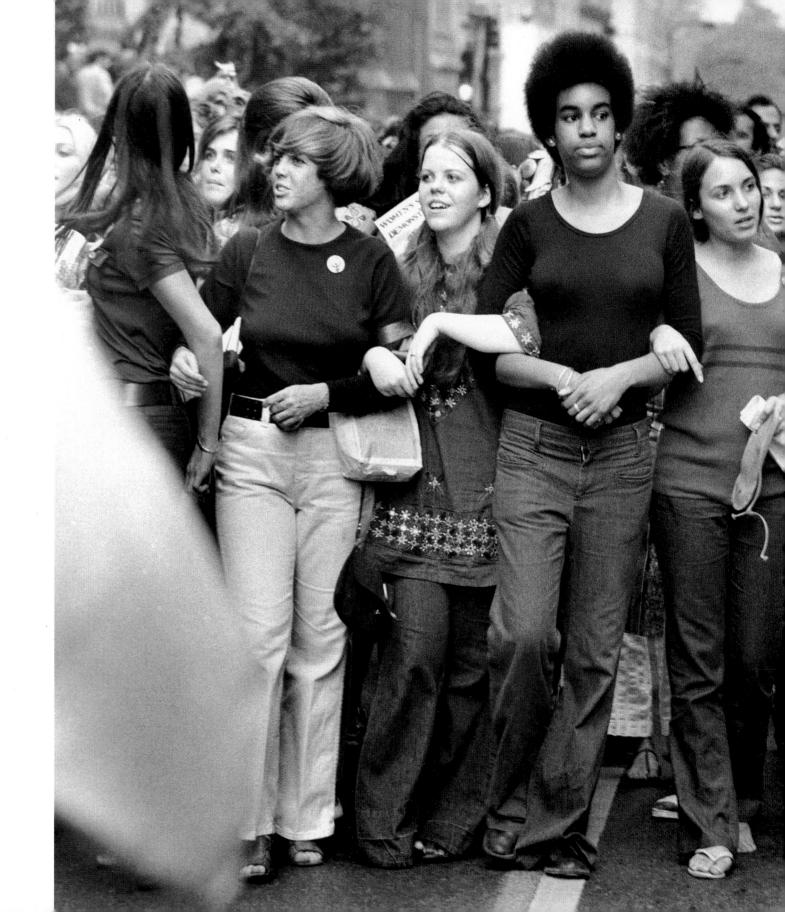

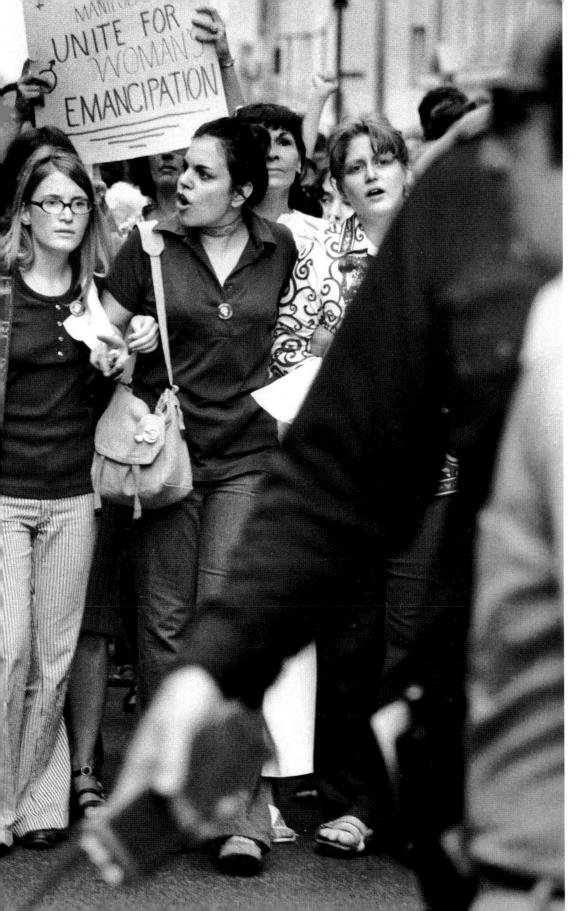

Women's March JOHN OLSON September 4, 1970

John Olson felt that walking a couple of blocks from *Life's* offices to photograph a march for women's rights on Fifth Avenue was pretty routine. The women's cause was a century old, but much of that time it had been publicly dormant.

At the time of this march, Olson was the youngest photographer on *Life's* staff by almost a decade, and therefore thought to be more in tune with various youthful protest groups. He remembers being asked to cover lots of marches, protests and drug stories. In Washington, D.C., he was beaten by protesters one month and by the police the next. The march by women in New York three months after students had been killed at Kent State by the National Guard seemed tame.

Olson took a simple picture. Almost instinctively, he picked out a line of rhythmically spaced faces to create, in his words, "a flow of movement through a still image." Doing so, he also caught the spirit of a cause just then relaunching its march for equal rights.

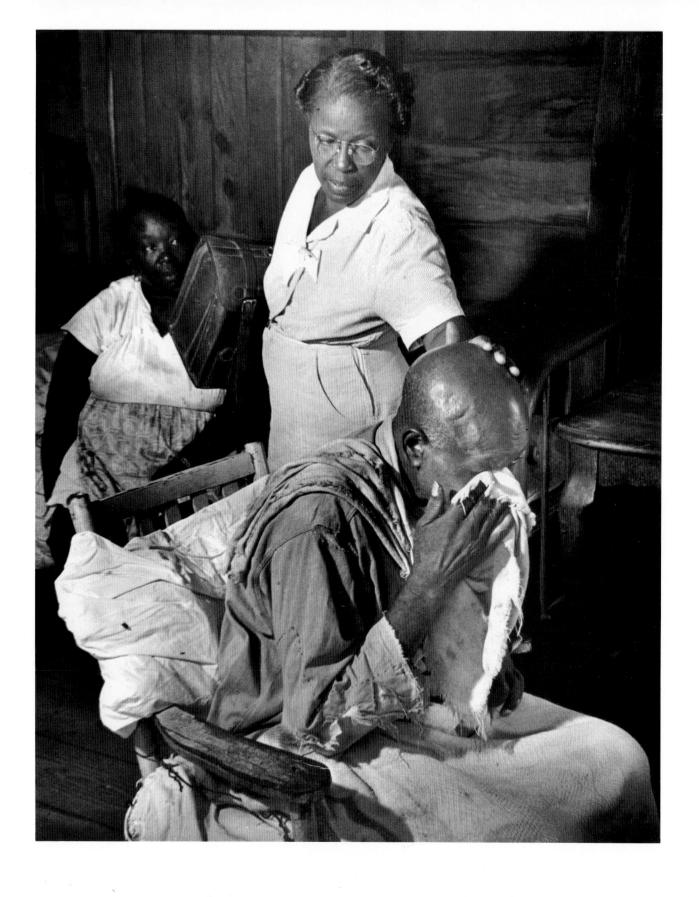

Nurse Midwife
W. EUGENE SMITH
December 3, 1951

n the 1940s and early 1950s many photographers were intent on photographing human activities it had been impossible to photograph before because film had not been very sensitive to light, nor lighting equipment very sophisticated. Simple indoor subjects like tying a shoe, typing a letter or, as in this photograph, the sympathetic touch of a hand, were exciting to try to capture.

Such scenes were often recorded with elaborate lighting arrangements, using either flashbulbs that went off only when the shutter was snapped and needed to be replaced after each exposure, or bright lights that burned continuously, giving a room the brilliance of a movie set.

Either way, this extra light permitted extreme sharpness from the foreground to the background. In this photograph, nurse Maude Callen's hand is not isolated, in focus by itself, but is related to the expressive figures and faces in the room.

Knowing this, there are apparent contradictions. When we realize how intrusive the light had to be. we wonder how such an intimate moment could be caught. Had the photographer expected this fleeting gesture, and lit the room accordingly? Were lights in place already to light another scene? Or had this gesture occurred earlier, and did W. Eugene Smith ask that it be repeated when his lights were ready? It is possible that this is the fourth time nurse Callen has turned to Frank McCray and the fourth time he has brought his handkerchief up (Smith sometimes directed his subjects to repeat an action until he felt he had the picture right). If so, what's remarkable is the genuineness of the gestures and the emotion, because whether directed or spontaneous, we *feel* the touch.

Yangtze DMITRI KESSEL April 4, 1955

he longest delay that I experienced between shooting a story and its publication in *Life* was eight years. Dmitri Kessel beat my record. His picture of the Yangtze River ran nine years after he took it.

Working in Shanghai in 1946, Kessel and *Life* editor John Hersey photographed an essay on the "Long River," as it's known in China.

As the story was going to press, an article Hersey had written on the dropping of the first atomic bomb on Hiroshima was published in another magazine and created a sensation.

Even though Hersey's Hiroshima idea had first been turned down at *Life*, so Kessel heard, *Life*'s editor in chief was so upset that he didn't want to print another word—even a caption—by Hersey just then. The essay on the Yangtze River, fifth longest in the world, was dropped.

In 1955 this photograph of the Magic Mountain Gorge, taken from an Army DC-3, was used in an article describing the world's great religions. The next year Hersey's novel *A Single Pebble*, based on his river trip with Kessel, appeared and Kessel's essay was dusted off again (by an editor with a long memory) and used to describe the reality on which the popular book was based.

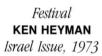

One afternoon in Israel, Ken Heyman looked down from a balcony overlooking a courtyard as Orthodox Jews danced to celebrate the ritual cutting of their young sons' hair.

What interested Heyman was their hands. He liked the fact that it was men who were holding hands. That is rare. Even more interesting to Heyman was the fact that the hands arrange themselves like notes in a bar of music.

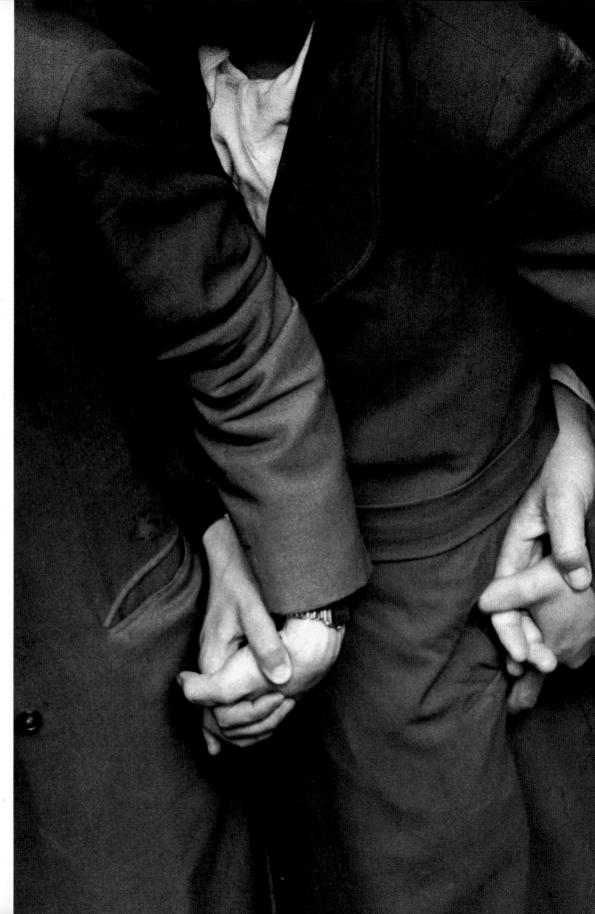

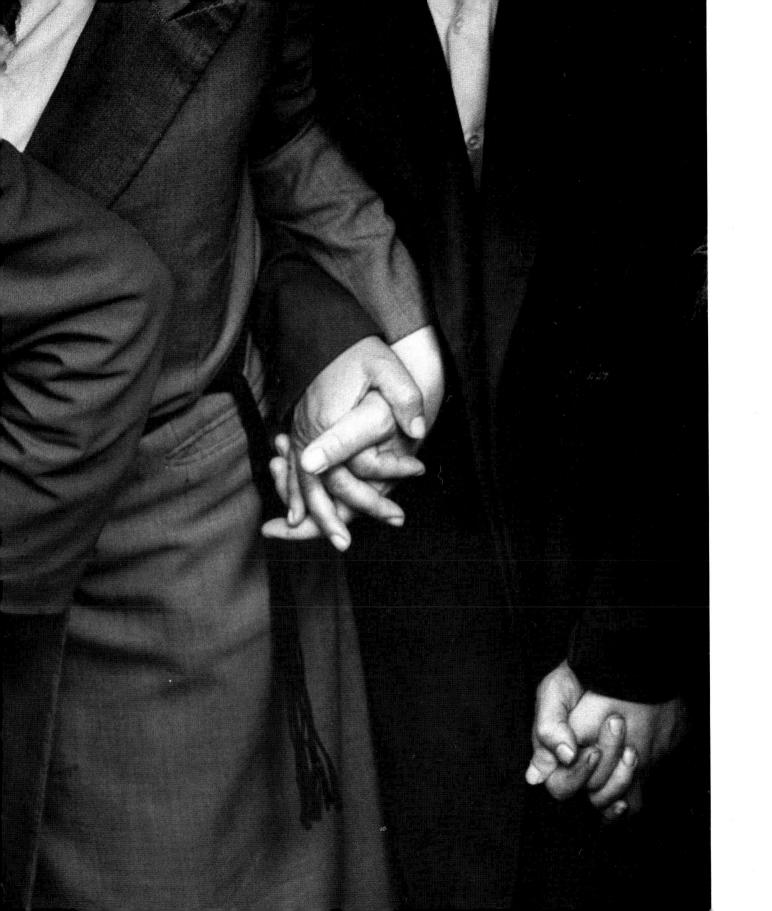

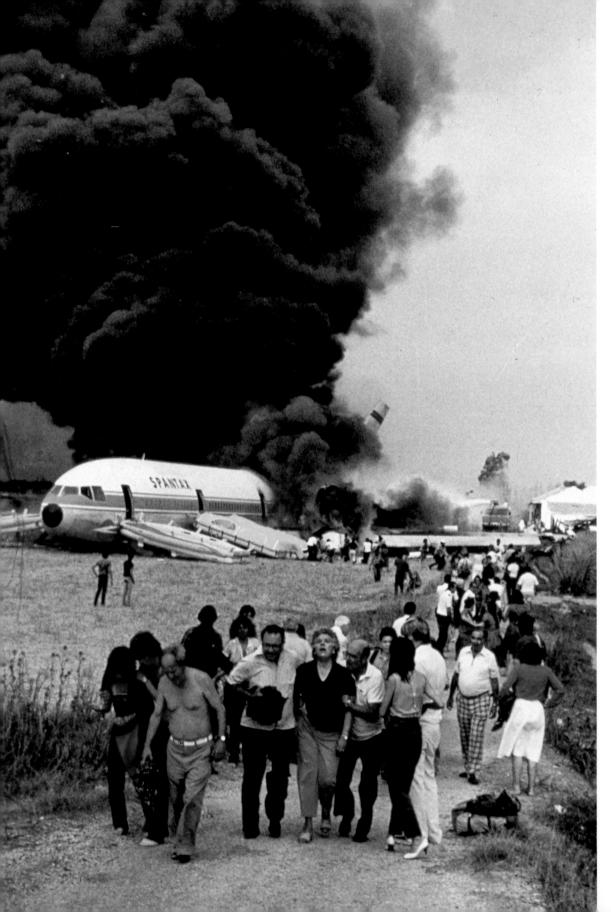

Plane Crash WERNER VOIGHT November, 1982

One passenger on the Spantex DC-10's aborted takeoff at Malaga, Spain, got off and looked back at every traveler's nightmare, recording what might be a 20th century version of a 19th century engraving of Dante's vision of Hell.

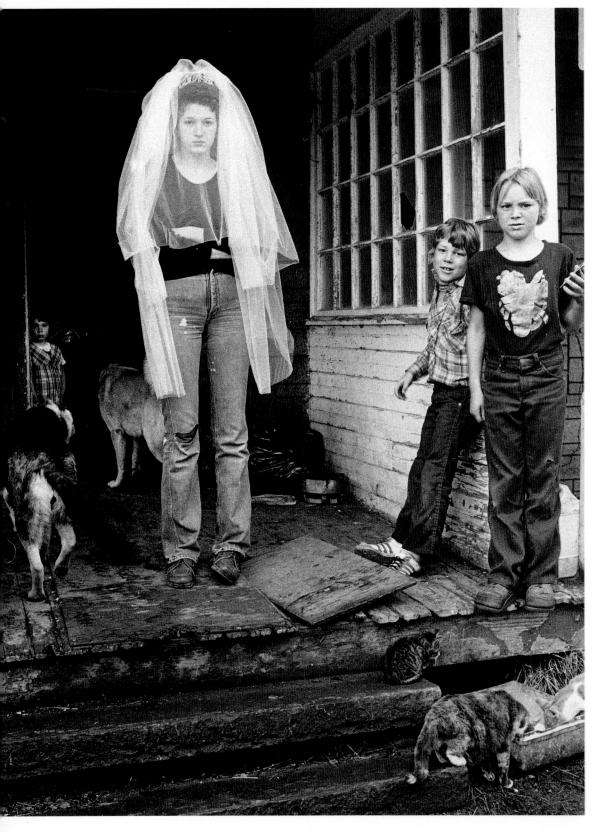

Bride PATT BLUE June, 1982

As a federal antipoverty worker on Long Island, Patt Blue worked with members of the Cleveland family. During the next ten years, while Blue became a professional photographer, she continued to photograph the Clevelands. By 1982, when Mrs. Cleveland earned a nurse's license and was able to take the family (including her severely disabled husband) off welfare, Blue finally had a story.

Because she photographed over a long period of time, Blue did not need to force situations. She could wait for a telling moment to appear, as Colleen, the eldest daughter, tried on her bridal veil. Colleen borrowed it from a neighbor the morning of her wedding and stepped outside to give her ten brothers and sisters, friends and other relations a look at a rose blossoming amid the thorns.

Walla Walla Prison ETHAN HOFFMAN August, 1979

After the 1971 riot at Attica State Prison in New York, which resulted in the deaths of 28 prisoners and nine hostages, many penitentiaries around the country tried various schemes to relieve the tension among their inmates. None made more spectacular changes than the state penitentiary in Walla Walla, Washington, where 1,400 maximum-security inmates could ride motorcycles at high speed around the prison yard or dress in whatever each felt was most becoming.

Ethan Hoffman photographed Leonard ("Star") Carter, who had been convicted of grand larceny, abduction and pimping. Carter, a prostitute, belonged to a homosexual group that promoted gay rights and mended other prisoners' clothes.

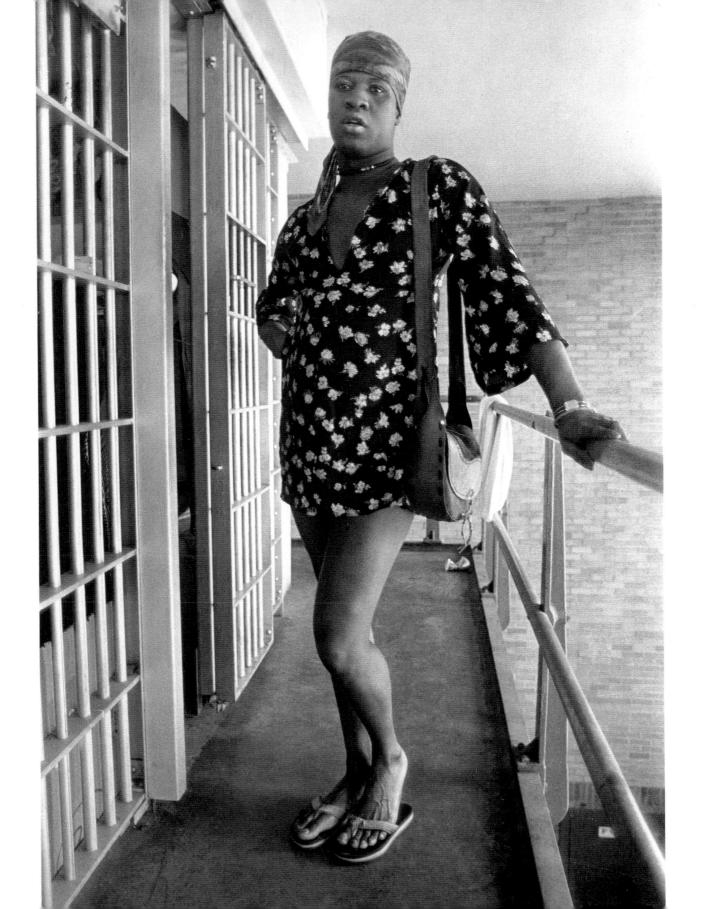

Luciano Pavarotti MIRELLA RICCIARDI October, 1980

or Mirella Ricciardi it was simple. The backyard of Luciano Pavarotti's home in Modena, Italy, was a setting for a performance. Pavarotti's wife and children were a chorus. The world's busiest tenor summoned up a belly laugh among his apple trees, suggesting that if "all the world's a stage," there is no reason not to mount an opera.

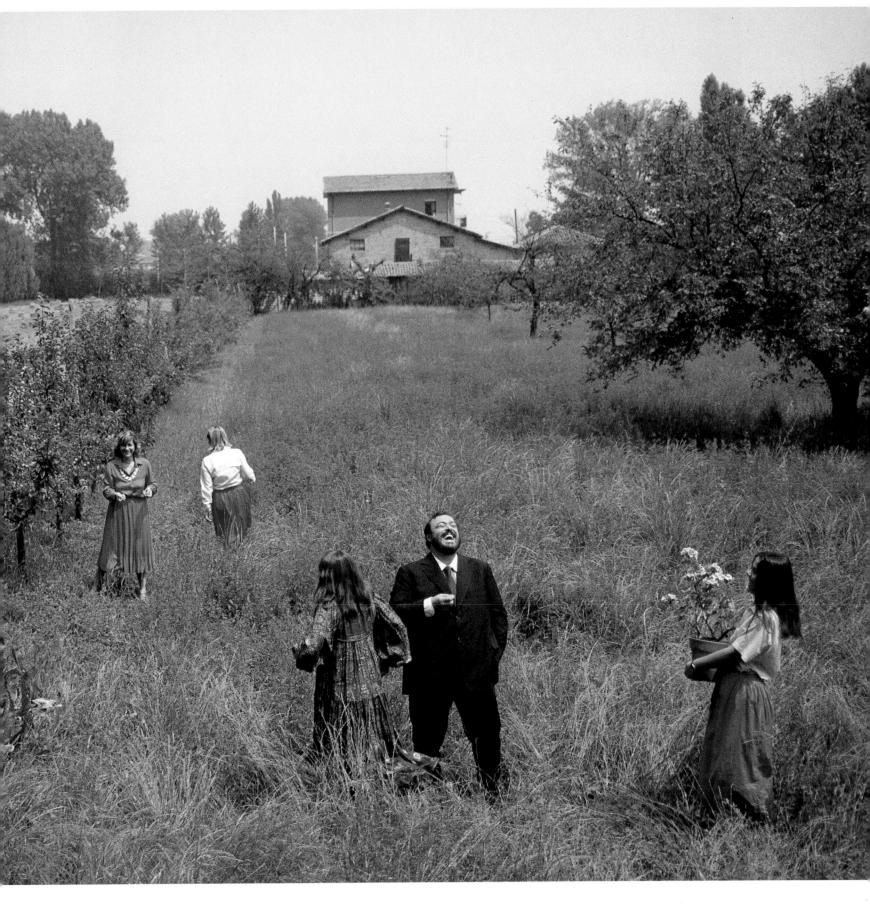

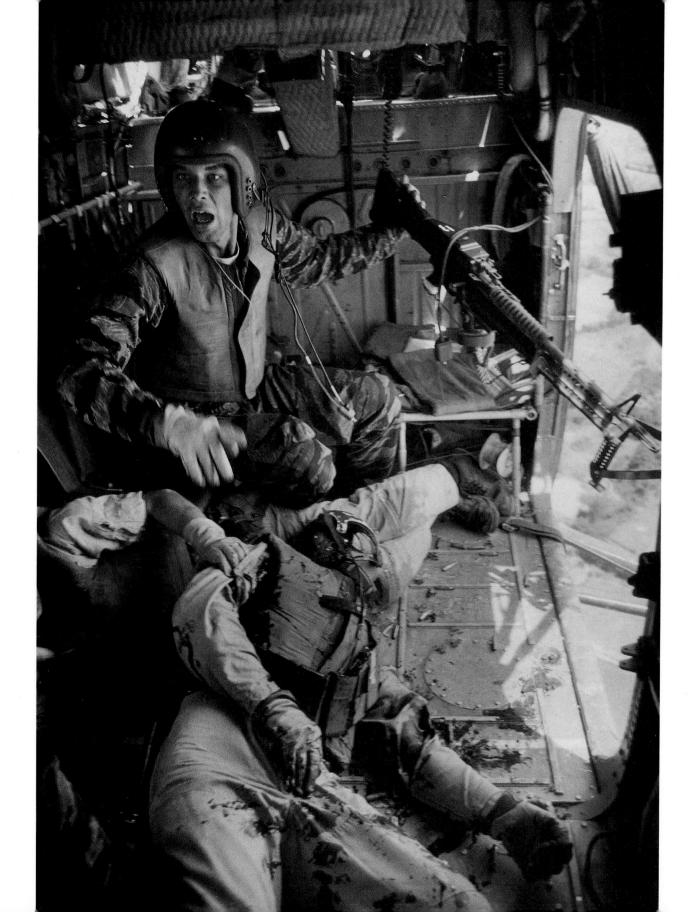

Yankee Papa 13 LARRY BURROWS April 16, 1965

arry Burrows initially covered the war in Vietnam for three years when all the fighting was done by Vietnamese soldiers advised by a handful of Americans. In early 1965, President Johnson announced plans to send in several U.S. Army and Marine divisions. Burrows prepared to do a close-up of an American unit.

Since the helicopter was a new tool of war, Burrows began a month-long study of a ship's crew. He chose *Yankee Papa 13*, partly because of its number, believing in reverse luck.

After working on the story long enough to expose 120 rolls of film, Burrows accompanied Yankee Papa 13 on a single mission that turned out to be a story in itself. Assigned to relay Vietnamese soldiers to the battlefield, the crew spotted a sister ship, Yankee Papa 3, disabled in the landing zone. Its copilot, Lieutenant James Magel, helped a wounded crewman make the dash to Yankee Papa 13. Just as they reached it, Magel was hit and badly wounded by machine-gun fire.

Yankee Papa 13's crew chief, Lance Corporal James C. Farley, with Burrows photographing beside him, went out to rescue the other ship's wounded pilot, but failed.

Airborne again, Farley gave first aid to the two survivors from the second helicopter. Farley's efforts could not save Lieutenant Magel. Burrows photographed Farley's reaction to Magel's death. One of those pictures was used on *Life's* cover.

Nearly two years later Burrows described his feelings about *Yankee Papa 13* in a special year-end issue of *Life* on photography: "It's not easy to photograph a man dying in the arms of his fellow countryman . . . Was I simply capitalizing on other men's grief? . . . I concluded that what I was doing would penetrate the hearts of those at home who are simply too indifferent. I felt I was free to act on that condition."

Soon after Burrows' words were in print, he got a letter from Lieutenant Magel's mother. She described her shock nearly two years earlier on finding a photograph of her dying son on the cover of a magazine only days after his funeral. She said that she wondered how a photographer could coolly photograph such a scene. Burrows' answer, she added, "took a load off my mind."

Burrows wrote Mrs. Magel that he realized the story must have been a great shock; his own wife and family had for the past five years lived with the fear of seeing a similar story about him.

Four years later, when a Vietnamese helicopter in which Burrows was riding crashed, and all aboard, never found, were presumed dead, Mrs. Magel sent the Burrows family a moving letter of condolence.

Splash! **GUY ANDERSON**February, 1982

Sometimes a picture editor just opens his mail and good things fall out. California wedding photographer Guy Anderson sent in a picture of Robin Huzar's marriage in San Jose. The bride had climbed to the roof of her parents' pool house to throw the bouquet.

Since wedding photography consists of recording a series of expected moments, the bouquet toss being one, Anderson got that shot. Then the bride began to mime what she might do next. The guests shouted encouragement. Anderson dropped back to be ready for something different. "Talk," *Life* wrote, "about taking the plunge!"

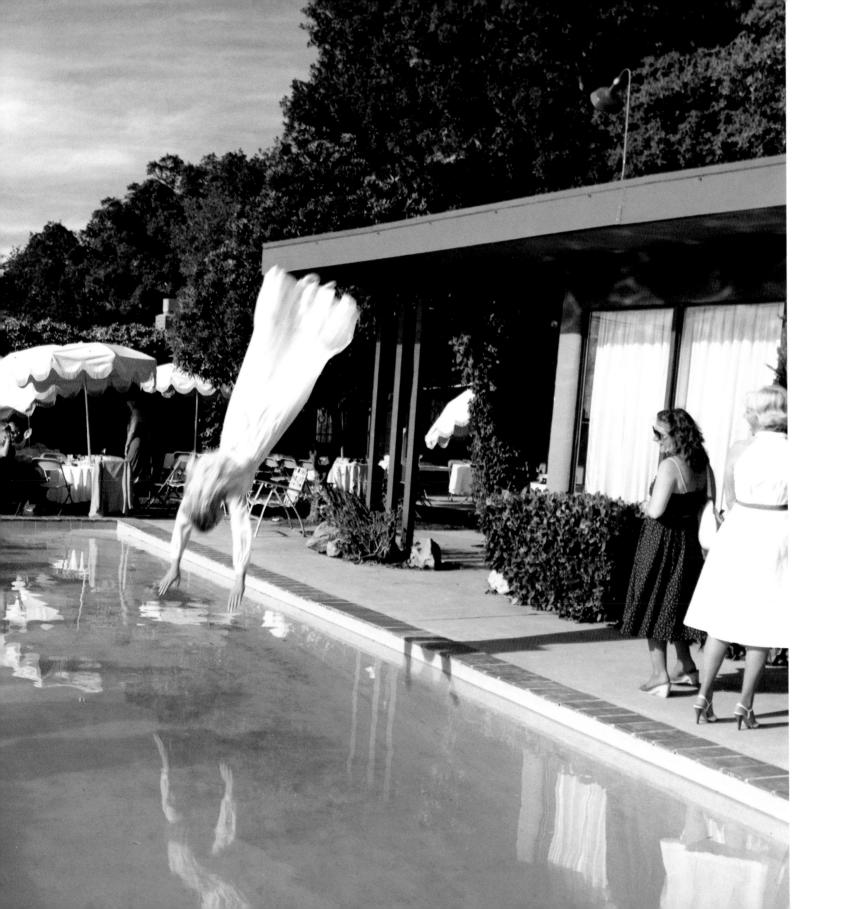

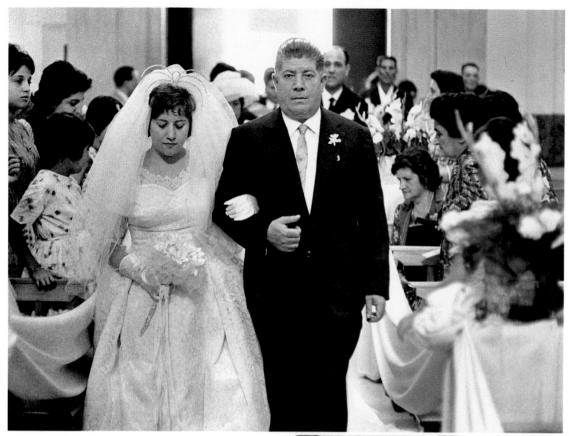

Italian Man
PAUL SCHUTZER
August 23, 1963

f *change* in a scene is more important than the scene itself, a series of photographs is more important than any single one. Paul Schutzer wanted to document the blend of machismo and sentimentality that he felt was peculiar to the male in Italy.

As this gentleman walked down the aisle of a church to give away the first of his seven daughters, the fact that he was in tears was not as important as the fact that the tears went from pianissimo to fortissimo as he took a few measured steps toward the altar.

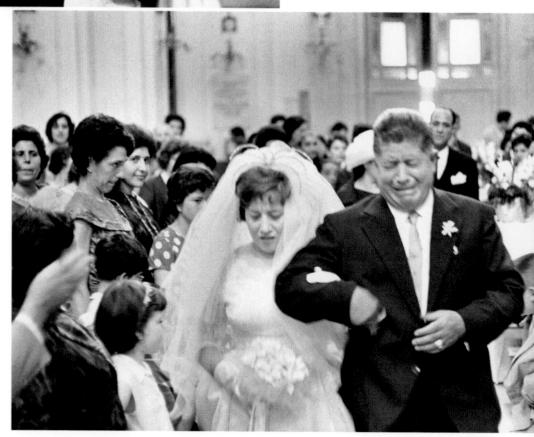

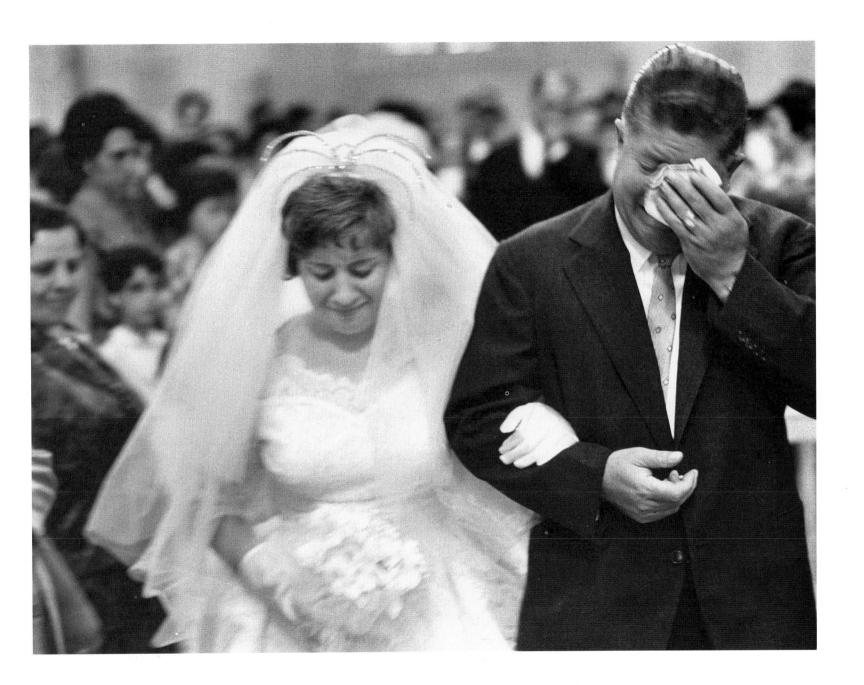

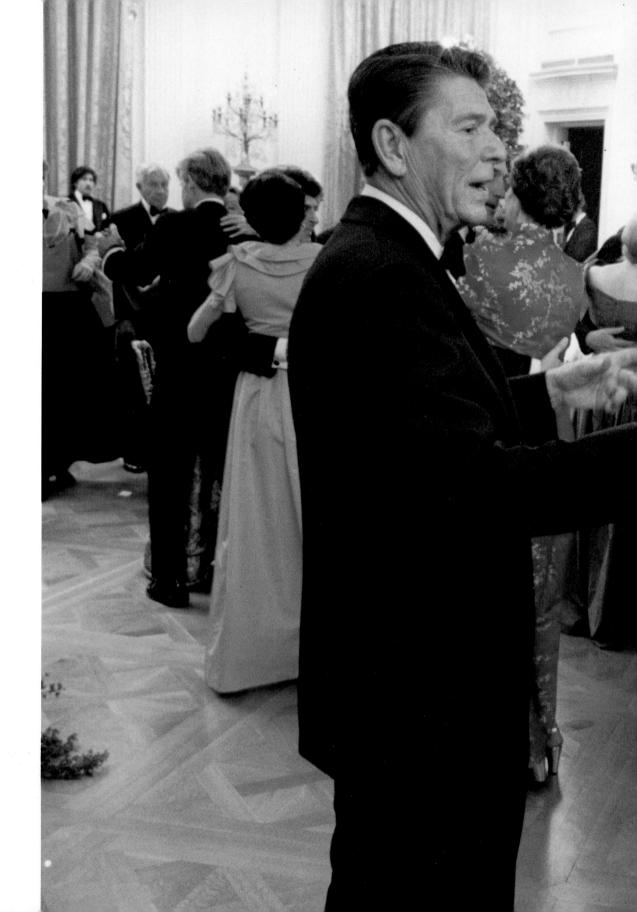

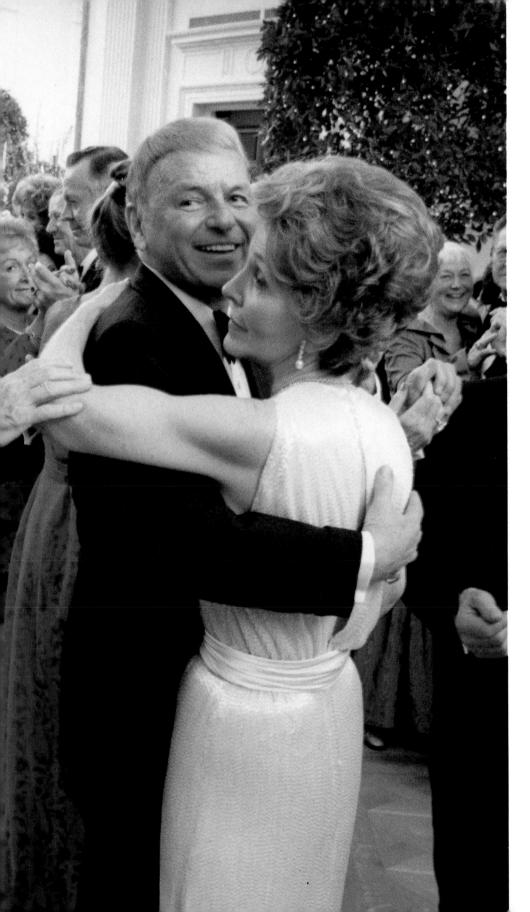

Presidential Birthday MICHAEL EVANS January, 1982

Ronald Reagan is not especially comfortable in front of the still camera. His career has been as an actor, not a model. His effectiveness on film comes when he moves and speaks. The best photographs of him look like stills from a movie.

A citizen living during the Kennedy Administration would have no trouble identifying this one. It must be another rat-pack flick. This time the boys are in the White House. Frank Sinatra is President. Ronald Reagan has probably replaced Dean Martin as one of the buddies, and the plot is about some whacko missile crisis with China; the movie must be called *Missiles from Manchuria* or something like that. Reagan cuts in on the first couple and makes a little joke.

O.K., wake up. It was really President Reagan's first birthday in the White House. A surprise party was planned for a Friday night. Michael Evans, the President's photographer, put large strobe lights pointed toward the ceiling in the tops of decorative trees in the four corners of the East Room in the White House. Light reflecting off the ceiling from these lamps enabled Evans to photograph anywhere in the large room with ease.

Since no one in the press office wanted to stay up all night, Evans edited his own film and released a picture at 4 o'clock Saturday morning in time for the newsmagazines' deadlines. His choice didn't thrill the sleeping advisers of the President, since Sinatra's reputation was, as usual, under some sort of scandalous cloud. Presidential aide Michael Deaver advised a sleepy Evans at 8 a.m. of his error. Too late.

Eventually *New York* magazine used the picture on its cover. Evans says that many readers thought the photograph was a painting. Who could imagine such a scene being from real life?

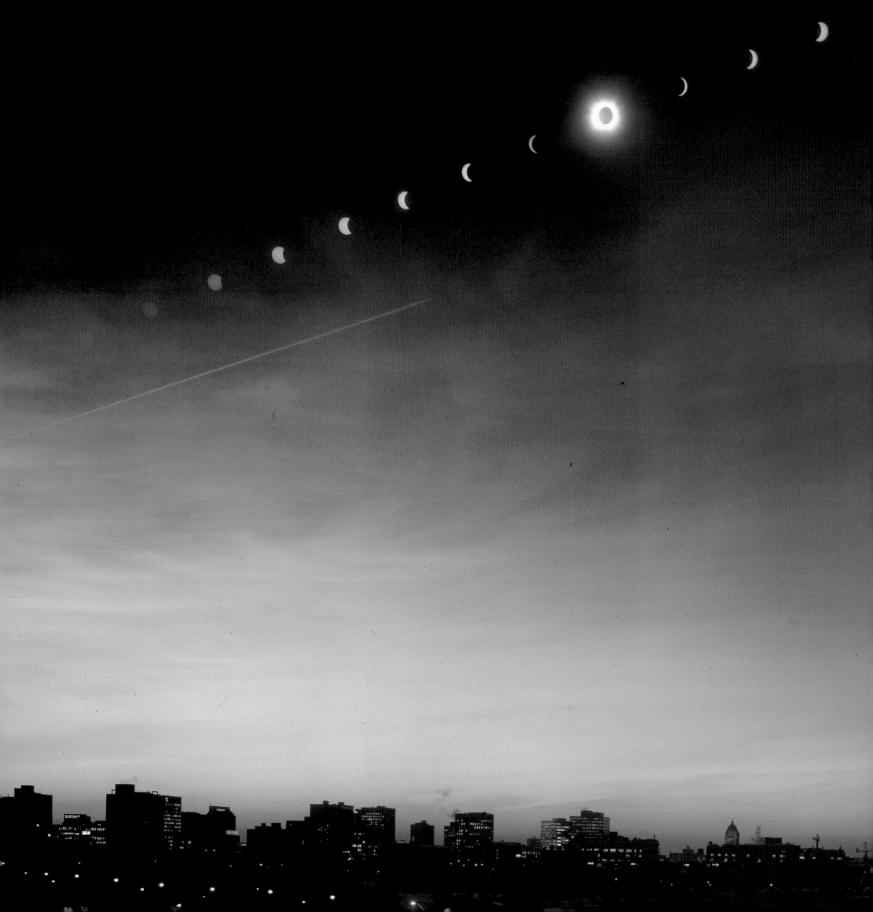

Eclipse HENRY GROSKINSKY April, 1979

n the late winter of 1979 Henry Groskinsky flew to Winnipeg to photograph the last eclipse of the sun to be seen in North America in this century. The moment of totality would last longer in Winnipeg than in any other city (almost three minutes), and clear weather was predicted. Hordes of eclipse watchers descended on the town.

On top of a twelve-story apartment house, he set up two 4x5-in. view cameras. One had a shutter that did not have to be cocked (a motion that could jiggle the camera). Using one piece of film, Groskinsky began to make exposures of the sun every 15 minutes, beginning more than two hours before the eclipse was due. Putting different filters on the lens, he darkened the camera's view while the sun shone, and removed the filters entirely for totality when the moon covered the sun completely. That exposure also recorded the city.

This multiple exposure was to be Groskinsky's backup picture. A second camera, with a widerangle lens, was set to capture the drama of the eclipse over the darkened city in a single exposure.

When totality came, Groskinsky quickly made an exposure on camera number one, then made his first exposure on camera two. He changed that film, and exposed again.

Changing the film holder after a third exposure, he worried that the shutter didn't sound right, and checking, discovered it wouldn't open. While still coaxing it to perform, he felt the first warm rays of the returning sun on his back.

There was no way to tell if the shutter had operated properly on any of the three single exposures except to develop the film. This Groskinsky did, one by one, in New York. Blank. Blank. Blank.

Oops! That meant not only that he'd lost his prime picture but also that he had no way to confirm that his exposure was correct for his multiple exposure of the eclipse. He decided to extend the development of the last sheet of film to compensate for possible underexposure.

But, no fear. If the picture hadn't worked out right on the button, Groskinsky could have reshot the scene in the year 2017, when he'd be 83 years old.

Why photograph one of the top movie stars in Hollywood and not show her face? Because sometimes there are different feelings of intimacy to convey. What a male photographer feels about an actress is as much a part of the equation in a photographic session as what the actress feels about the photographer.

Part of a movie actor's business is to project sex appeal. Outside her home in Malibu, Goldie Hawn was pitching, and Enrico Ferorelli didn't miss the catch.

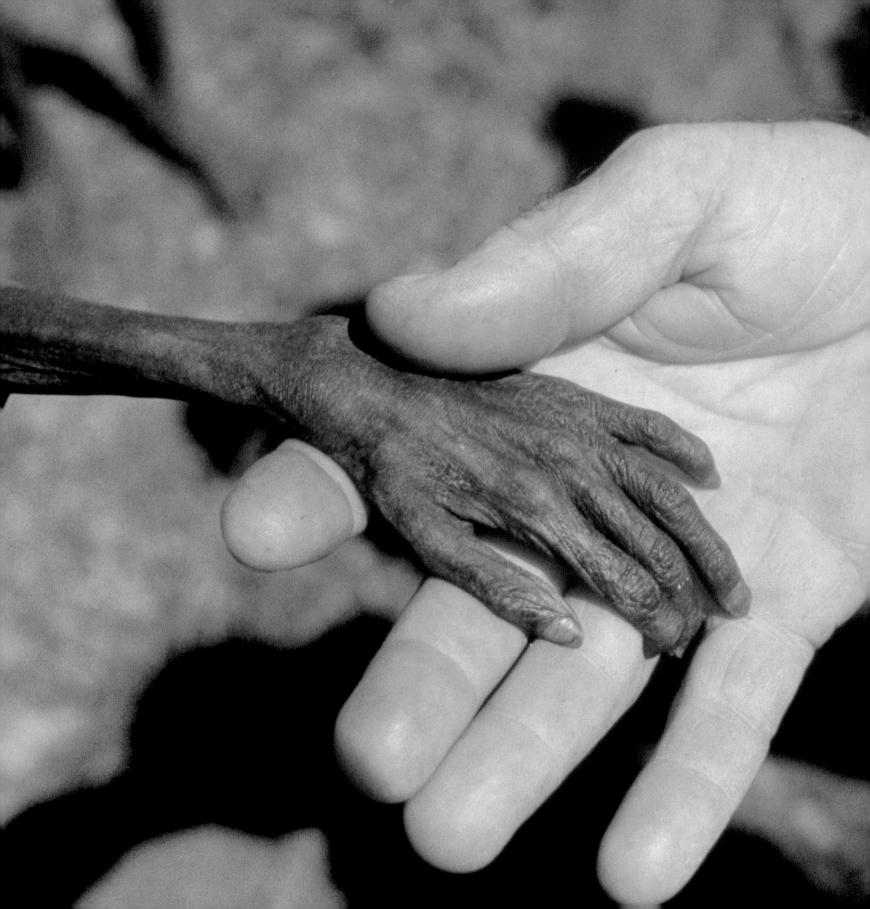

Hand MIKE WELLS October, 1980

Photographers and their public do not always agree. The World Press Photo contest named this disturbing picture "Photograph of the Year." The photographer wishes they hadn't.

In April, 1980, Mike Wells went with an aid group into northeastern Uganda to investigate rumors of a famine. At a Catholic mission in the Karamoja region, an Italian priest led Wells to the main gate, where some Karamojong stood waiting for what food might be given out. The priest beckoned a mother with children to come over, and speaking to Wells in Italian, seemed to say that the small amount of food they could give would not help this boy.

"He put the boy's hand in his," Wells recalls. "I reacted as we do by quickly taking pictures. I didn't think much of it. Just by chance the larger hand was white. But because it is, other people think the photograph has colonialist overtones. That's too bad, because eventually numberless local Africans were helping.

"Besides, I thought the picture was extremely corny. Hackneyed. A cliché. I still do. It's not in any sense a great picture. The lighting is not interesting. The composition is not interesting. I found the people's whole bodies more frightening and their faces more important. People should see the whole truth.

"I felt very useful in Uganda. The world did not yet know this famine existed. I am glad this picture helped make people notice. We photographers are only the medium. We take the pictures. Other people use them. I can't criticize people for liking this picture. I just wish they'd like others too."

Aborigines
RAY KENNEDY
September, 1985

When Australia's telephone company expanded its service into the outback, Ray Kennedy, who works for a Melbourne newspaper, hitched a ride up to Darwin, then hopped a light plane for an hour's flight to an aboriginal mission at Daly River. There he persuaded someone in charge to ask Jimmy Numbatu and Jacob Miler to put on their traditional dress and pose in a new phone booth.

Most photographers in developed countries do not take pictures that rely on a condescending view of a minority. Australian society, however, is still adolescent enough for this scene to be considered a step up from tossing dwarfs about the barroom (a popular sport in the same year).

On the other hand, as Kennedy points out, when he was through, Numbatu and Miler simply walked back off into the bush, making it not all that clear who the so-called primitives are.

3-D Movies J.R. EYERMAN December 15, 1952

By all accounts this picture is better than the picture they were watching. Polaroid lenses in their glasses kept the left eye from seeing exactly what the right eye saw. Thus a lion in *Bwana Devil* could seem to leap out of the screen in three full dimensions. With an audience that looked like this, that would take a brave cat.

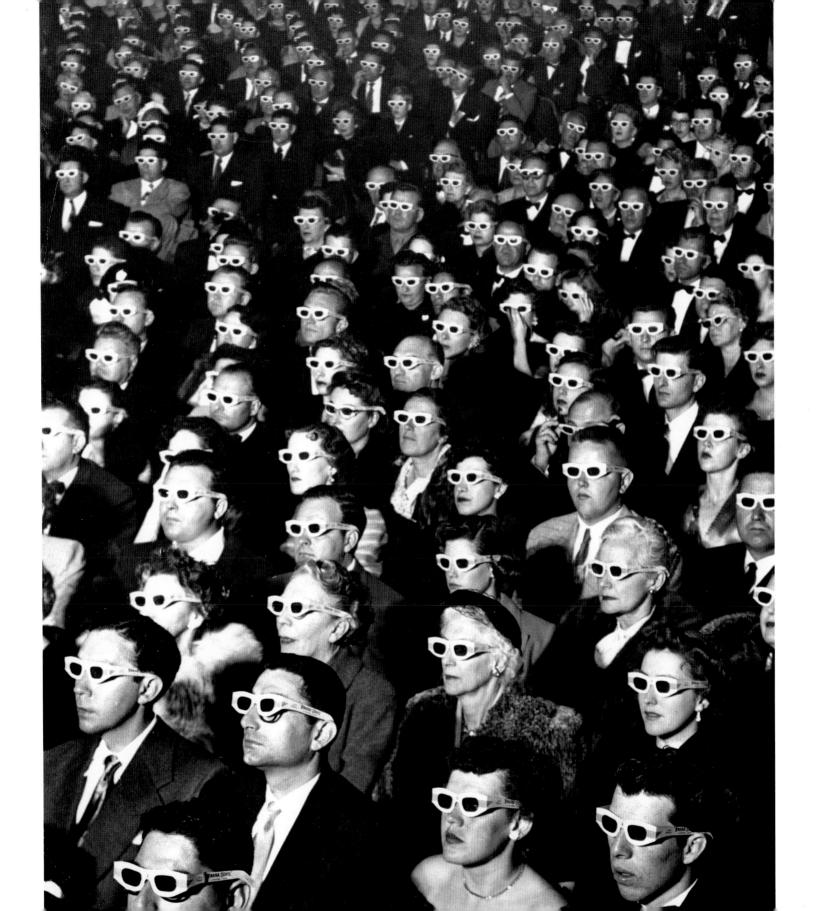

Mike and Rat MARY ELLEN MARK July, 1983

'd been seeing Mike and Rat for almost a week while doing a story on runaway kids living on the streets in Seattle. Late one afternoon 17-year-old Mike pulled out a gun. I did not know they had one. He and Rat, who was 16, started showing off and playing around. They even tossed the gun up in the air, at one point, and missed the catch so it fell in the street.

"I *had* to take pictures showing them with their weapon because seeing it brought the story to a much more serious level.

"I didn't think it was loaded, and I didn't think they would hurt anyone. Still, I was scared. If a cop came by, we'd all be in trouble.

"Finally I said, 'Please, put the gun away.' When Mike put it back under his jacket, it seemed to stop being their toy. I felt a heavy sense of their own paranoia fall over the scene."

Matisse HENRI CARTIER-BRESSON January 25, 1960

n 1943, Henri Cartier-Bresson escaped from a prisoner-of-war camp in Württemberg, Germany. He was no ordinary French soldier. At 35, Cartier-Bresson was already an internationally known photographer. The Museum of Modern Art in New York, fearing him dead, was about to plan a posthumous exhibit of his work.

A year later, he was living in Paris carrying false identity papers, when a publisher made contact and hired him to photograph several painters.

Henri Matisse was working peacefully in Vence, in the south of France, strangely remote from the war. Cartier-Bresson made no attempt to disturb this milieu in his photography of Matisse. "We must respect the atmosphere which surrounds the human being," he later wrote, "and integrate into the portrait the individual's habitat—for man, no less than animals, has his habitat."

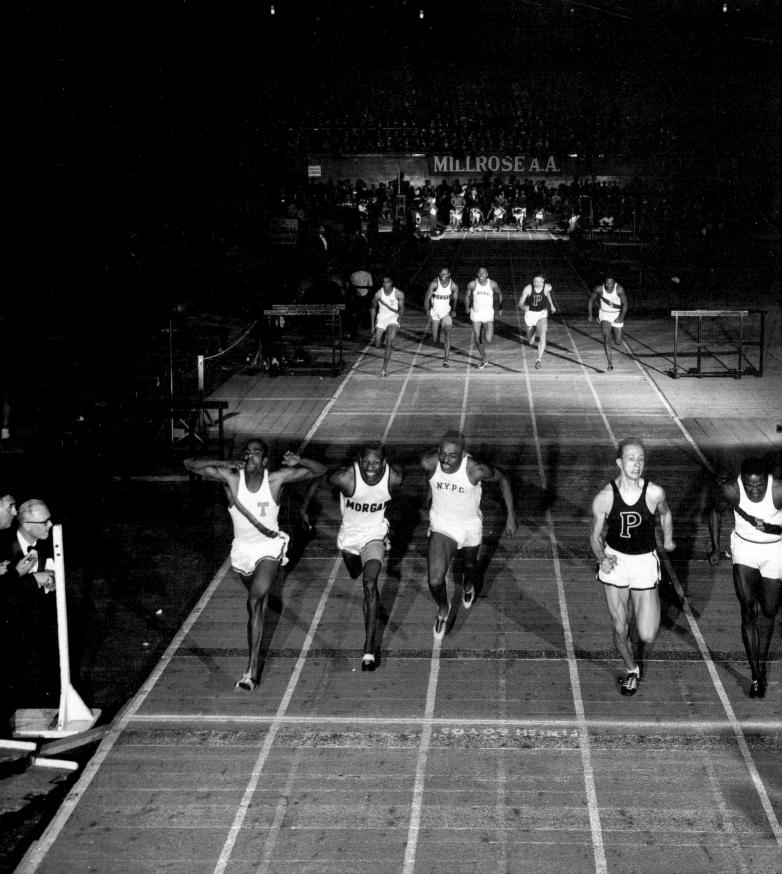

Bad Boy RALPH CRANE May 12, 1947

his boy, whom *Life* called Butch, had tried at age seven to set fire to the foster home in which he lived. As a result, he was sent to various institutions for emotionally disturbed children until he had the good fortune to end up in Seattle's Ryther Child Center.

When he was 13, Ralph Crane asked him to reenact scenes from his difficult childhood, as well as stages of his successful adjustment to society. Without showing the boy's face, Crane re-created dramatic highlights of Butch's story, including this naked dash for freedom down the corridors of a home for children five years before. That institution's authorities, intent on preventing a repetition of an earlier escape, had removed all of the eight-year-old boy's clothing.

The Millrose Games RALPH MORSE February 27, 1956

Showing the 60-yd. dash—start to finish—in one photograph sounds simple. Doing it is more elaborate. Ralph Morse had a steel platform built for himself and his camera and hung it 12 ft. off the ground on the wall below the box seats at New York's Madison Square Garden.

He connected a three-way switch (by running wire under the track) to each of three pairs of battery operated strobe lights—one pair at the start, one at the midpoint and one at the finish.

Morse opened his shutter and flipped his switch three times during the 6.2 sec. it took John Haines of Pennsylvania to win. The brevity of the race made the photograph possible, since the natural light in the arena barely registered on the film. If Morse had miscalculated this effect, the runners would have pieces of the track visible through their bodies.

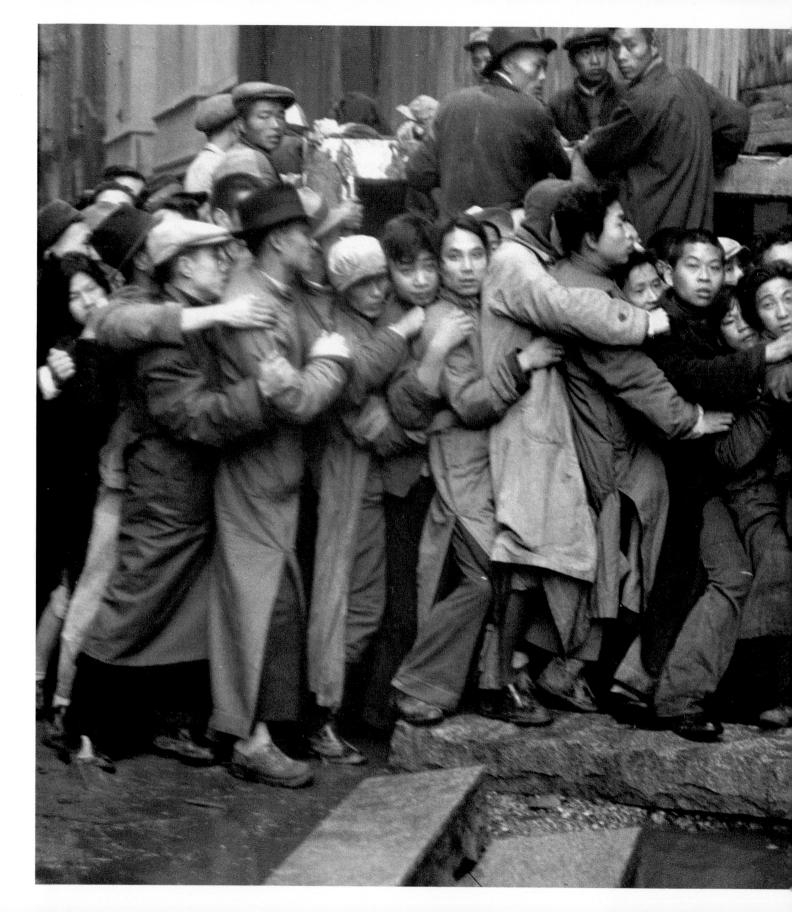

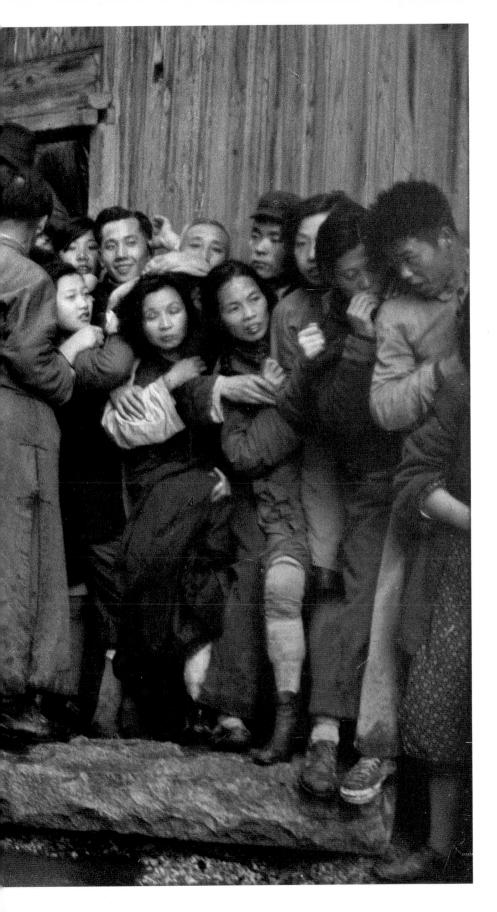

Bank in Shanghai HENRI CARTIER-BRESSON January 17, 1949

he facts are that in an effort to deny rumors of its defeat, China's Nationalist government offered to redeem paper currency with gold for half the black-market rate at four banks on the riverfront in Shanghai. The first day, after seven people were trampled to death in the crush, the offer was rescinded.

"An event is so rich in possibilities that you hover around while it develops," says Cartier-Bresson of reportin. "You hunt for the solution. Sometimes you find it in the fraction of a second, sometimes it takes hours, or even days. There is no standard solution, no recipe; you must be alert, as in a game of tennis."

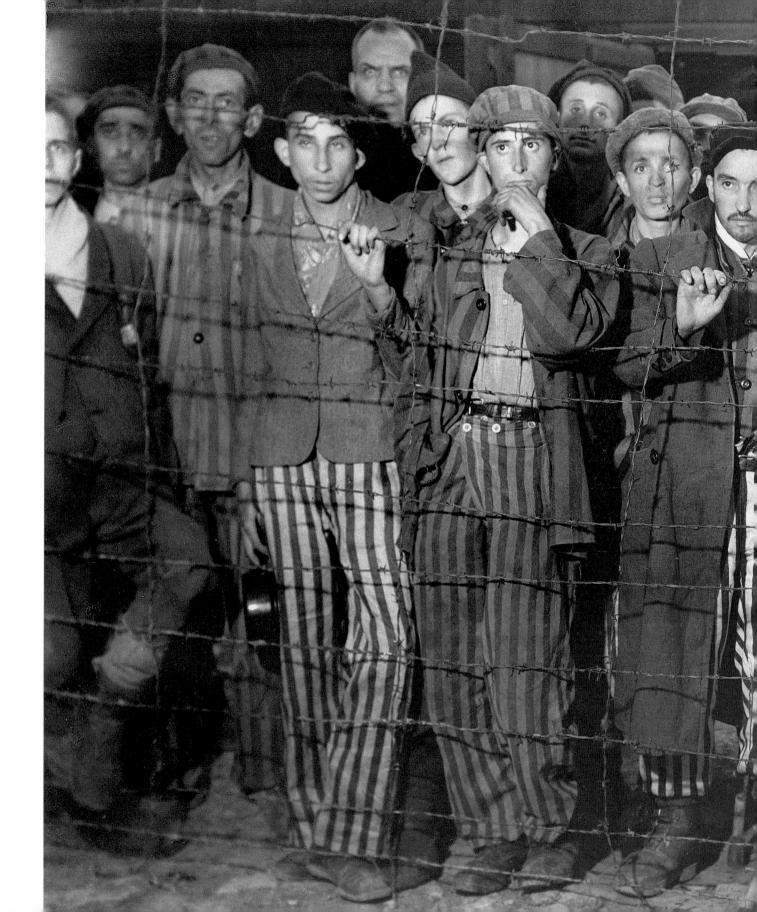

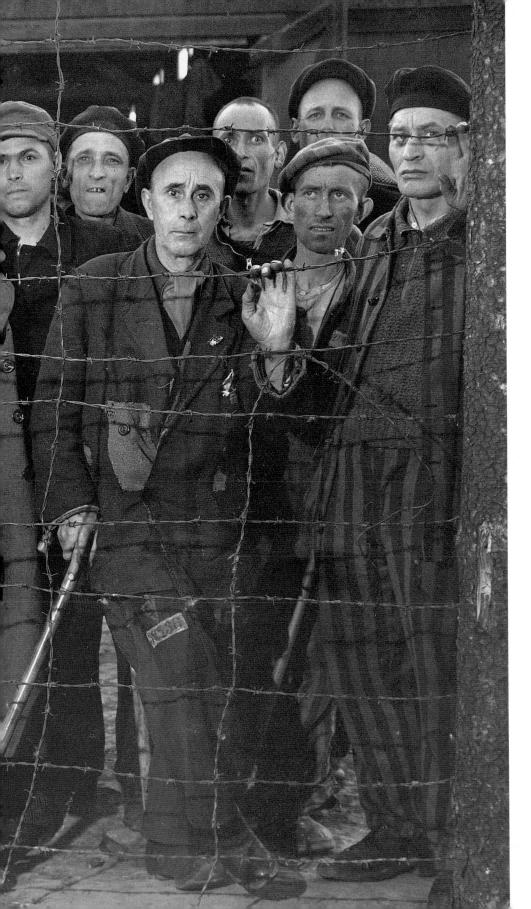

Buchenwald MARGARET BOURKE-WHITE

December 26, 1960

n 1945 General Patton's Third Army swept through Weimar, Germany, liberating the Buchenwald concentration camp. "Using the camera was almost a relief. It interposed a slight barrier between myself and the horror in front of me," wrote Margaret Bourke-White.

Two of her photographs taken that day were published as part of *Life's* sole picture story on the discovery of the German death camps. "I have to work with a veil over my mind. In photographing the murder camp, the protective veil was so tightly drawn that I hardly knew what I had taken until I saw prints of my own photographs."

This one was not published in the magazine until 1960, in an issue celebrating *Life's* 25th anniversary. It is now considered to be one of Bourke-White's most memorable.

Mother and Child ELLIOTT ERWITT February 14, 1955

Like any proud father with a six-day-old first child, Elliott Erwitt took pictures. "What's surprising," he notes, "is that usually when there's a good situation, you work at it for a few frames to be sure you have it right. But this picture is quite different from the other pictures on the roll.

"I entered it into a big contest at *Popular Photography* magazine. They told me it had won something, but they would not say which prize unless, like every other winner, I signed over all rights to the picture. I was four months out of the Army, and just starting as a photographer in New York, but I said, 'No way!'

"Edward Steichen picked it for the *Family* of *Man* exhibit at the Museum of Modern Art a year later, and since then it's been used so many times in magazines and advertisements, I'm certain it has paid for Ellen's college education."

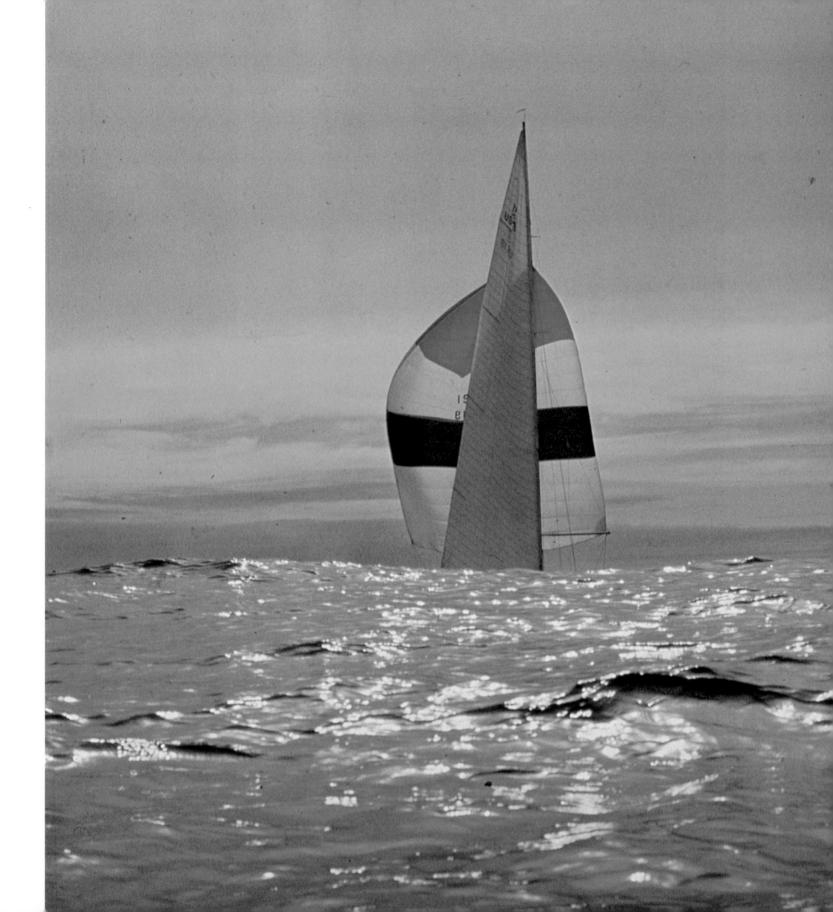

Nefertiti GEORGE SILK August 24, 1962

really wanted the viewer to be involved in sailing a boat, rather than looking at a scene," George Silk explains. Silk specialized in sports pictures during the early 1960s, trying to find new ways to photograph familiar stories, like one on the four contenders for the America's Cup.

"Nefertiti's spinnaker rising above a swell may be the first yacht picture ever published in which you can't see any of the boat. After the story ran, an admiring reader wrote, 'The feel of the sails, the wet salt spray... how could this be contained on the printed page?' I knew then that I really had done it!"

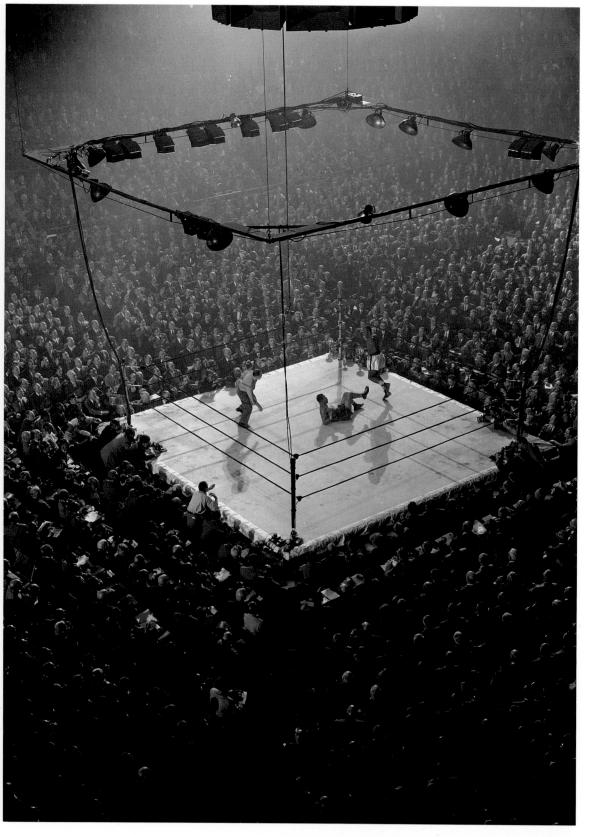

The Louis-Walcott Fight GJON MILI December 15, 1947

Gion Mili came from Albania by way of Ruma (where he grew up) to Boston (where he gra ated from the Massachusetts Institute of Technolog and became a lighting engineer at Westinghouse. Years later, in 1937, he heard Professor Harold Edgerton lecture about a new stroboscopic lathat produced a flash lasting only 1/100,000th a second. It was bright enough to use to to pictures.

Mili borrowed some lights from Profes Edgerton and became a professional photograp His technical knowledge allowed him to use th strobe lights to photograph sports, the theater a dance in ways that had not been possible befo

Mili often used his lights to carve pictu from the dark, highlighting the edges of his so jects to emphasize their volume. The sense of dra in this scene at New York's Yankee Stadium wo be the same no matter who was hitting whom

In fact, Mili was there to cover Joe Louis, great heavyweight, defending his title agains then undistinguished fighter, Jersey Joe Walcott. 'I crowd was astonished when Walcott knocked Lo down in the first round and again in the four which is the moment Mili caught. Although Lo got up to finish 15 rounds and win on point experts in the crowd felt it was the beginning the end of a legendary career. At 33, Louis already being edged out of the limelight.

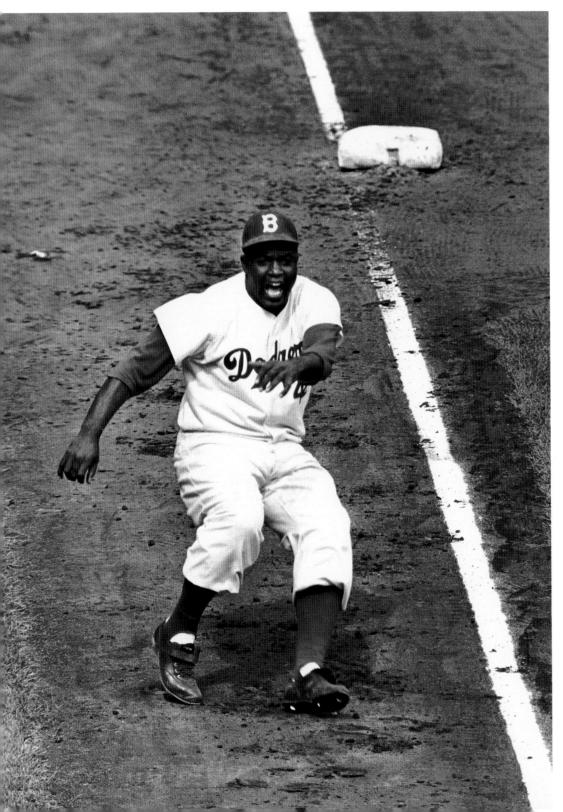

Jackie Robinson RALPH MORSE Bicentennial Issue, 1975

A musician is not the only person who can operate like a one-man band. When the Yankees faced the Dodgers in the 1955 World Series, Ralph Morse sat in the photographers' booth at Ebbets Field in Brooklyn.

In his hand he held a camera with a long lens ready to take pictures of action in the outfield and at first and second base. Under Morse's foot was a switch that operated a second camera aimed down the third base line.

The Dodgers were behind by two runs in an early inning. Yankee catcher Yogi Berra told pitcher Whitey Ford to ignore Jackie Robinson, who was on third base, threatening to steal home. Berra felt Robinson wouldn't take the risk of stealing home with the potential tying run at bat.

Ever since Robinson in 1947 had become the first black to play in major league baseball, his record for stealing bases made every pitcher nervous.

On third, he took a lead off the bag. He feinted. He faked. He shouted. All of which Morse caught. (After this picture was taken, Robinson made his run, sliding under Berra's mitt before Ford's pitch reached the plate.)

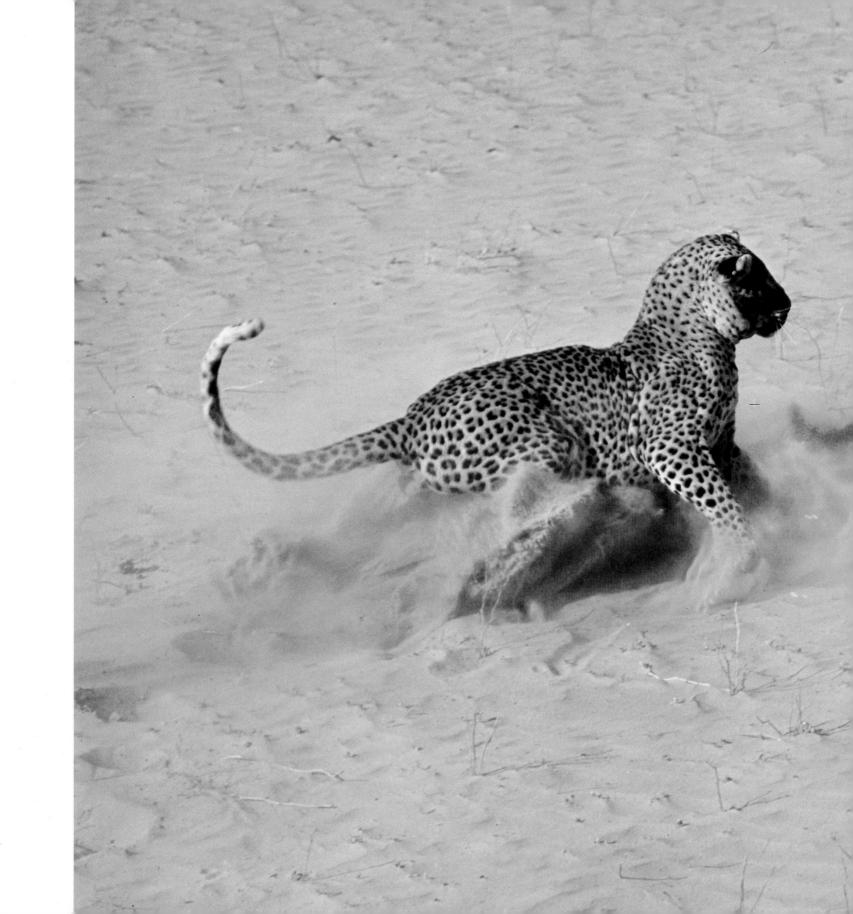

Leopard and Baboon JOHN DOMINIS January 6, 1967

Originally John Dominis was going to spend a year photographing "The Cats of the World," but after he had spent three months in Africa just photographing the leopard, he phoned New York and suggested that "The Cats of Africa" might be enough. *Life* agreed.

Dominis wanted a story that would document the life-style of each breed of cat. Before he left New York, editors had put him in touch with a hunter in Botswana who had a captive leopard. It was not tame (indeed, it had attacked the man's daughter just before Dominis arrived), but it could be set free to roam. Water being scarce in the region, a dish of it placed in his cage in the rear of a truck would bring him back.

The intent was to let the leopard loose in an area rich in antelope. The area also turned out to have a large baboon population, and the leopard did what it would do naturally. So did Dominis, capturing the fearsome and unequal confrontation between the two beasts.

Which raises questions. Is the picture "faked"? Hardly, from the baboon's point of view, or the leopard's. The photograph is extraordinary in showing the natural movements of two animals at the climax of their mortal confrontation. Of course, man, not nature, put them in proximity and this action killed a baboon.

Is it wrong for an animal to die for a picture? I don't know. At any rate there was nothing Dominis could do to prevent it. What's important is not the beauty of the photograph, but that the photograph deftly captures the terrible beauty of the natural world.

Pearl Harbor

Bicentennial Issue, 1975

print was pinned on the wall of a photoengraving shop at the Imperial Naval Base in Yokohama, Japan, in 1945. A young American sailor saw it, and thought it worth copying. Using the shop's camera, he took his picture on a glass plate about ten by eleven inches. The copy faithfully records all the creases and crumples of the original print.

The photograph had been taken by a robot camera in the wing of a Japanese plane arriving over Honolulu early on the morning of December 7, 1941. It shows several American battleships moored at their piers in Pearl Harbor. Another Japanese plane has dropped a bomb and banked sharply to the right. A geyser of water appears in the bay. No smoke is billowing yet from the ships. Nothing is burning on the land. There is no evidence of opposition. The United States had been living under the illusion that it could remain isolated from world affairs.

Photographs taken later that day through dense black smoke show listing battleships, burning airplanes and anguished hurrying figures. In those photographs, the holocaust on the ground looks terrible and real. From the air, at the start, the scene is as abstract as a modern painting and has the flat perspective of a Japanese print.

The picture appeared in *Life* in 1975 as part of an issue describing 100 events that shaped America, but it was not the first time the picture had been seen in the West. The sailor who photographed the Yokohama print and brought the plate home saw it published by newspapers and magazines in 1946 as a war souvenir. Then interest in it died, as it had in 1942 when other prints had found their way to New York, presumably through neutral embassies in Tokyo and Berlin.

Those prints arrived four months after the event. *Time* magazine published an unwrinkled version in April, and *Life* used a tightly cropped one copied from a German magazine in July. But they were cool and abstract compared to the emotionally searing photographs that had already been seen, and their record of the very moment when the United States was swept into World War II was soon forgotten.

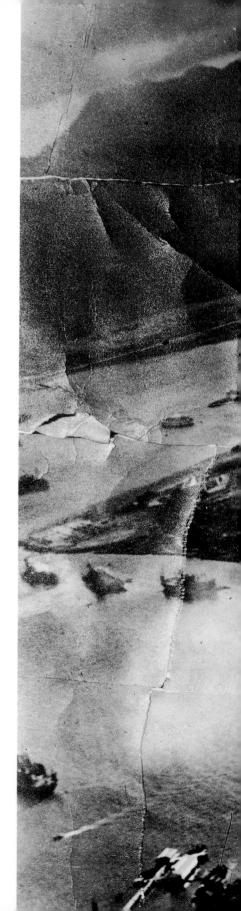

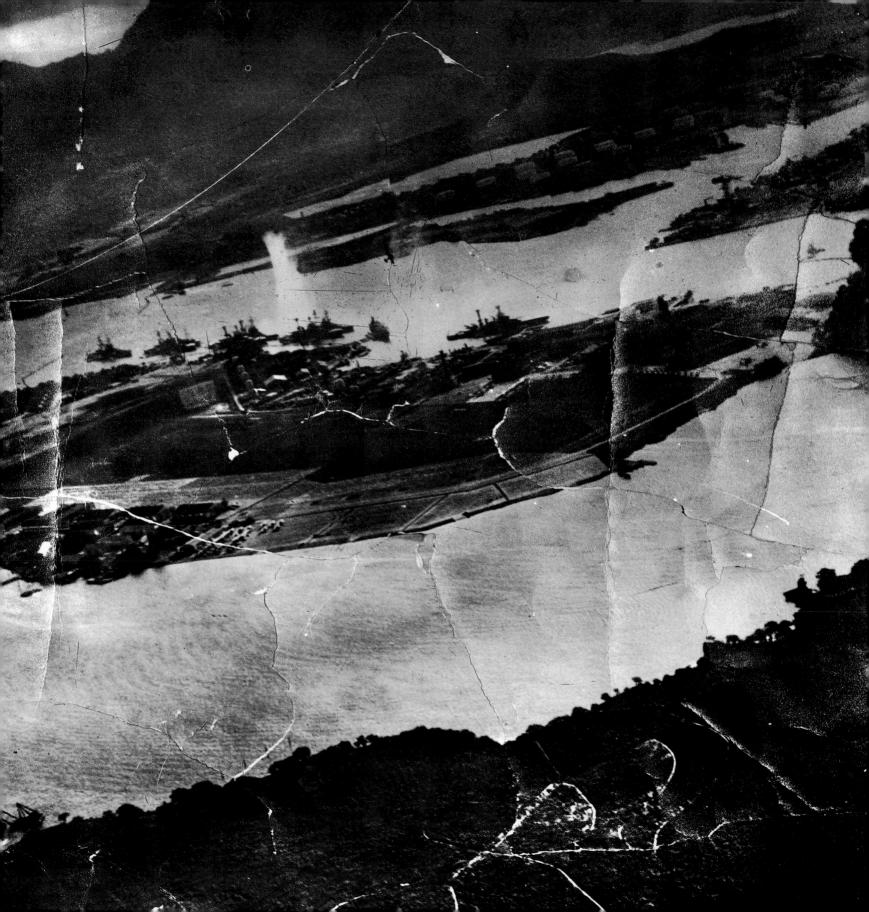

Piano Recital YALE JOEL June 29, 1962

very small fact can spark a story. In 1961 more Americans bought pianos than in any year since 1927. *Life* looked for a typical piano teacher and found Mrs. Edith Davis, who had taught children in Manchester, Iowa, for 50 years.

Yale Joel spent a week with Mrs. Davis in the early winter photographing her classes. A student recital was to take place at the end of his stay, and he knew that this small-town ritual, with its formality and tension, could make a good picture. The problem, however, was that Mrs. Davis' living room was small. Her grand piano pretty much filled it, and the room would be even more crowded with an audience.

Joel figured he could stand outside and photograph through the living room's picture window. The problem there was that he and his camera's shutter would freeze in temperatures that might be as low as -20° . So he had a carpenter build a plywood lean-to against the window. In this shelter Joel made himself comfortable with an electric heater and his 4x5 in. camera on a tripod.

Inside the house Joel had aimed a few floodlights at the ceiling to make the room brighter than normal so his exposure would not have to be longer than half a second. From the outside he could barely hear nine-year-old Jimmy Childs play Brahms' *Lullaby*, but he could see what he cared about—that the attentive audience was not fidgeting during his long exposure.

"We all dream as photographers of merging into the woodwork and not being seen or noticed by an audience," says Joel. "In this case I actually merged into the plywood."

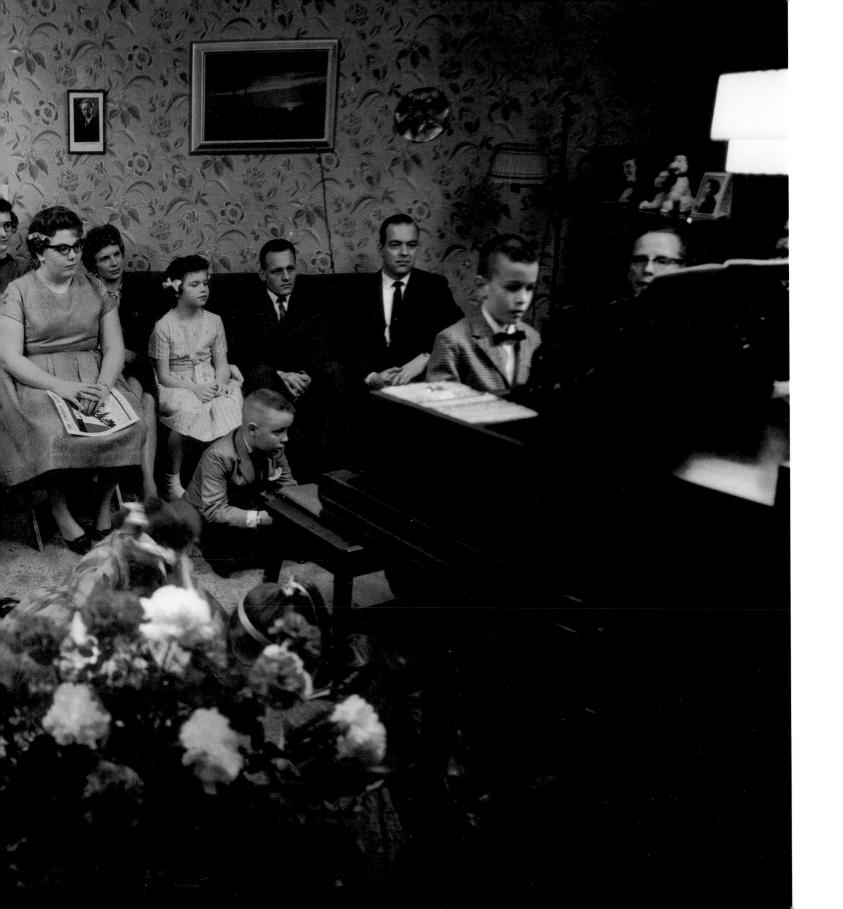

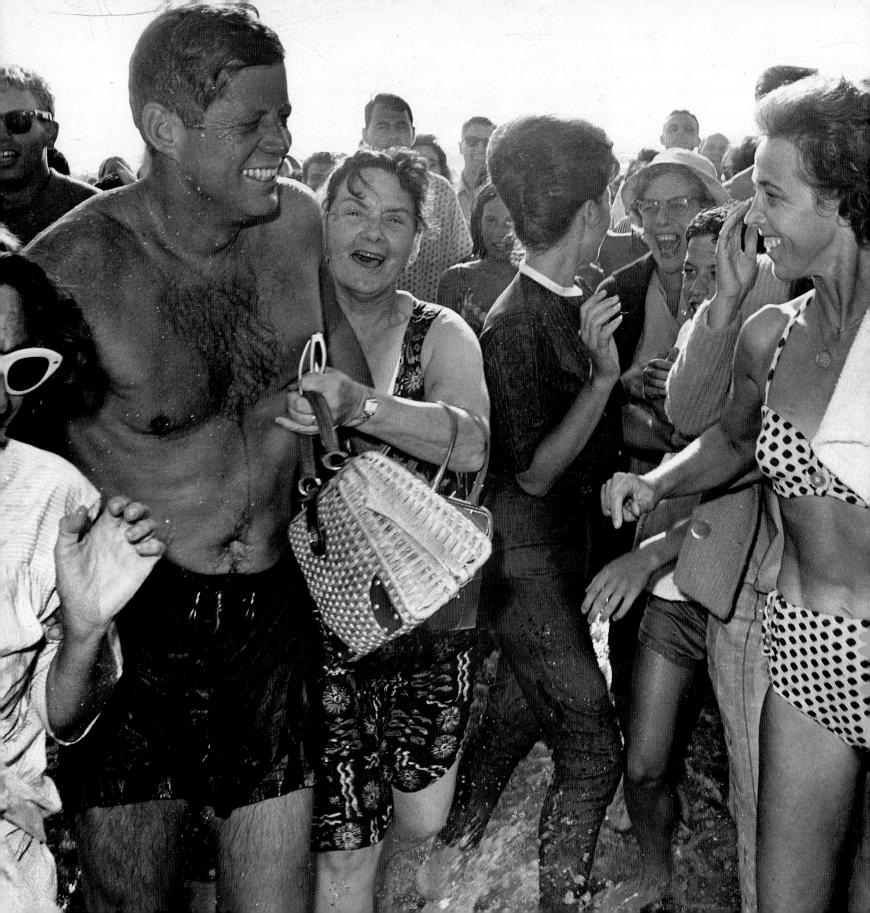

The President's Swim
BILL BEEBE
August 31, 1962

remember this scene well, because I wasn't there. While his wife was on a vacation in Italy, President John Kennedy took a long weekend "nonpolitical" trip west, inaugurating a dam in South Dakota and a reservoir in California and enjoying himself. I was assigned for "drop-dead" coverage—that is, no one expected to be interested in seeing any of my pictures unless something unpleasant happened.

After church Sunday in Beverly Hills, the White House assured us that nothing more would take place in public before the President went back to Washington. I was due to start another story in the west, so I checked with New York and got their O.K. to leave. Smarter heads, like Bill Beebe of the Los Angeles *Times*, staked out the Santa Monica beach house belonging to the President's sister Patricia Lawford. Sure enough, the little devil went out there for an unannounced swim. "Nothing public happening"—ha!

John F. Kennedy CORNELL CAPA November, 1983

Ornell Capa, I think, uses a camera as a journalist should. His aim is to make the reader see this fact and that fact. He does not fill his picture with rhythms and relationships that please only the eye. Of course, Capa's pictures might be boring and simpleminded, except that the facts that intrigue Capa's mind are subtle and significant.

It was his idea to produce a visual history of the first 100 days of John Kennedy's Administration. The President permitted him access.

Kneeling down in the Cabinet room behind a chair, Capa noticed two things: first, that the chairs have labels, presumably so that no one sits in the wrong one. And second, that this chair has the right occupant. We know that by the hair we see, which at the time was a striking and youthful contrast to his predecessor's bald pate.

MacArthur CARL MYDANS February 19, 1945

photographer may be part of the story he covers. While photographing Americans defending the Philippines in 1942, Carl Mydans was captured by the Japanese. First held in Santo Tomás prison in Manila, he heard rumors that General Douglas MacArthur had escaped to Australia. Later, through the prison grapevine, he heard of MacArthur's famous promise, "I shall return."

Mydans was part of an exchange of diplomatic and civilian prisoners in late 1943. Soon he was back covering the war in Italy and the south of France for *Life*. In 1944 a wire from New York urged him to return to the Pacific. He did so at once, but missed MacArthur's return to Leyte in the southern Philippine islands. Another photographer recorded the general's wade to the shore and flashed the picture around the world.

A few weeks later Mydans drew the lucky slip from a helmet, winning the chance to accompany MacArthur on the cruiser *Boise* during the landing on the main island of Luzon.

At 2:30 on the afternoon of January 9, 1945, Mydans came in to the freshly liberated Lingayen beach with MacArthur on the general's landing craft. He leaped off as soon as the boat touched the pontoon landing pier already in place awaiting the general. Then Mydans had to race a couple of hundred yards down the beach as, at MacArthur's orders, the landing craft suddenly backed away from the pier and came in instead at a less well prepared spot where MacArthur could yet again get his feet wet for cameras and for history.

It was MacArthur's second landing in the Philippines, but for Mydans it was the one that counted. He joined in the emotional liberation of 3,700 emaciated prisoners at his own prison camp, Santo Tomás. Someone cried out joyfully, "My God! It's Carl Mydans!" That call, with its recognition of their shared imprisonment, was glorious confirmation that they had lived to see the whispered rumors of three years before come true.

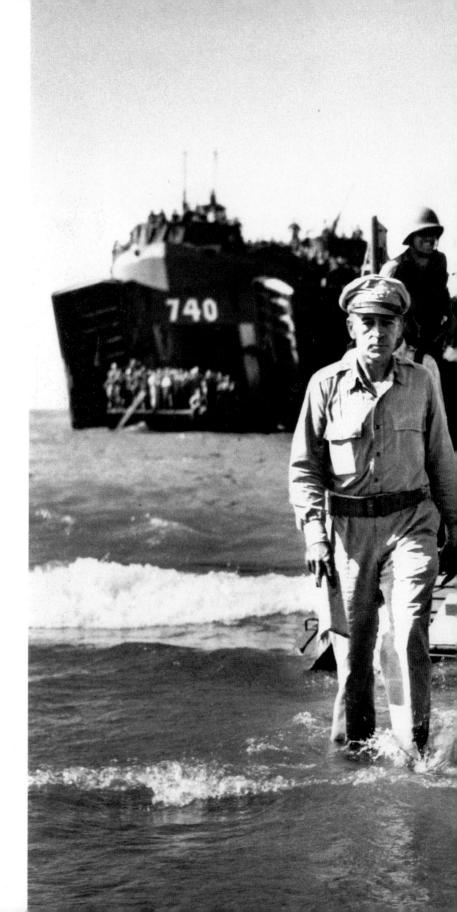

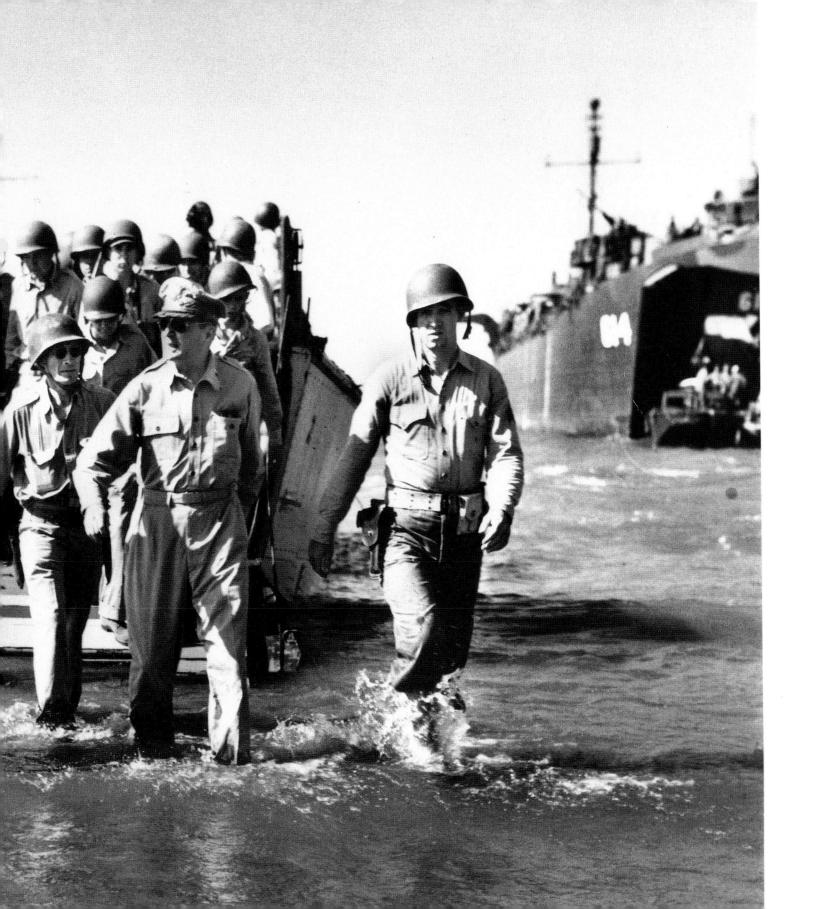

Andrea Doria LOOMIS DEAN August 6, 1956

On the first night out of New York aboard the *lle de France,* Loomis Dean had a drink with his friend Andrew Heiskell, then *Life's* publisher. Dean was excited by his first trip on an ocean liner, as well as the fact that he was moving from *Life's* Los Angeles bureau to one in Paris. Heiskell was starting his vacation.

Dean put his three children to bed right after dinner, and feeling tired from the busy day, turned in early himself.

About 1:30 in the morning Heiskell was awakened by an odd silence. The ship's engines had stopped. A half mile away he saw another liner, the *Andrea Doria*, lit by floodlights and listing badly. Heiskell woke Dean, saying, "Loomis, it looks like there's a shipwreck out there. Maybe we ought to do something."

Two hours earlier, in a dense fog off Nantucket Island, the *Andrea Doria* had been rammed and almost cut in two by the Swedish liner *Stockholm* (the *Stockholm*'s bow was specially reinforced to break through ice). More than a score of passengers and crew on the two ships were dead or missing.

The Andrea Doria's list prevented launching half its lifeboats. The *lle de France* sent its boats over to help, and Dean photographed the survivors as they came on board. Just before dawn, with his camera on a tripod, he had enough light to record the full sweep of the scene as lifeboats from both ships ferried the remaining passengers and crew across the water.

The Andrea Doria sank a few hours later. The *Ile de France* returned to New York with the survivors. Within a year, jet airplane service started across the Atlantic and quickly put an end to the reign of the ocean liner.

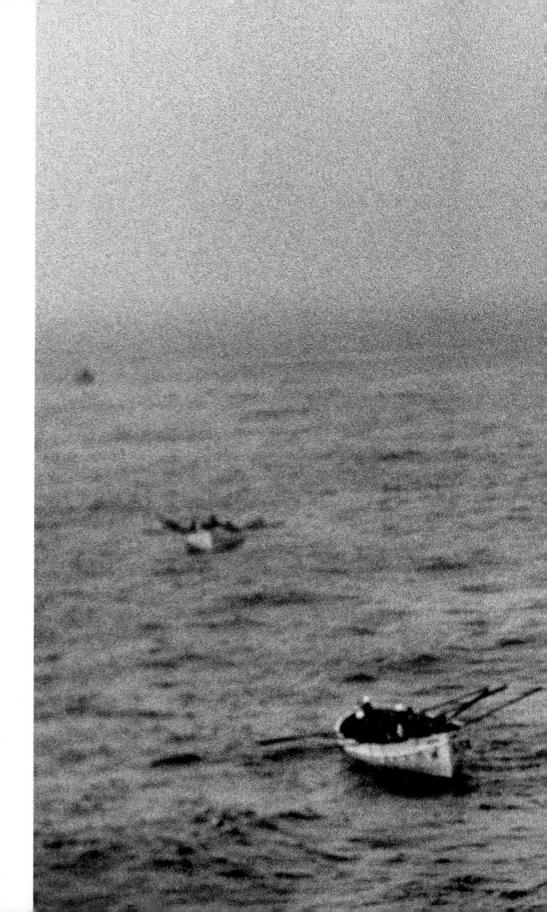

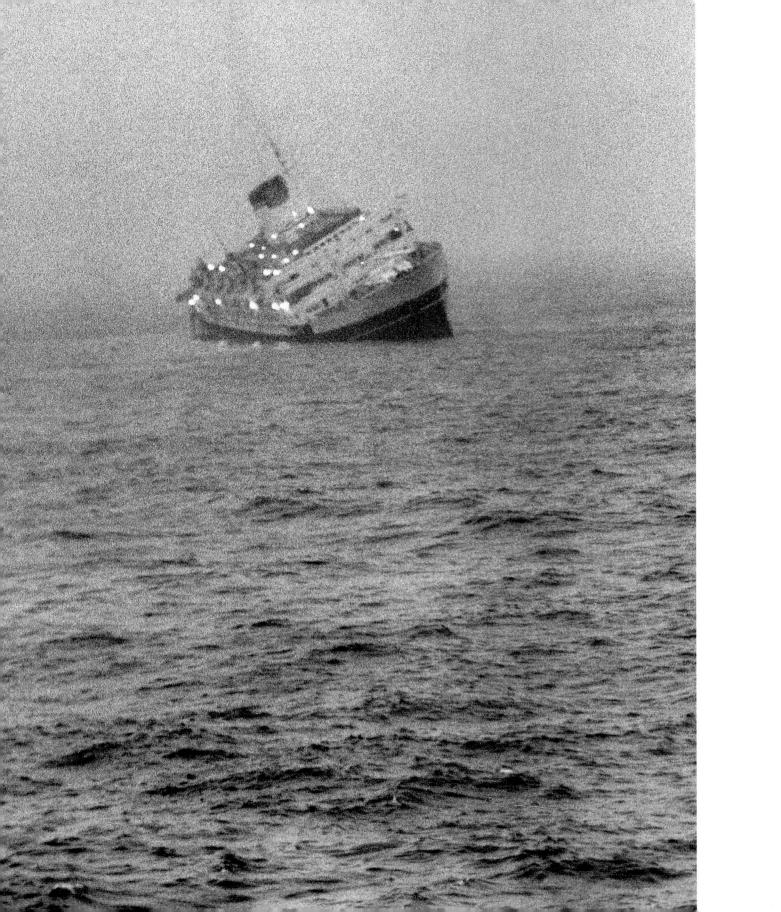

Farm Lawyer GREY VILLET November, 1982

Finding a focus is crucial in a story about a large, abstract topic. The farm crisis deepened in the early 1980s as prices for farmland collapsed. Grey Villet focused his story on Sarah Vogel, a lawyer who left her career with the Treasury Department in Washington to come home to try to help farmers facing bankruptcy.

Though telling her personal story, Villet wanted to open his essay on a larger note. An opening picture should announce the subject and set the tone for what follows. Villet thought that one of the decaying buildings in the area might play a part in a symbolic picture, but it was not until the lawyer talked with a couple on a farm in Wing, North Dakota, that he found the sinking feeling of abandonment he needed.

Kenny LYNN JOHNSON February, 1984

A good rule of thumb in journalism is to avoid doing stories on subjects that the reader can only pity. Lynn Johnson spotted ten-year-old Kenny Easterday skateboarding along the sidewalk with his family in Aliquippa, Pennsylvania. She stopped her car and went over to talk.

Kenny felt he was anyone's equal. He was born with the base of his spine unformed and his legs not properly connected to his torso. Before he was three he endured a series of operations in which his legs were amputated and their bones used to finish his spine. Living with his loving family, including an older brother and sister, Kenny learned to walk on his hands as well as use a 10-lb. set of artificial legs. Moreover, a neighbor had given him a skateboard when he was eight, and it was his skill and dexterity on that that let him move throughout his neighborhood with an astonishing display of agility.

Johnson spent several months photographing Kenny and his relationships with the people around him, especially his mother, who rarely tried to give her son unneeded help. "He rides that board from one end of town to another," she said. "It worries me, but I have to let him go."

High School MICHAEL O'BRIEN March, 1981

Sometimes a photograph must be read the way an Indian scout follows a trail looking for tiny signs. The boy's two legs, for example. The woman's hands and the turn of her head. The turn of his.

Some photographers have the patience to wait, camera poised, for the drop of an eyelash or the turn of a foot that describes a subject's emotional state.

The lockers on the side of the wide corridor and the high sheen of wax on the floor suggest the setting is a school. The boy's load of books confirms this. We sense that he's suddenly changed his pace. Maybe, guilty, he wants to change his direction. She seems surprised, as if the sight of him requires her to take some unpleasant action.

We see very little of this confrontation between a hall monitor and a student in a strict Chicago high school, but we know a great deal. Small gestures have made clear two states of mind.

Old Woman

ABIGAIL HEYMAN

One Day in the Life of America, 1974

Abigail Heyman went to the Masonic Home and Hospital in Wallingford, Connecticut. "I was moved very deeply," says Heyman. "It was the first time I'd visited a psychiatric ward. Kate Barton struck me as a symbol of many of us who, in old age, will return to earlier stages of our lives."

Inner Mongolia EVE ARNOLD October, 1980

nce a year for ten years I applied to the Chinese embassy for a visa and every year heard nothing more," recalls Eve Arnold. "Three days after diplomatic relations were re-established with the United States in 1979, I had a visa. Five days later I was in China.

"Oh! To be there then—to be an American and a photographer and a woman was heaven! Everybody welcomed me. Because of my age, they respected me. I went everywhere.

"In Inner Mongolia the Golden River White Horse Company knew that a girl with a rifle could not stop a tank. When I saw the beautiful horses that they trained to lie so still they could shoot over them, it seemed like a romantic fairy tale from another age.

"It's really psychological training. They keep themselves prepared for what might 'come from the north'—the frigid winds from Siberia or soldiers.

"Still, I think this scene remains more understandable in a culture where language is pictorial, the ideogram represents the word, and the epigram takes the place of long-winded explanation."

Caroline Kennedy HARRY BENSON September, 1986

he wedding of President John Kennedy's only daughter was closed to the press, with one exception: Harry Benson, a photographer whose father was the founder of the zoo in Glasgow, Scotland.

Benson came to the United States in 1964 along with the Beatles, covering them for the London *Daily Express*. By 1972 he was ready to join *Life's* staff when, suddenly, the magazine suspended weekly publication.

Twelve years later *Life* wrote to the children of former Presidents asking them to pose for Benson, who by then was an important contributor to the monthly *Life*. All the children in good health agreed, including Grover Cleveland's son and Caroline and John Kennedy. Neither Kennedy had posed formally for the press since leaving the White House. Benson's portrait of them together was used on *Life's* cover.

Two years later the young Miss Kennedy, buoyed by their earlier collaboration, asked Benson if he would take her wedding pictures. He was honored, he replied, but he was really a journalist. If he covered the wedding, some of the pictures would have to be available to *Life*. She agreed.

Benson and his assistant Jon Delano worked all day and into the night. The lovely bride got a thick album of pictures. *Life* got an exclusive story. The bride's mother pointed out that this picture (caught on the fly as the bride moved up from a picture session on the beach) might make a smashing cover.

It did, but then Jacqueline Onassis ought to know. She has been on *Life's* cover 19 times herself. It was the fourth time for her daughter, and the 48th for someone in the Kennedy family.

Roger Gardiner GREGORY HEISLER November, 1981

Rick Smolan was the last and youngest photographer I hired to work on the *Life* issue "One Day in the Life of America" in 1974. Seven years later Smolan orchestrated the same kind of project in Australia. As we had done, he invited 100 photographers to take pictures on the same day.

At 12 midnight as the day began, New York photographer Gregory Heisler found himself in a rough-and-ready Quonset canteen on the railroad line up from Port Hedland in northwest Australia. "This little guy walked in who looked like he'd been dipped in a bucket of iron dust," says Heisler. "I finally worked my nerve up to ask him if he'd pose for a picture. I was afraid he might knock my teeth in.

"At that time he was making good money taking core samples to search for iron ore. Otherwise he lived in Sydney and worked as a movie cameraman. When the book *A Day in the Life of Australia* came out, he came to the book-launching party all cleaned up, which disappointed the women on the staff—and some of the men too."

Hippy Family JOHN OLSON July 18, 1969

ohn Olson grew up in Wayzata, Minnesota, got a job in the mailroom of United Press International in New York hoping to become a photographer, and during the Vietnam war was drafted.

In the Army he became a photographer on *Stars and Stripes*, and the striking pictures he took of combat in Hué during the Tet offensive brought him to *Life's* attention. Four months later, at 21 years of age, he began to do assignments for *Life*, and by Christmas, after two years in Vietnam, he came home.

He soon found himself in a teepee at the Family of the Mystic Arts commune in Sunny Valley, Oregon, photographing Ron and Nancy Bray reading fairy tales to their children.

"The counterculture people in Oregon were obviously unlike the people in Vietnam, but I wasn't bothered by that. Which could be because I just straddled the picket fence the same way I've been doing all my life. But, also, I think there's a safety switch in photography which keeps us from being overly affected by different situations in which we find ourselves.

"What we are doing is photographing what takes place. The picture is what's real to us, and one picture, when we find it, relates to the others we have found before, even when the contexts they are part of are remarkably different."

Queen Elizabeth GEORG P. UEBEL May, 1982

Sometimes an event only *nearly* catastrophic fades quickly from our memory. In June,1981, a tourist in London photographed the Queen of England reviewing her troops. Some shots rang out. The Queen's horse shied. Police hurried into the crowd.

On his return home, the tourist developed his film and discovered this chilling scene. He promptly turned the picture, at their request, over to the British police, who used it to prosecute 17-year-old Marcus Sarjeant. The unemployed young man, seemingly inspired by the shootings of the Pope and President Reagan in recent weeks, and John Lennon a few months before, had fired only blanks. He was sentenced to five years in prison.

The picture, made public at his trial, did not attract attention in the United States. I suppose other editors felt the event had been forgotten—a misfired moment of minor note.

Maybe so. But the ominous possibility of a gun in the crowd is a constant threat to any public figure. What's significant here is that it is only by the grace of God that this picture does *not* show a bit of news so gripping that we remember exactly what we were doing when we heard it.

Joseph Goebbels ALFRED EISENSTAEDT November 29, 1954

The story has often been told. The Berlin free-lancer covering the League of Nations meeting in Geneva in 1933 approached Hitler's Propaganda Minister and took his photograph as he sat surrounded by aides. Joseph Goebbels appears malevolent—no more so, I suppose, than any public official with a clubfoot might feel, caught off guard by a photographer with a miniature camera.

It's not that his glare means that he wants to eat Eisenstaedt, but it's rare to see on the face of a high-ranking official such a look of naked displeasure. "Sit up straight and smile" are watchwords for politicians even in totalitarian states. Perhaps the Propaganda Minister's scowl reveals his character, his feelings about "inferior races" —Jews, Gypsies, Slavs, blacks, as well as the mentally retarded and the chronically ill. In fact, he seemed to despise most of mankind, except for his wife and children, but then he ended up killing his family too, by his own hand.

Buna Beach GEORGE STROCK September 20, 1943

hree American soldiers lie dead in the tide on a beach at Buna, New Guinea. They had chased a group of Japanese soldiers out of the jungle, past some destroyed Japanese landing craft, and toward a concealed machine-gun nest in the jungle behind the camera. It was thought that they died instantly.

More than a year and a half after Pearl Harbor, this was the first photograph of dead American soldiers released by Army censors. The release was authorized by President Roosevelt.

Life wrote a moving eulogy on the page facing George Strock's photograph to justify using it. Due to the temper of those times, similar care was not taken with photographs of German or Japanese dead.

Mark Spitz CO RENTMEESTER August 18, 1972

n 1960 Co Rentmeester, rowing for his native Holland, finished fifth in the finals of the Olympic double scull competition. Soon afterward, as planned, he was in Anderson, California, learning English and the lumber business. Someone saw some pictures Rentmeester had taken and suggested he might have the talent to become a professional. That suggestion was enough; four years later Rentmeester graduated from art school in Los Angeles with one *Life* cover already to his credit.

In 1972, to capture the intensity of Olympic swimmer Mark Spitz, Rentmeester used a Hulcher camera. Like a movie camera, the Hulcher uses long rolls of 35mm film and holds each frame motionless and flat against the film plane at the moment of exposure. It does this 30 to 40 times a second . . . However, unlike a movie camera, which takes slightly blurred images so that the 24 frames shown each second blend smoothly together in the eye, the Hulcher delivers each frame as sharp as it would be if taken with a conventional still camera.

Rentmeester waded into the pool, placing his camera at water level on the edge of the lane in which Spitz trained. Up this close, all that was needed was that Spitz take his breath in just the correct spot, keep his eyes open wide, and that no splash of water should obscure his face. If all this happened within the 6-in. range of focus dictated by the camera's high shutter speed, Rentmeester—at 40 frames per sec.—couldn't miss.

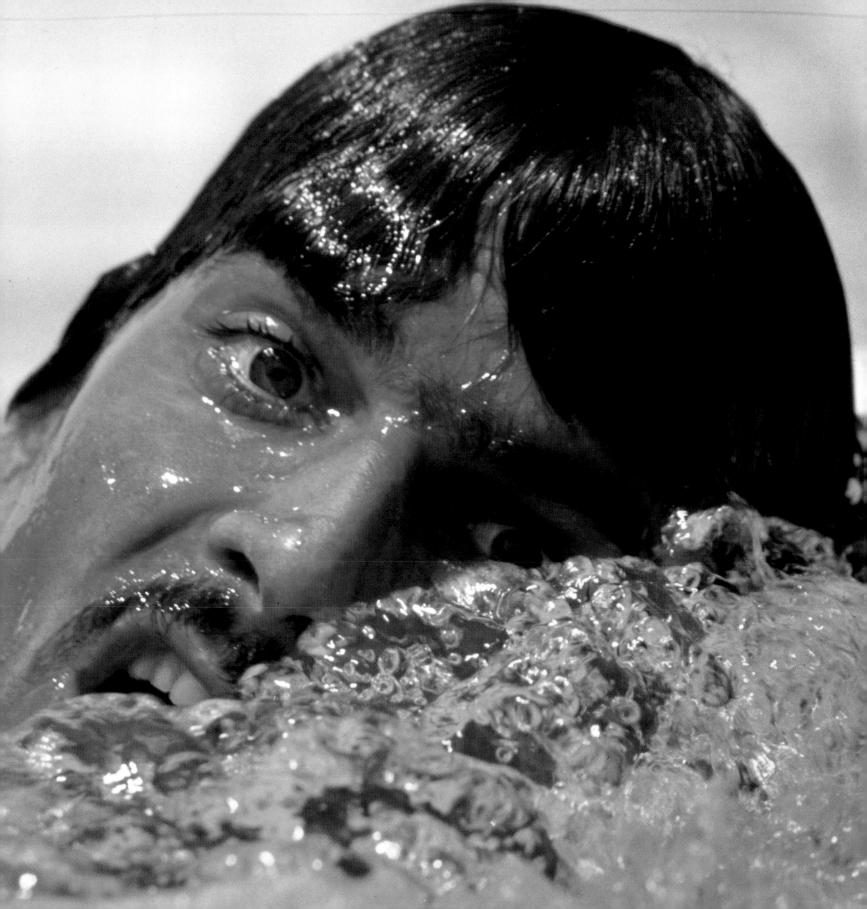

Madonna BRUCE WEBER December, 1986

Adonna Ciccone said she was excited by the thought of having Bruce Weber photograph her, and Weber said he was excited by the prospect of photographing Madonna, so it seemed a match made in heaven, or wherever picture editors operate. Weber wanted to photograph at a sleepy bar in SoHo near his loft, which itself is only a hubcap's roll from the entrance to the Holland Tunnel. Her people thought maybe it was a little more sleazy than sleepy for a star of Madonna's magnitude.

Weber prevailed, and Madonna loved it, as did her seven sisters and brothers. They squeezed together in a bit of a family reunion, one sister having flown in from Rio de Janeiro just for the occasion.

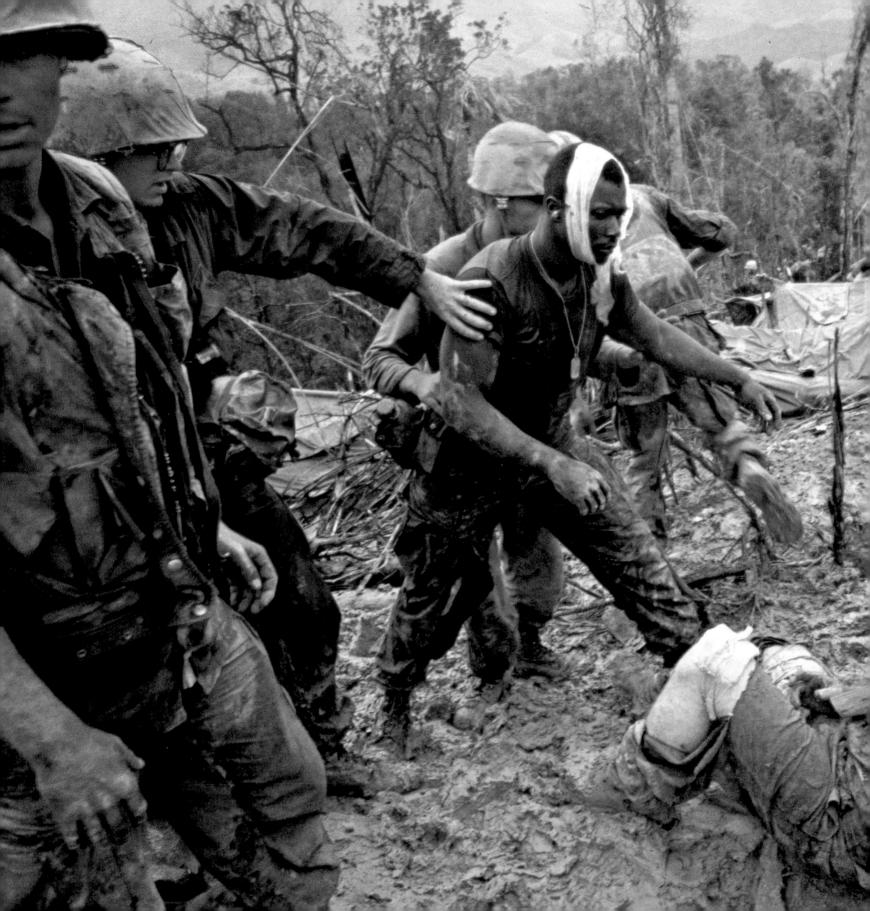

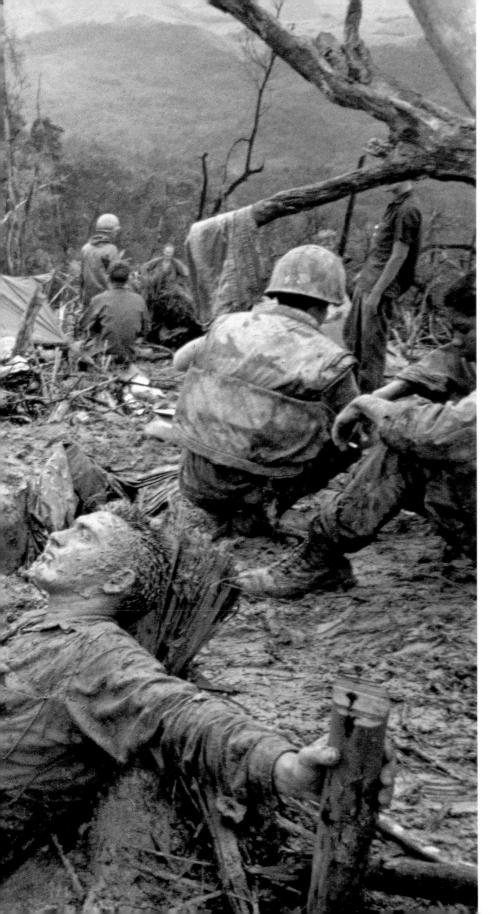

Vietnam LARRY BURROWS February 26, 1971

et's face it. Editors are not infallible. When Larry Burrows shipped his story of a firefight near the DMZ in Vietnam to New York, unprocessed, this picture was not published. A different, vertical frame taken a few moments before was paired effectively with a second Burrows photograph also taken during the battle for Hill 484.

Coming to the United States to give some lectures, Burrows went through his outtakes and put this photograph of Marine Gunnery Sergeant Jeremiah Purdie in a carousel of slides to show his audiences.

When Burrows was reported missing over Laos in 1971, his lecture slides were found in a credenza in the picture department.

The frame preferred by Burrows shows Purdie, who had been hit by shrapnel in the knee and behind his left ear, making his way past a wounded comrade to a helicopter. *Life* printed the photograph as part of its tribute to a very brave photographer. Since then, it has become the Burrows picture most often published.

Streaker IAN BRADSHAW Winter: 1975

t is curious that stills from motion pictures are not confused with stills from real life. A cinema gangster shot dead on a back lot is not confused with the real work of Al Capone.

If Ian Bradshaw had been directing a movie rather than covering a rugby game for the London *Daily Mirror*, he might have hired a few hundred extras to fill the stands and half a dozen experienced actors to play the police, the streaker and the huffing, puffing gent. Someone would think up the business about the policeman's hat. That's a nice touch.

Actually, Michael O'Brien, an Australian accountant, has just run naked past 50,000 fans at a rugby match in Twickenham. His action has caught everyone's attention. Their amusement seems spontaneous. The bobbies are as relaxed as the streaker is graceful.

Bradshaw's luck was threefold. First, he generally covers rugby by staying at one end of the field, using a long lens to focus on the players. His colleagues prefer to run along the sidelines, staying close to the action. The ball had been at the far end of the field as the half ended, which was when O'Brien made his run. Bradshaw was separated from the other photographers in an exclusive position. His lens compressed the apparent distance between the police, the streaker and the bustling gentleman. They are all moving toward Bradshaw as they hurry to an exit. That was Bradshaw's second bit of luck.

His third was that even though the policeman's helmet was bobbing up and down as they walked along, it covered the proper spot at the same moment that the flapping topcoat mimicked the streaker's languid limbs.

All this, combined with the focused hubbub in the stands, seems to my eye to be beyond the skills of an ensemble of actors. I can't explain why, except to say that too many natural reactions occur at once for pretense. In photography truth tends to be stronger than fiction—especially when we recognize that the complexity of a moment is superbly human.

Mickey Rooney GREGORY HEISLER March, 1980

regory Heisler was an intense 25-year-old with a few years' experience assisting some of New York's most distinguished photographers. Melvin L. Scott, *Life's* assistant picture editor, was certain he could handle the assignment. It required getting Mickey Rooney, with his co-star Ann Miller and the rest of the cast of the Broadway musical *Sugar Babies*, into a rented studio for a couple of hours to shoot pictures that would capture the spirit of the show. The prospect of commanding that much show business temperament could daunt the most experienced professional. "I was naive," explains Heisler; "I didn't know what I was getting into. So I didn't worry.

"Besides, I had time to prepare, so I knew what I was going to do. Mickey Rooney, whom I had heard my parents talk about a lot, came late and had to leave early, but that was all right because he's a pro. Toss him another hat or a scarf or a pair of pants and he'd just put it on right there and get on to the next picture.

"Well, actually there was a certain level of anxiety. I felt like the guy that used to juggle plates on the end of sticks on the Ed Sullivan show. My heart was beating a thousand times a minute. I may have reached the level of metabolism of a hummingbird."

Ike **HANK WALKER** *February 2, 1953*

The scene has a democratic feel to it, with the mighty being made to take a joke. Times change, however, and this photograph makes us aware how much. Today's lariat tosser has to deal with bulletproof glass and a very nervous Secret Service.

The Secret Service wasn't asleep then either; and this Hollywood cowboy, in the parade at Eisenhower's first inauguration, had wisely asked Ike's permission first.

Elizabeth Taylor BOB LANDRY July 14, 1947

f a picture is used on *Life's* cover, there is a story inside to support it. The story might be of major importance, but, truth be told, sometimes it isn't. Fifteen-year-old Elizabeth Taylor made the first of her twelve cover appearances with the support of a story all of one page long. The reader learned that Taylor was paid \$1,200 per week. She had a car but wasn't allowed to drive. She had a pet chipmunk. Actually, the point of the story was contained in this sensual portrait: three years after thrilling the nation in the movie *National Velvet*, Liz was not a little girl any more.

18-Week-Old Human Embryo LENNART NILSSON April 30, 1965

n 1960, when editor Richard Pollard worked in *Life's* London bureau, he went to Stockholm to see a group of young photographers. They all told him he shouldn't leave town without meeting Lennart Nilsson.

"I found Nilsson working at a hospital, assisting in an operation. He wasn't a doctor. He hadn't been to medical school. He didn't impress me much until we were having dinner. It wasn't that he showed me any great pictures. It was more the passion with which he talked. He told me his project was to take pictures of the human embryo in all its various stages of development.

"There's a hell of a difference between a very good photographer and an extraordinary one," says Pollard, who a year later became *Life's* picture editor. "The great ones have a passion about their pictures that I could sense in Nilsson. That's all they care about.

"I gave him equipment. Lenses. Cameras. And encouraged him. He worked alongside doctors in Stockholm hospitals. Four years later he brought his results to New York, and spread them around my office. I was astounded. I think it was one of the most spectacular sets of pictures *Life* has ever published.

"Was there any more equipment Nilsson wanted? Well, he needed an \$8,000 fiber-optic lens so he could photograph a fetus inside the womb. We got him that. He went back and took the essay's opening picture with it.

"Later he let me know that he really liked the new Mustang automobiles Ford was making. Boy! For someone who took pictures like these, I got a car on the next boat to Sweden."

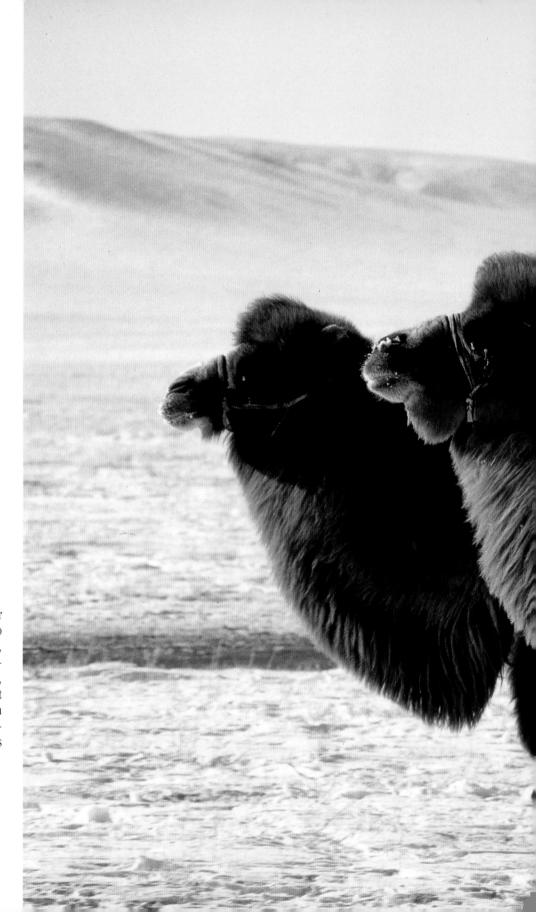

Camels HIROJI KUBOTA December, 1985

h! I can't ride a camel! Have you ever tried? It's terribly difficult. I just had to run around a lot!" explains Hiroji Kubota. In 1978, at age 40, he made the first of 30 trips to photograph the whole of China, including Dabuxiletu, Inner Mongolia. "If I'd gone any later I wouldn't have had the physical endurance I needed." When his book *China* came out in 1985, Kubota estimated he had exposed at least 1,000 photographs for each of the 186 pictures it contained.

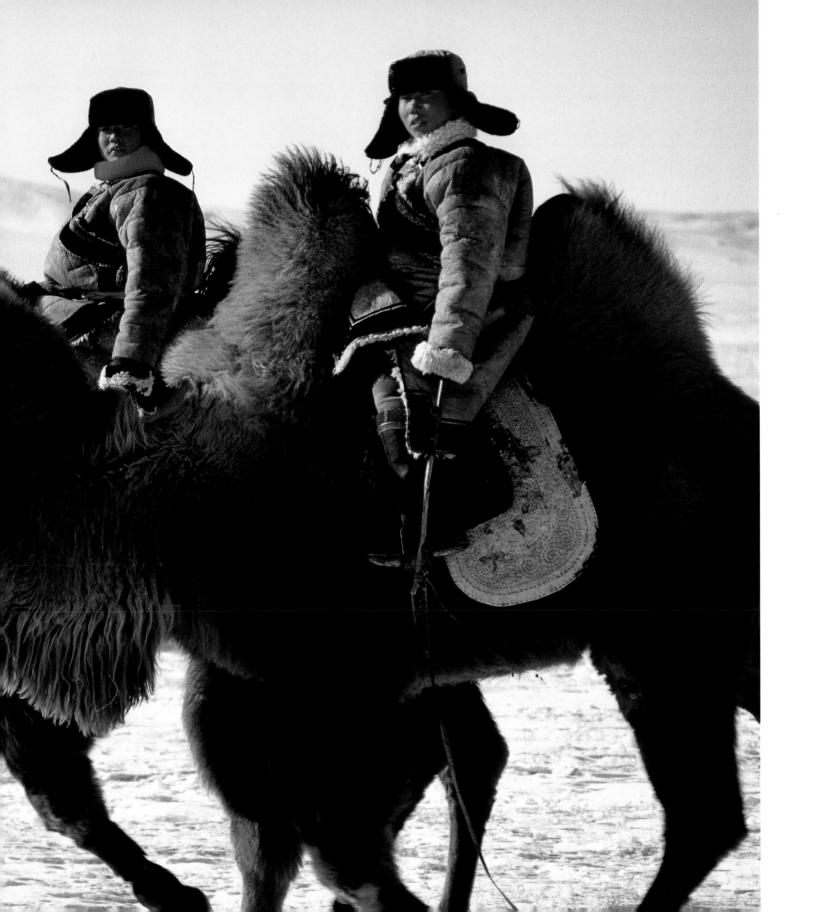

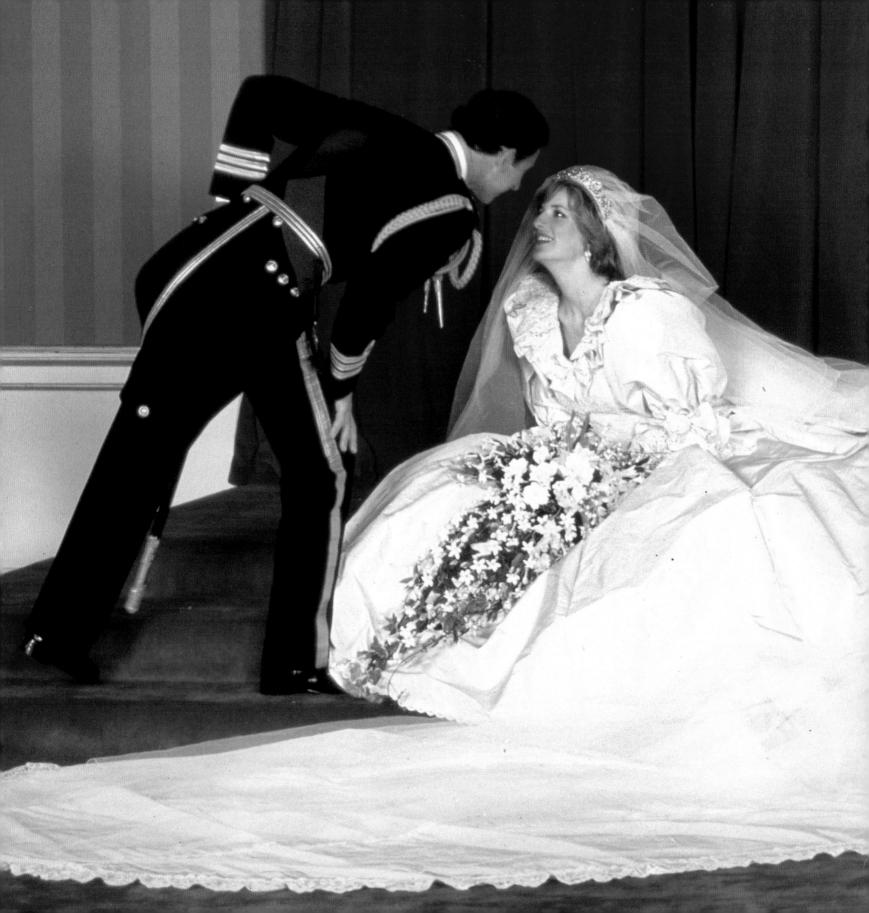

Royal Wedding PATRICK LICHFIELD September, 1981

f the TV melodrama *Dallas* were filmed in the palace, it might look like this. The Queen's uncle, the King, ran off with the woman he loved. When his niece Lillibet became Queen, she raised her son Charles to be a conscientious heir to the throne, and the audience was thrilled when Charles decided to marry the girl his sweet old grandmother picked out for him.

Charlie's Uncle Tony, who is a crackerjack photographer, took the couple's portrait for the engagement announcement, but since he and Charlie's Aunt Margaret were splitsville, I guess Tony wasn't invited to the wedding reception. Whatever the reason, Cousin Patrick (who's no slouch with the camera either) was drafted to take pictures of the wedding party.

Which probably was all to the good. Patrick Lichfield does not have the inventive sense of composition Lord Snowdon has—he prefers to photograph in a less calculated, more candid style—but this worked to our advantage when the family got back from the church. Having set up his lights for the formal portraits of the wedding party, Lord Lichfield, with his instinct for the moment, clicked away as the bride and groom digressed from the day's splendid pomp to make no bones about their feelings for each other.

Lucille Ball WALTER SANDERS

Remarkable American Women, 1976

n 1943 Lucille Ball had made 40 movies and was known as "Technicolor Tessie." Walter Sanders photographed the red lips, fair skin and blue eyes that set the standard for the rendition of women in color in movies.

However, it was Miss Ball's hair that was the crowning glory. *Life* said that people described her locks variously as "carrot-topped," "apricot-colored," "strawberry blonde" and "orange." Someone else is quoted as saying they resembled "the highly polished, brassy interior of Tommy Dorsey's trombone"—huh? "My love is as beautiful as the inside of a trombone?" Even if most men were in the Army at the time, I'm surprised brass had *that* much appeal.

Brett Weston BRIAN LANKER June, 1981

f he's lucky, the biggest problem a photographer may have is getting his subject to take off his glasses. I've asked any number of people to remove their spectacles so I can see what's behind them. Sometimes they are reluctant and sometimes they won't. And sometimes, when they do, the change can be so startling it's like seeing a tortoise remove its shell.

Brian Lanker wanted to see behind the stylish frames Brett Weston wore, and the photographer's sharp gaze is the focus of this picture. But there is another peculiarity. Like his famous father Edward, Weston uses Amidol in his print developer. It's an old-fashioned developing agent that produces deep, rich blacks in prints. If rubber gloves are not worn, it does the same for fingernails.

That becomes a badge of the trade for some photographers, and a small peculiarity made large in Brian Lanker's photograph.

Flavio GORDON PARKS June 16, 1961

A few sets of pictures actually do good. Gordon Parks went to Rio de Janeiro intending to photograph a story on its terrible slums, the *favelas*. He found a family, the Da Silvas, that had little money, little hope and eight children. The six eldest slept with their parents in one bed. The family

owned only three plates.

The oldest boy, twelve-year-old Flavio, took care of the others, rising early to set water boiling for a breakfast of coffee and (if lucky) stale bread. On Sundays his mother was able to do this chore and Flavio stayed in bed, where Parks photographed him. "He had bronchial asthma. He'd often just collapse," recollects Parks, who quoted Flavio as saying, "I am not afraid of death, but what will they do after?"

Thirty letters instead of a normal two or three were printed after the story appeared. One man in San Francisco wrote, "That picture of the exhausted Flavio has reached deep and I beg an opportunity to help him. Please let me know how I can get some money to the boy and his family."

Readers sent in \$30,000, and *Life* matched those contributions. Flavio was brought to the United States for successful medical treatment, and a house was purchased in Brazil for his family.

In 1986 Flavio lived in a five-room house around the corner from his parents. He had three children, two steady jobs, a color TV and dreams of owning a car. "Thank God," he said, "dreaming isn't prohibited."

John Mitchell HARRY BENSON Winter, 1975

John Mitchell, the Attorney General in the Nixon Administration, was on trial in New York City for conspiracy and obstructing justice. While the jury deliberated, I asked Harry Benson to cover Mitchell. Every morning at 6 o'clock Harry went to the hotel where Mitchell was staying in order to stand on the sidewalk and say "Good morning" to the former Cabinet member as he came out for a walk in Central Park. Benson was the only person on the sidewalk. Every day he was there with a cheerful greeting, but he did not take any pictures. He wanted Mitchell to see that he was diligent and vigilant in doing his job, but that he was also considerate and friendly.

Harry felt he had to give me some explanation—I was paying him, after all, yet getting no pictures. "I want him to recognize me. See me around. When the verdict's done, I'll go in for the kill."

Three days later the jury delivered a verdict of not guilty. That night, as the press crowded into Mitchell's suite for pictures and interviews, Benson stayed in the back of the room. Only when the last photographers were leaving did Benson greet his now exuberant early-morning acquaintance.

Soon Harry was sitting on the floor, facing the couch where Mitchell and three of his lawyers relaxed with drinks in their hands, leading them in Scottish songs. (Benson sounds as Scots now as the day he left Scotland more than two decades ago.) He only stayed a few minutes. There were a few tunes. A few jokes. A few exposures, and then a happy, cheerful good night.

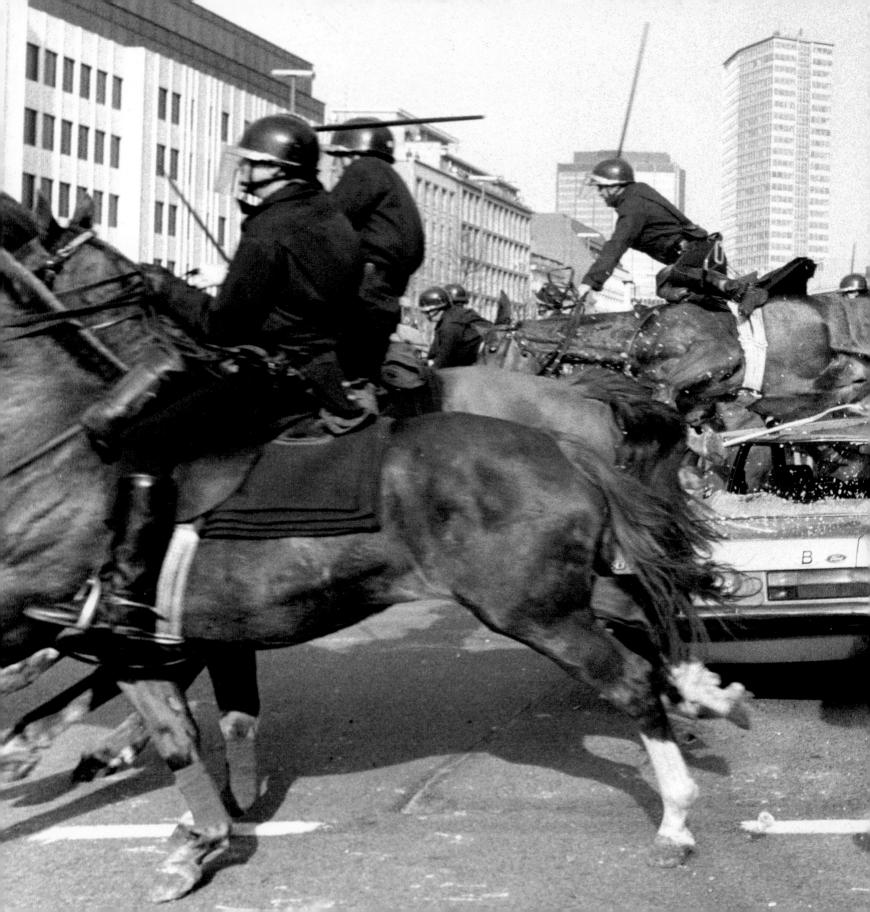

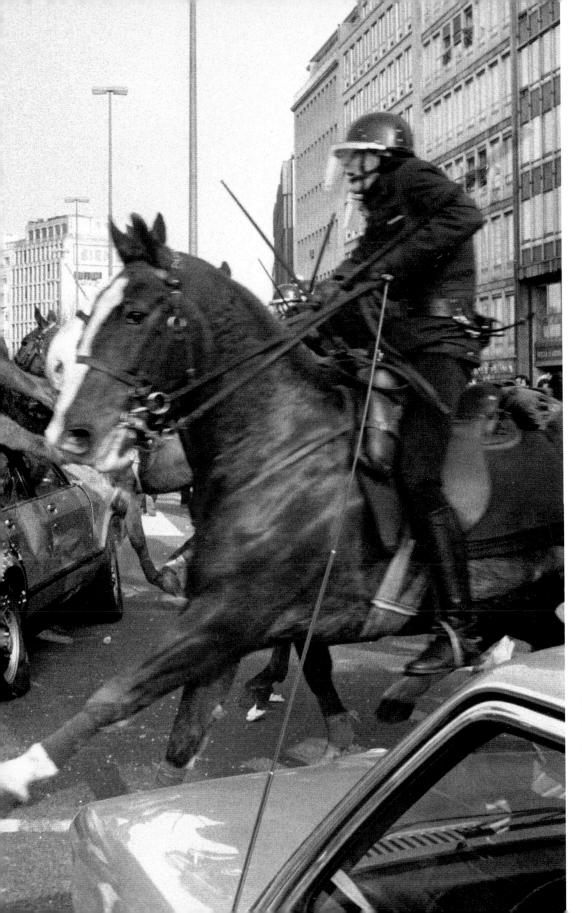

Belgian Horses GINO ZAMBONI April, 1982

Belgium is famous for many reasons, but one is that René Magritte, the much admired surrealist painter, lived there. After looking at this picture, I see how he might have gotten inspiration from the local scene. The mounted police in Brussels decided to charge a group of striking steelworkers who had approached the Prime Minister's office, but it looks more as if the 19th century has just attacked the 20th.

Ku Klux Klan MAGGIE STEBER June, 1981

n autumn 1952 I stood with a group of press photographers in a street near Harvard College, waiting for candidate Dwight Eisenhower's motorcade to appear. The Cambridge police asked people to keep back on the curb, and the people pretty much ignored the request. "Wait till the state troopers come," said a newspaper photographer standing beside me. "They'll get back then."

Sure enough two columns of mounted state police (well-trained, well-disciplined cops that aren't just local boys) came on ahead of the slow-moving motorcade. They steered their motorcycles directly at people standing in the street, then swept along the curb like lawn mowers. The street was clear in no time.

I keep thinking of that event as I look at Maggie Steber's photograph of a Ku Klux Klan march in Meridan, Connecticut. No great general was there, only 23 Klansmen marching in support of a local policeman charged with killing a black suspected shoplifter. Tempers were high. The Klan had to march with police protection.

In time a crowd of locals began to pelt the marchers with stones, and both the police and Klan members scurried back to the squad cars for safety.

I don't care much for people who throw rocks at demonstrators (although I admit I don't mind seeing the Klan getting a bit of its own back after all these years). It's also pleasant to realize that the Klan is so tiny it needs to be protected from us, rather than we from them. But mostly it pleases me that the police and the local Klansmen look enough alike that we need to see their uniforms to tell them apart. I think that's good.

A local police force may be bumbling, ineffective or even evil sometimes, like the rest of us, but it's these very human qualities that make it hard to imagine this country ever turning into a police state.

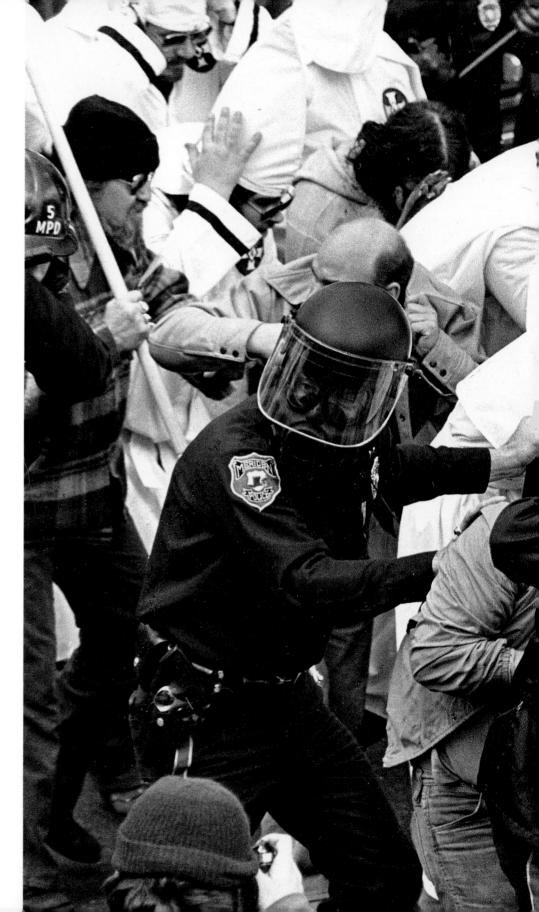

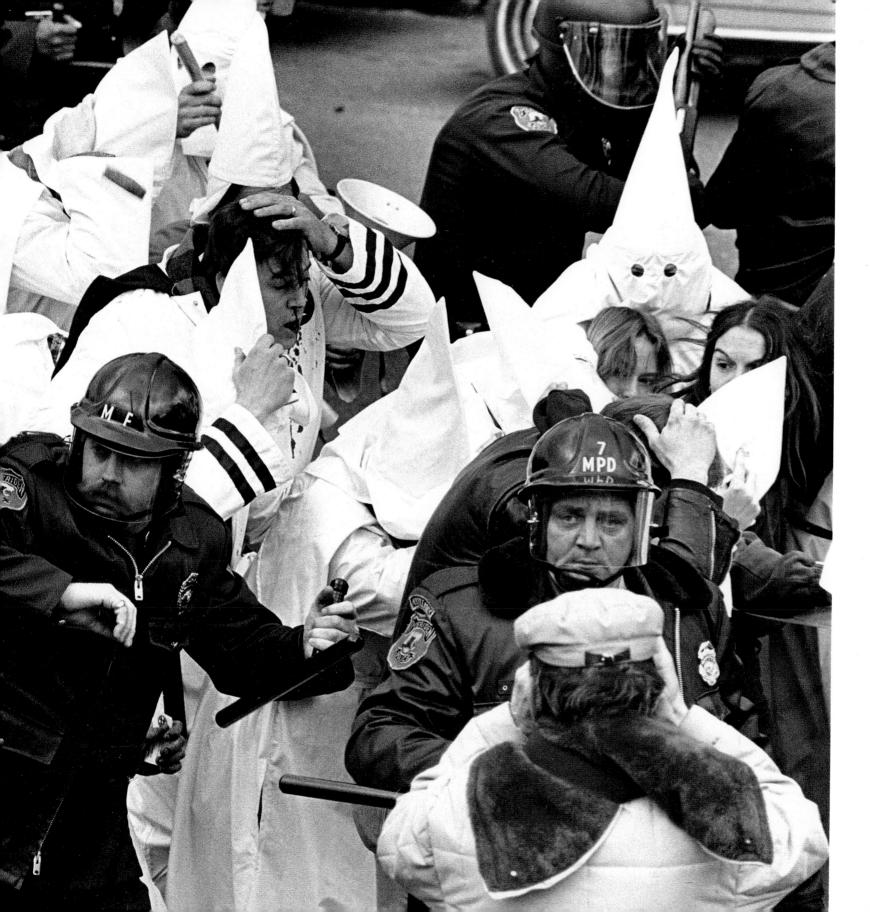

Snow Monkey
CO RENTMEESTER
January 30, 1970

She was a very attractive little lady. At least she had the reddest face. The nicest fur. The biggest male made sure she had the best spot in the pool, and the second biggest male would chase away all intruders. She sat there with a tremendous sense of enjoyment, even drowsing away sometimes with the heat of the water." That is Co Rentmeester's recollection of the simian beauty he met in the mountains west of Tokyo.

INDEX

Aborigine	106	Canterbury Cathedral	26	Goebbels, Joseph	156
Airplane crash	86	Capa, Cornell	133	Greene, Milton	61
America's Cup	122	Capa, Robert	30	Groskinsky, Henry	100
Anders, William	18	Cartier-Bresson, Henri	112, 116	,	
Anderson, Guy	94	Castoral, Frank	36	Halloween	66
Anderson, John	62	China	82, 116, 146, 172	Halsman, Philippe	14, 69
Andrea Doria	136	Clark, Ed	72	Hawn, Goldie	102
Anonymous	55, 128	Clock	32	Hayworth, Rita	58
Apollo 8	18	Collins, John D.	38	Heisler, Gregory	150, 166
Arnold, Eve	146	Commune family	152	Helicopter	40, 92
Auriol, Vincent	42	Coward, Noël	28	Heyman, Abigail	144
Australia	150	Crain, Jeanne	33	Heyman, Ken	84
Automobile	76, 184	Crane, Ralph	76, 115	High school	142
		Crimea	64	Hindenburg	24
Babies	50, 120			Hoffman, Ethan	89
Ball, Lucille	176	D day	30		
Baltermants, Dmitri	64	Dali, Salvador	14	Israel	55, 84
Barbey, Bruno	70	Dean, Loomis	28, 136		,
Beebe, Bill	132	Dietrich, Marlene	61	Joel, Yale	130
Belgium	184	Dominis, John	126	Johnson, Lynn	140
Benson, Harry	148, 182	Drum major	52	, ,	
Bergen, Edgar	44			Kennedy, Caroline	148
Bertucci, Lena	50	Eclipse	100	Kennedy, John F.	16, 133
Birmingham, Alabama	63	Eisenhower, Dwight David	168	Kennedy, Ray	106
Blue, Patt	88	Eisenstaedt, Alfred	52, 156	Kenny	140
Body builders	58	Embryo	170	Kessel, Dmitri	42, 82
Bourke-White, Margaret	12, 118	Eppridge, Bill	22	Koepnick, James	32
Bradshaw, Ian	164	Erwitt, Elliott	120	Ku Klux Klan	186
Bryson, John	60	Evans, Michael	98	Kubota, Hiroji	172
Buchenwald	118	Eyerman, J.R.	109	,	
Buna Beach	157				
Burrows, Larry	92, 162	Farm	20, 138		
		Feininger, Andreas	40		
		Ferorelli, Enrico	102		
		Flavio	180		
		Fonda, Henry	60		
		Fort Peck, Montana	12		

Landry, Bob	58, 169	O'Brien, Michael	142	Uebel, Georg P.	154
Lanker, Brian	178	Olson, John	78, 152	Uganda	104
Leibovitz, Annie	34	O'Neill, Michael	16		02 1/2
Leopard	126			Vietnam	92, 162
Lichfield, Patrick	174	Parks, Gordon	180	Villet, Grey	138
Lindbergh, Charles	56	Pavarotti, Luciano	90	Voight, Werner	86
Louis, Joe	124	Pearl Harbor	128		
, y = -		Piano	130	Walker, Hank	168
MacArthur, Douglas	134	Picasso, Pablo	49	Walla Walla Prison	89
Madonna	160	Poland	70	Warren, Robert Penn	34
Mafia	36			Waugh, Denis	26
Mark, Mary Ellen	44, 110	Queen Elizabeth	154	Weber, Bruce	160
Matisse, Henri	112			Weddings	88, 94, 96, 148, 174
McCombe, Leonard	74	Reagan, Ronald	98	Wells, Mike	104
McKinley, Barry	62	Rentmeester, Co	158, 188	Westenberger, Theo	35
Melford, Michael	20, 54	Ricciardi, Mirella	90	Weston, Brett	178
Midwife	80	Robinson, Jackie	125	Wheat	20
Mili, Gjon	49, 124	Rooney, Mickey	166	Willkie, Wendell	38
Millrose Games	114	Roosevelt, Franklin D.	72	Windsor, Duchess of	69
Mirage jet	54	Runaway kids	110, 115	Winnipeg	100
Mitchell, John	182			Women's march	78
Monkey, snow	188	Sanders, Walter	176	Wrestler	35
Moore, Charles	63	Sanford, Tobey	58		
Morse, Ralph	114, 125	Schutzer, Paul	96	Yangtze River	82
Movie, three-dimensional	109	Seattle	110	O	
Multiple exposures	58	Shanghai	116	Zamboni, Gino	184
Munroe, Joe	68	Shere, Sam	24	,	
Mydans, Carl	134	Silk, George	66, 122		
Mydans, Carr	131	Smith, W. Eugene	46, 80		
NASA	18	Snake	54		
Nefertiti	122	Sorce, Wayne	56		
Nilsson, Lennart	170	Spain	46, 86		
Novak, Kim	74	Spitz, Mark	158		
Novak, Killi	/ 1	Stackpole, Peter	33		
		Steber, Maggie	186		
		Streaker	164		
		Strock, George	157		
		outoek, deorge	-21		
		Taylor, Elizabeth	169		
		Telephone booth	68		
		Time Inc. Picture Collection	76		

PICTURE SOURCES

Archive / 44, 89, 110, 142, 144

Aspect Picture Library Ltd. / 104

Associated Press / 38

Bettmann Archives/UPI / 24

Black Star / 63, 140

Camera Press / 174

Contact Press Images / 34

ISO Press / 184

Los Angeles *Times /* 132

Magnum Photos Inc. / 30, 70, 112, 116, 120, 133, 146, 172

The Melbourne Age / 106

NASA / 18

New York News Inc. / 36

Shemanski, Collection of Martin J. / 128

Sipa Press / 86

Sygma / 35, 60

Syndication International/Photo Trends / 164

The White House / 98

*